The Patrick Moore Practical Astronomy Series

More information about this series at http://www.springer.com/series/3192

Making Beautiful Deep-Sky Images

Astrophotography with Affordable Equipment and Software

Greg Parker

Second Edition

Greg Parker
Brockenhurst, Hampshire, UK

ISSN 1431-9756 ISSN 2197-6562 (electronic)
The Patrick Moore Practical Astronomy Series
ISBN 978-3-319-46315-5 ISBN 978-3-319-46316-2 (eBook)
DOI 10.1007/978-3-319-46316-2

Library of Congress Control Number: 2016953734

© Springer International Publishing Switzerland 2007, 2017
This work is subject to copyright. All rights are reserved by the Publisher, whether the whole or part of the material is concerned, specifically the rights of translation, reprinting, reuse of illustrations, recitation, broadcasting, reproduction on microfilms or in any other physical way, and transmission or information storage and retrieval, electronic adaptation, computer software, or by similar or dissimilar methodology now known or hereafter developed.
The use of general descriptive names, registered names, trademarks, service marks, etc. in this publication does not imply, even in the absence of a specific statement, that such names are exempt from the relevant protective laws and regulations and therefore free for general use.
The publisher, the authors and the editors are safe to assume that the advice and information in this book are believed to be true and accurate at the date of publication. Neither the publisher nor the authors or the editors give a warranty, express or implied, with respect to the material contained herein or for any errors or omissions that may have been made.

This Springer imprint is published by Springer Nature
The registered company is Springer International Publishing AG
The registered company address is: Gewerbestrasse 11, 6330 Cham, Switzerland

*I dedicate this book to my wife **Helga** who continues to support my obsession and who (also) no longer has a single favourite image.*

Preface to the Second Edition

A great deal has happened since the first edition of this book was published nine years ago in 2007. This new edition incorporates a lot of the changes and developments that have occurred in deep-sky imaging, and many of the tips and tricks I have learned throughout the past few years.

I took early retirement from the University of Southampton in 2010, which has allowed me to spend a great deal more time on my obsession and hobby. There have also been major changes at the New Forest Observatory ® and with the original Hyperstar, which has since been replaced by a collimatable Hyperstar III.

Also in this edition are new chapters on parallel imaging and on how to process professional data to make high-quality deep-sky images without having to capture any ancient photons of your own. I have learned more about processing images from astrophotographer Noel Carboni during the past nine years. With my better understanding of how to properly create and process images, I am pleased to say that a completely rewritten chapter on image processing has been incorporated into the 2nd Edition of this book.

This book also contains new deep-sky images that I have processed over time. While the first edition contained Noel Carboni's images, this book features new material and new pretty pictures, many from the parallel imaging array. Thank you for the interactive Internet processing lessons, Noel.

I really envy those of you who will embark on this adventure for the very first time after reading the contents of my book. Savour and record every moment, it is truly a unique life experience!

Brockenhurst, UK
2016

Greg Parker

Acknowledgements

Firstly, I would like to thank John Watson from Springer Publishing who contacted me just over a year ago and told me that Springer was interested in a Second Edition of "Making Beautiful Deep-Sky Images." I would also like to thank everyone at Springer who gave me the go-ahead for this project, and then followed through by helping me put this book together.

I continue to be extremely grateful to Noel Carboni for showing me the arcane secrets of processing deep-sky images. Noel has patiently sat with me through many hours of Radmin sessions, allowing me to see exactly what he does on his computer to monitor Florida, U.S.A., thousands of miles away. Your patience is boundless Noel, as is your knowledge of Photoshop.

I am still very grateful for Alan Chen's help on the Yahoo Starlight Xpress (SX) forum, and to Bud Guinn on the "Our Dark Skies" (ODS) forum, which no longer exists. Bud introduced me to ODS from the SX forum and has been a great help and inspiration to me since I first started imaging. Bud also introduced me to the deep-sky imaging guru Noel Carboni on the ODS forum – and the rest, as they say, is history.

Much thanks and appreciation goes to David Squibb of Tavistock, Devon, who was my "A"-level Physics teacher many decades ago. It was David's dedication to the Physics education that led me to write this book and a textbook on semiconductor device physics.

Finally, although I have already dedicated this book to her, I would like to mention that without my wife's continuing interest and support in something she doesn't even understand (although she really likes the results), this project would not have been started, let alone completed.

Brockenhurst, UK Greg Parker
2016

Contents

1	**How did I start?**	1
	Conclusions	13
2	**The Beginning – and a Serious Health Warning**	15
3	**Assembling your Imaging System**	19
	Refractor or Reflector, or Perhaps Both?	19
	Reflecting Telescope as the Main Imaging Scope	22
	Refractor as the Main Imaging Telescope	25
	Reflector/Refractor Imaging Combination	27
	Polar Alignment	28
	Collimation of an SCT	28
	The CCD Camera	29
	Celestron Nexstar 11 GPS SCT	30
	Takahashi Sky 90 Refractor	31
	Sub-exposure Times	32
	Narrowband Imaging and Light Pollution Filters	36
4	**Computational Considerations – Data Acquisition and Image Processing**	39
	The "Powerhouse" Indoor Computer System	40
	The South Dome Computer System	42
	The North Dome Computer System - the mini-WASP Array	43
5	**A Permanent Setup**	45

6	**First Light – Choosing your Objects**	51
	Some Possible Examples	52
	Spring	52
	Summer	53
	Autumn	55
	Winter	56
	Other Things to Image	57
7	**First Light – your First Objects**	59
	Stop Press!	62
8	**Wide-Field Imaging with a Short Focal Length Refractor**	63
9	**Hyperstar III Imaging**	69
10	**Parallel Imaging with an Array**	75
	History of the imaging systems at the New Forest Observatory	75
	The Sky 90 imaging array	77
	The Canon EF 200 mm f#2.8 prime lens imagers on the mini-WASP array	80
11	**Fundamentals of Image Processing**	85
	Very first step: sift the data	85
	Processing a star field	86
	Processing a nebula	90
	Creating a mosaic	92
12	**Processing Professional Data**	95
13	**The Deep-Sky Images**	107
14	**Differentiating your Work**	153
	Asteroid 162 Laurentia	160
15	**Your Largest Resource**	161
16	**Book Recommendations**	167
	Appendix 1: The Angular Size of Objects in the Sky	171
	Appendix 2: The Designation of Deep-Sky Objects	173
	Greg Parker	176
	Physics World Article	179
	Postscript to the Second Edition	181
	Index	183

Chapter 1

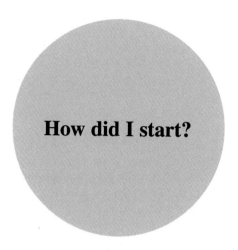

How did I start?

This chapter is meant to give you some idea of deep-space imaging if you are just starting out in the field. Personally, I find it very useful to see how other people entered the hobby, because then you can see what their major mistakes were and learn from them.

I am fortunate enough to live in a semi-rural location with reasonably dark skies. I was also in the fortunate financial position of being able to buy myself a reasonable-quality telescope. At this point in time, sometime in January or February of 2002, I was solely interested in carrying out visual work, which I knew nothing about, and had very little interest in imaging of any sort at all. So, as I wanted a good telescope for visual observation, I went for the biggest refractor that my budget would allow. My first purchase was a beautiful 6-inch Helios refractor with motor drives for both axes, and no computer control. This was a considered choice on my part, I wanted the "fun" of finding all the deep-sky objects I'd read about, using my own skills, no computers. The scope performed admirably and gave beautiful bright, high-contrast views of the planets, and also of large galaxies and nebulae. On the other hand, I did not perform admirably; I was clearly useless at finding where all these Messier and Caldwell objects were hiding. I did not properly polar align the telescope, and I did not use the motor drives correctly, so when I did find objects, they were always drifting out of the field of view. After returning to view the few objects I could find night after night I realised I had actually made a big mistake – I really did need the computer "goto" capability to get these evasive objects into my field of view. After admitting defeat after about three months, I bought the Celestron Nexstar 11 GPS Schmidt-Cassegrain reflector with an Alt-Az computer-driven mount (fork mount), and I spent the next two years happily carrying out visual observations.

The first couple of outings with the Nexstar 11 GPS were very disappointing indeed, mainly because I didn't really know what I was doing and I was only just beginning to get to grips with the basics of the system; a system that seemed incredibly complicated to me at the time. In addition, setting up the "goto" required me to know the position of two alignment stars, so I had to start learning my way around the sky anyway, even if it was just to know what the brightest stars were called, and where they were located.

On a Thursday night in May, a clear crisp evening with good viewing settings, and what subsequently happened is the subject of a "Lateral Thoughts" article in the September 2002 issue of Physics World. To cut a long story short, this was the first time I had set the telescope up properly, and armed with my copy of Norton's, I quickly logged up 24 of the 27 objects listed on one page. I had never seen any of these objects before, and it really was a defining moment in my life and a night I shall never forget. My first ever views of M13, the Great Globular Cluster in Hercules, and NGC3242 a planetary nebula in Hydra called "the Ghost of Jupiter" are now permanently etched into my memory. I still get a "tingle" of excitement when I recall the beauty of that crisp, crystal-clear (Moonless) night.

As I was primarily into observing, it wasn't too long before I invested in the superb Celestron Bino-Viewers, which of course meant I then had to double up on all my eyepieces – an expensive move. This turned out to be a bit of a blow when I finally took the plunge and began CCD imaging, as I haven't looked through an eyepiece since. The first thing that I changed on the main scope was the totally abysmal holder for the little finder scope. I bought the Celestron "quick release" holder for the finder scope and to be honest this is the one Celestron should fit as standard as the supplied version simply isn't worth bothering with in my opinion. With the Celestron f#6.3 reducer/corrector and a few other optical accessories I was extremely happy observing for around two years. However, there are only a handful of objects that look truly spectacular through the eyepiece of an 11" reflector, and I found I was returning to these few objects time and time again. I was not searching out the less dramatic objects because, to be quite honest, I found them quite boring when I eventually did manage to track them down. It was clear that I was rapidly approaching the time when I needed to image the skies rather than just view them, so that I could see both faint and bright objects in all their glory, and in colour.

The move to create an imaging setup meant that I had to go for a permanent mounting rather than carrying the scope in and out of doors for each observing session. I will discuss my observatory in another chapter, but on reflection, I think I was very lucky not to have dropped the rather heavy Nexstar 11 GPS on its many trips in and out of the lounge door, with the rather large step down into the garden. So, the acquisition of a fibreglass dome also meant the purchase of a pier, and the fixing of the pier to a large concrete block in the ground. Details are covered in the observatory chapter, but the first major change from observing to imaging was the construction of the observatory.

To start serious deep-sky imaging I bought the Starlight Xpress SXV-H9C colour CCD. I had already purchased the Hyperstar lens from Starizona [http://starizona.com/acb/hyperstar/index.aspx] that converts the very slow f#10 Nexstar 11GPS into an extremely fast f#1.85 imaging system. It was the availability of the

Hyperstar lens assembly that led to my buying the Nexstar 11GPS over other similar makes of scope in the first place, just in case I wanted to move onto imaging at some later date. The decision to choose the Starlight Xpress SXV-H9C [http://www.sxccd.com/trius-sx9c] was quite easy to make (please note my original camera was not the Trius version shown in the link). I wanted a U.K. manufactured device in case it needed to be returned to base for repair. I also wanted a single shot colour camera as I was only interested in taking pretty pictures, and it seemed perverse to take monochrome images through at least 3 different filters and combine them all at the end when the job could actually be done in one go. So the final decision, for me, came down to either the massive SXV-M25C camera [http://www.sxccd.com/trius-sx25c] coming in at 6 Megapixels, or the smaller SXV-H9C coming in at a tiny 1.4 Megapixels. Both Starlight Xpress (Terry Platt) and Starizona (Dean) suggested the H9C as it would be much better matched to the (original) Hyperstar lens, and they have both been proved correct in practice. The M25C would have been far too large, and a lot of the chip's imaging capability would have been wasted due to the Hyperstar's small focal plane diameter. The SXV-H9C together with the Hyperstar lens [see Figure 1.1] gave me an extremely fast f#1.85 system with a field of view of 1 degree by three-quarters of a degree and a sampling of 2.57 arcseconds per pixel. For other "field reducer" systems, I found the Celestron f#6.3 reducer to be very nice, and the Meade f#3.3 to be unusable (due to vignetting and coma) at the lower f-numbers. It should be noted that all Starlight Xpress SXV imaging cameras are now of the more advanced Trius design.

So my initial imaging system was a standard Nexstar 11GPS in Alt-Az mode, SXV-H9C colour CCD imaging camera, and the original Hyperstar lens. The first thing that had to be changed was the focuser on the Nexstar 11, which turned out to be far too coarse for f#1.85 imaging. The depth of focus for the Hyperstar system on the 11 GPS is only around 7 microns; where the diameter of a human hair is on average around 80 microns. The standard Celestron focuser was replaced by the "FeatherTouch" focuser [http://starizona.com/acb/Feathertouch-SCT-MicroFocuser---Celestron-11-except-CPC-1100-P982C654.aspx] from Starizona, a straight replacement that gives coarse and fine focusing options using an outer and inner focusing knob. This is a truly superb product and it is indispensable for fine focusing if you are moving the main mirror of a large reflector to micron accuracy. At this point I also changed from taking a little VAIO laptop into the observatory to having a home-built 1GHz mini-ATX machine in permanent residence. Not having the portable little laptop made it difficult for me to manually focus the scope whilst trying to look at an image on the display, so the next addition was a Celestron motorised focuser that I modified to go onto the FeatherTouch focuser, see Figure 1.2. Now, whatever direction the telescope was pointing in, I could sit in front of the monitor and focus the scope with the hand-controller. At this point I could now start acquiring my first images. I was over the Moon (sorry) with my first efforts imaging M42, I thought they were fantastic, but I realise now of course that they were in fact very poor images. For a start, I did not use (or understand the benefits of) stacking sub-exposures, and I didn't realise how extremely poor the star shapes were either. More of very poor star shapes and the Hyperstar lens assembly a little later.

Figure 1.1 The Hyperstar lens assembly and the SXV-H9C one-shot colour CCD camera from Starlight Xpress. Bottom photo – the two elements connected.

Next, I started to use stacking, remember the telescope was in Alt-Az mode. The fast Hyperstar system meant I could take short sub-exposures (less than 30 seconds to prevent field rotation problems) and stack the subs together to get a reasonable final image. Except the supplied Starlight Xpress software would not stack AND rotate as was necessary for my field-rotated series of subs. Although the field rotation on any one sub was undetectable, if you took an hour's worth overall you could get several degrees of rotation that needed to be accounted for in the stacking software. So the next excursion was into different software packages. At first, I used AstroArt [http://www.msb-astroart.com/], a package I was very happy with, but I quickly moved onto Maxim DL for reasons I actually cannot now remember,

1 How did I start?

Figure 1.2 The standard Celestron electric focuser, mounted on home-built aluminium stand-off pillars, to fit the Starizona "FeatherTouch" focuser.

and I have stayed with Maxim DL ever since [http://www.cyanogen.com/]. At this stage Maxim DL was used for data (image) acquisition, and for all the image processing.

At this point, it would seem that things are entirely satisfactory, but of course the field rotation limitations of Alt-Az imaging finally got to me so I was forced to go equatorial. This required purchasing the Celestron heavy-duty wedge and adjusters (very naughty that the adjusters are bought separately Celestron) and I then had to redesign my all-aluminium Alt-Az pier for the new Equatorial system. The redesigned aluminium pier can be seen in Figure 1.3. Another thing I noted was the so-called "heavy duty" wedge was not so heavy duty after all, and it would shift a little depending on how the very heavy Nexstar 11GPS was cantilevered, i.e. the telescope's imaging position in the sky. Fortunately a very simple modification could rectify this design fault in the wedge, and I found that I did not have to reposition the wedge, after carrying out the first drift alignment, for over a year. The wedge modification can be seen in Figure 1.4.

As you can see the modification, using 2 mm thick Aluminium basically closes off the open box-section at the end of the wedge that led to the "warping" and loss of alignment when the scope was slewed across the sky.

Surely we must be there now? Equatorially aligned, fast imaging, large aperture scope, color CCD and software that both acquires the CCD data and carries out powerful image processing. Not quite, we still have the problem with "funny-shaped" stars, and sorting this one out took many months of effort and much pain. You will see from the original Hyperstar images presented in Chapter 13 of this book that the stars are pretty round, with the exception possibly of some coma at

Figure 1.3 The custom-made all-aluminium Equatorial mode pillar.

the extreme top corners of the field which is very hard to eradicate in any low f# optical system. I don't think you will find ANY other original Hyperstar/Fastar images that can show you decent round stars (unless they have been nicely "rounded" in software) across the whole field of view. The reason for this is quite nasty. An f#1.85 system is very unforgiving in alignment/focusing and the Hyperstar lens just sits in the secondary mirror cell. Now the secondary cell has some "slop" around the edge giving maybe +/- 1 mm of movement of the cell. Absolutely no bother if you have the standard secondary mirror in the cell, you just use the adjustment screws to set your collimation, but what about the f#1.85 Hyperstar lens? There was no adjustment in the initial design (the one that I had when I first started imaging of course have), and the placement of the lens within the corrector plate is a very hit or miss affair. I won't bore you with the details that

1 How did I start?

Figure 1.4 The modification made to the standard Celestron "heavy-duty" wedge. A 2 mm thick aluminium sheet is used to close off the open-ended box section of the wedge. Right-hand photo, the wedge in-situ.

made me persevere with getting this system finely tuned – suffice to say I knew there was a "sweet spot" where a collimated Hyperstar system would give very good results – so I had an "existence proof". Problem was, how do you "collimate" an original Hyperstar system that doesn't have any collimation adjustment screws?

I took a drill to my beloved Nexstar 11 GPS telescope, glued nuts to the outside of the secondary cell ring, and fitted four threaded rods that could physically push the Hyperstar assembly around within the corrector plate. The assembly can be seen in Figure 1.5. The collimation procedure is now exactly the same as for collimating the secondary mirror. Image an out of focus star and move the Hyperstar assembly to get symmetrical star patterns in the centre of the field of view; it is as difficult/ easy as conventional reflector collimation. These four adjuster rods are the reason I get diffraction spikes around the brighter stars. I also got diffraction spikes before fitting the adjuster rods as the four cables from the back of the CCD need to somehow be routed out across the corrector plate. So, however you go about it, the Hyperstar assembly will give you some sort of diffraction pattern around bright stars.

Are we there yet? Sorry, not quite. It now became clear that for the fainter objects I wanted to image I needed to go for longer sub-exposures, I needed to move to auto guiding. This was a little more straightforward than I was expecting with only a couple of minor glitches to contend with. I bought the Starlight Xpress SXV auto guider camera, as this was compatible with the SXV-H9C. Maxim DL was already set up to be able to handle an auto guider with the SXV-H9C, so it was just a matter of buying a suitable guide-scope and I'd be ready to take some long exposures. I chose the superb little Celestron 80 wide-field scope as a guide scope. This is extremely light at only 2 kg and it operates at f#7.5, which meant that my auto guiding was very precise since I was only imaging at f#1.85. Typically during an imaging session the errors were less than 0.1 pixels. So what were the glitches? Well at first, the auto guiding simply did not work. It was fortunate that there was

Figure 1.5 The threaded rod adjusters used to collimate the Hyperstar lens to the Nexstar 11 GPS. The threads are covered in black tape prior to imaging or you will get a very strange diffraction pattern around bright stars due to the fine threads.

a "manual control" in the Maxim software as this allowed you to see if you could physically move the scope by clicking on direction buttons. The scope did not move. It turned out that you couldn't use a standard "telephone" cable connection between the imaging CCD and the Nexstar 11 GPS; it doesn't have enough connections. I put together my own home-built solution and at last the software "talked" to the scope and I could start to try auto guiding. My first auto guiding session was very disappointing. The stars were badly trailed and I actually had better results without the auto-guiding being enabled. This was due to incorrect parameters being used in the auto-guiding program. With a couple of nights of trial and error I iterated to a set of guider parameters that seemed to work rather well, as stated earlier, the R.M.S. errors for an evening's observing were typically less than 0.1 pixels. I now use auto guiding for all subs longer than about 30 seconds, and no auto-guiding if my subs are less than this.

There was still yet another addition to the system, in truth I don't think you ever finally end up with a final stable configuration. The very fast Hyperstar lens was not only unforgiving in the precision needed to set it up, it was also very unforgiving in showing you how much local light pollution (sky glow) you had. In order to try and cut down the sky glow in my location I made one of the best accessory

acquisitions yet – the Hutech IDAS light pollution filter. This filter together with the Hyperstar meant that I typically took sub-exposures of 120-seconds, without the filter I was limited to around 60 seconds before sky glow became intrusive. I did not properly recalibrate the system (with the filter in) to see just how far I could go before the sky glow became really intrusive again before I moved onto wide field refractor imaging; this was a big mistake on my part. However, from the experience gained with the refractor, I now estimate that I could have gone to 5 or 6-minute sub-exposures with the Hyperstar and IDAS filter before the light pollution once again reared its ugly head.

Now, we're just about there - surely. It's been a long fraught journey, and it's still far from over. I had to invest in a dehumidifier for the observatory [http://www.pulsarobservatories.com/] as living in the New Forest gave me severe condensation problems during the last few months of 2005. Severe, and costly, the damp wrote off my nice little 15" CRT monitor, and I don't think it did much for the computer's life expectancy either.

After a great deal of painstaking deliberation, I then finally opened my wallet (a painful experience) and invested in PhotoShop CS2, a worthwhile investment if you want to get the last 0.5 % out of your images. I also use Noel Carboni's PhotoShop actions extensively [http://www.prodigitalsoftware.com/Astronomy_Tools_For_Full_Version.html] and even better than that, Noel Carboni actually processes all of my images nowadays (that was back in 2005. Noel still processes some of my images, typically the ones I can't get to behave, but I now do a lot of the processing myself).

In terms of system reliability, it seems I have gained a couple of "hot-pixels" in the SXV-H9C that I can live with, and the azimuth motor of the Nexstar 11GPS simply stopped working a few months back. I know that this was due to leaving the scope totally unused for two months due to a spell of really bad weather. I replaced the motor assembly (surprisingly cheap considering what you get) and found on close examination what the problem was. The motor and worm gear "floats " over the main gear cog due to a sprung loaded swivel mount. The mount had seized (simply an Allen screw that had pinched itself up), so I have fixed the old motor drive and now have a spare. Michael Swanson was extremely helpful in showing me how to track down where the problem was (was it the motor, or the motor controller?) and if you have a Celestron scope you really should use his site and buy his book [https://www.amazon.co.uk/NexStar-Users-Guide-Patrick-Moore--Practical-Astronomy-ebook/dp/B00FBTTEVQ/ref=sr_1_1?ie=UTF8&qid=1464965740&sr=8-1&keywords=the+nexstar+user%27s+guide]. Don't run into unnecessary trouble like I did. If you have a long spell of bad weather, don't just leave the system untouched, go out and fire it up anyway a couple of times a week, it may just save you from severe grief when the skies finally clear. So have we now finally got there? No of course not, there have been some further recent changes to the system. The Celestron wide field guide scope has been replaced with a Takahashi Sky 90 refractor and f#4.5 reducer/corrector for wide field imaging. In order to make full use of the Sky 90's imaging plane I now also have the large format CCD camera SXVF-M25C to give me those very big field-of-views (FOVs) necessary

for imaging objects like M31 with a single frame. The trusty Starlight Xpress SXV-H9C workhorse camera has been sold to a UKAI forum colleague and has gone to a good home (9 years on this is a sale I bitterly regret and I wish I had held onto that superb little camera). The Hyperstar has been removed altogether from the Nexstar 11 GPS and now if I am wide field imaging using the Sky 90, the Nexstar 11 GPS is relegated to the role of guide scope, which sounds, and looks, rather perverse. However, if I want high-resolution images of the smaller galaxies, I can put the big SXVF-M25C camera on the 11 GPS with an f#6.3 reducer/corrector, and then use the Sky 90 as the guide scope at f#5 (i.e. I remove the Sky 90 reducer/corrector lens). Lastly, the Nexstar 11 GPS hand-controller started to play up (the buttons got "sticky"), so I moved to the NexRemote software and now drive the telescope through the computer keyboard and a "Gamepad" controller. This is the system I currently have in place, and I don't think there is much that can be done to improve the system overall now without going for a replacement for the Nexstar 11 GPS itself. You can see the piggybacked Sky 90 on the Nexstar 11 GPS in Figure 1.6, and the 7' 6" diameter fibreglass dome garden observatory itself can be seen in Figure 1.7.

Would I choose the same overall setup if I were starting from scratch again? Well, with the price limitations I was working to I probably would. I like the look of the all-refractor alternatives, but for me the big aperture of a reflector, and the potential of f#1.85 imaging really take some beating. Maybe the 14" Celestron with a Hyperstar lens, but then that wouldn't fit too easily in my 7 foot 6 inch glass-fibre dome observatory, so maybe a new observatory and then…. and then…and then. You get the picture.

Celestron have brought out a Rowe-Ackermann Schmidt astrograph which gives f#2.2 imaging as it has effectively "built in" the Hyperstar lens to make an integrated optical unit [http://www.celestron.uk.com/productinfo.php/rowe-ackermann_schmidt_astrograph/telescopes/optical_tubes_ota/3863]

Stop Press!!! Just when you thought it was safe to go back into the water. I found in September 2006 that there is a conflict between the NexRemote software and Maxim DL configured for the SXVF-M25C camera (there was no problem with the H9C camera??). My immediate solution to this was to purchase a new programmable hand controller as this doesn't seem to conflict with Maxim DL (I don't think the big camera likes anything else running on another USB port). There was also a camera firmware upgrade needed for the new M25C camera as the colour planes were shifted in a peculiar way. Terry Platt responded very quickly to get this particular problem sorted. Finally (?) there was a light smear towards the right of bright stars, and a dark band above bright stars in the red channel. These problems were overcome by me soldering a Tantalum bead capacitor onto the M25C circuit board as described by Terry Platt in a private communication. My advice – when you get a system sorted and fine-tuned, don't change ANYTHING.

Stop Press 2!!! I live in the New Forest, Hampshire, U.K. but at times I wonder if I'm in a 3rd World country. We seem to suffer more than our fair share of power outages, and these cause severe grief if you're in the middle of an imaging session,

1 How did I start?

Figure 1.6 The Sky 90 f#4.5 refractor system mounted piggyback on the Nexstar11 GPS.

not to mention the possibility of line glitches and computer damage. It appears I did suffer computer damage from one of these outages and so there have been three more additions/changes to the observatory setup. Since November 2006, my extension cables in the observatory are now the Belkin surge-protection type. I do not

Figure 1.7 The Pulsar Optical 7 foot diameter fibreglass dome in its back-garden location in the New Forest, Hampshire, U.K. The dome sits on a hexagonal 10-foot diameter wooden decking.

use the transformer to power my Nexstar 11 GPS telescope anymore, but instead I use the excellent Celestron "power tank" http://www.celestron.com/c2/product.php?CatID=51&ProdID=371 which makes the telescope totally mains independent, so that I don't need to go back to the two-star align and object location if I suffer a mains glitch! Lastly, I bought an uninterruptible power supply (UPS) for the computer/monitor, this gives an audible warning if mains power goes off, as well as giving that extra bit of buffer protection between any mains spikes and my delicate computer innards. I also get the benefit of a few tens of seconds to shut down the computer properly if it looks like mains power will be off for a while.

I am sure that in the months/years to come there will be the need for many more additions that I presently don't see any requirement for, such are the never-ending joys of this hobby.

I do not use the Celestron Power Tank anymore for powering the C11, instead I use a battery eliminator and power that through the uninterruptible power supply. I have also installed a greenhouse heater set on the "frost" setting, and this is always powered on in the observatory. There are two reasons for having the heater: one, the type of dehumidifier I am using in the Hyperstar dome does not like being operated at near freezing temperatures, and two, I didn't like subjecting the electronics for all the gear in the observatory to such massive temperature excursions. Touch wood, everything has run without a glitch for well over 5-6 years now. The heater is of course turned off during an imaging session.

Conclusions

When I first started imaging and posting my Hyperstar images on the forums, people were very complimentary, and there were often suggestions that it might be a good idea to move from Alt-Az to Equatorial if I wished to improve my images. People were extremely polite and helpful, they did not say, "You must go Equatorial if you want to take decent images"; they merely suggested it might be a good idea. Well, from what I've learned, I guess I won't be so polite. If you want to take excellent images with perfectly round stars with an amateur setup, you must go Equatorial – eventually. I'm not saying you can't get very good practice imaging in Alt-Az mode because you can, I've done it, and you can turn out reasonable quality images. But when the time comes to going up a notch in quality, there simply is no way of getting around an Equatorial mounting for your system (well, there is, but do you really want to go in for rotating camera systems?).

Chapter 2

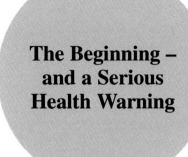

The Beginning – and a Serious Health Warning

In writing an introductory book of this nature, we need to assume some common starting point. I will assume the reader has a keen interest in astronomy, and that the only optical instruments currently to hand are a pair of eyes. The sequence of events as we progress with this chapter need not be followed to the letter, if indeed at all, and if you have no interest in anything other than immediately starting to take deep-sky images please turn straight to Chapter 3. On the other hand, if you'd like to immerse yourself in this hobby at a more leisurely place, please continue here.

Before getting straight into imaging, I strongly recommend you spend at least a year at your proposed imaging site, whether that is your garden, or some local dark location, simply observing the night sky using just your eyes or perhaps a pair of low power binoculars – 10×50 s will be more than adequate. On reading this, it may sound like a very boring way to start what is a very exciting hobby, but a great deal of useful information can be recorded during that year. You will need a notebook, a star map or star atlas, and a weak red light to see your map without destroying your night vision. Take good notes of what you see in the sky and where it is located — North, South, directly overhead, etc. — and also note what the viewing conditions are like, such as poor visibility, fog, exceptionally clear, etc. This may sound a bit strange right now, but the value of this data will be made clear as we go on. What constellations are visible, what constellations are not visible, and in what direction is your view hampered by trees, or buildings, or hills? By observing and keeping good notes, you will be able to carefully plan your future imaging sessions, find out that certain objects can only be imaged during certain months of the year (if at all) and you will see how the Moon badly interferes with your attempts to view faint objects. You will also discover how certain "wet" months will interfere with viewing and imaging. Is there any light pollution in your proposed location?

By studying your proposed site carefully, you may find that viewing is exceptionally good on most clear evenings, but becomes impossible on the Saturday nights when the local football team is playing and the huge banks of halogen lights are turned on. Lastly, you will learn your way around the night sky, which is important on two counts. Firstly, if your first "real" telescope is of the "goto" variety, as it is very likely to be, then you will know where to look for the scope's alignment stars. Secondly, you will know what the faint fuzzy areas are that suddenly come into view as your eyes become adapted to the dark, and observing sky conditions becomes easier. Even though your "goto" scope will take you very close to the object you have keyed in, it is still a good idea to know in your mind where that object is actually located in the night sky.

So what did you discover during your observing year? The stars twinkled more, that is the "seeing" was poor, when there were very strong winds and when there was a lot of atmospheric water vapour. If it was slightly foggy, you could still observe directly overhead (the Zenith), but the stars became very faint as you approached your horizons where you are looking through a lot more atmosphere (and dust). Also with the slight fog, any light pollution was made very clear again as you approached the horizon, you may have even found the horizon in certain directions was actually "lit up" by the scattering of artificial lights by the water droplets in the air. All this information will be very important in planning your future imaging sessions.

What else did you find out? Certain stars were clearly coloured, but most were simply white, and any deep-sky object observed was in black and white. This is due to the physiology of the eye; things look black and white only (no colour) when the light intensity is weak. Color appears "out of nowhere" when using your colour CCD camera as it is much more sensitive than your eye to the incoming photons (light particles). Disappointingly, using the naked eye, there were far less stars to see than appeared to be on your map. Anything else? Well, during your year's naked-eye observing, you saw M31 the Andromeda galaxy, M42 the Great Nebula in Orion, you could just make out M33 the Pinwheel galaxy in Triangulum, and there was a clear patch of fuzzy light where the Double Cluster in Perseus is located. With binoculars things improved enormously, still no color for faint objects, but the Double Cluster was an amazing sight, and M13 the Great Globular Cluster in Hercules was clearly a great glowing ball of stars. Many more stars appeared out of nowhere, and it looks like you can now actually see more stars than you have on your map. Virtually any reasonable pair of binoculars, or small telescope, greatly increases the number of stars and deep-sky objects you can see. Replacing your eye with a sensitive CCD camera improves the detection capabilities by further orders of magnitude, and it was this discovery in particular that moved me on from purely visual observing to CCD imaging. To be frank, when I saw the huge number of stars on my very first CCD image, orders more than I could see by simply looking through the eyepiece, I knew my observing days were over. I used to feel sorry for the professional astronomers in their huge observatories who never actually "looked through" these giant telescopes, but simply took pictures all the time. Now I know why, and I don't look through my telescopes any more either – but I do occasionally still use my binoculars.

2 The Beginning – and a Serious Health Warning

Before we move on to look at the hardware and software requirements for carrying out deep-sky imaging, I feel it is my responsibility to provide you with a very serious Health Warning. Deep-sky imaging has a tendency to become addictive or the object of obsession. Maybe that is due to the sort of person that enters the hobby, or maybe it is the nature of the hobby itself, but I don't know. However, I repeat, deep-sky imaging can become an addictive hobby and it can have a negative impact on your private life if you allow it to take over all your free time. I warn you, after your first good image of the Heavens, you are likely to be hooked for life. Here ends the serious Health Warning.

Chapter 3

Assembling your Imaging System

Refractor or Reflector, or Perhaps Both?

You will need a good quality telescope for deep-sky imaging and these come in two flavours, refractors or reflectors. Refractors are the ones with the objective lens at the front, reflectors utilise a big light-collecting mirror and come in several different configurations. So here's your first big decision, refractor or reflector, and what size? Also these telescopes come with a variety of different mounting and control options, Altazimuth, equatorial and "goto". Which do you choose? Unfortunately, these are very difficult questions from the outset, and I have personally oscillated between the two optical systems, so my compromise option would be to suggest that you eventually have both.

Modern day refractors are beautiful instruments, especially those with multi-element lenses that are designed to cut down chromatic aberration. These refractors are often referred to as apochromatic, but the point is, by using different glasses in the multi-element lenses, the splitting up of light into its constituent colours (just as light does in passing through a glass prism) is minimized. If the refractor is to be your main imaging telescope, you will need the more expensive three-element apochromat in order to eradicate "blue halos" around bright stars and "star bloating". If your telescope only had one type of glass in its construction, then it would split the light up into its constituent colors as it passed through the optical system, and finally the different colours would be focused in slightly different positions at the eyepiece end. There are filters you can use to reduce these unwanted effects, and these are usually referred to as "fringe-killers". These filters cut down the blue and infrared wavelengths passing through your refractor by minimizing the blue halos and the bloated (oversize) stars caused mainly by the near infrared radiation

your CCD camera is sensitive to. Since your CCD camera is invariably based on Silicon technology, it will detect radiation up to near 1 micron (10^{-6} m) in wavelength. Very deep red extends to around 0.695 microns, so the CCD is sensitive well beyond the eye's visible wavelength limit and it extends your detection limits to the near infrared. The filter may sound like a good way of turning a "cheap" refractor into an effective apochromat for imaging purposes, but of course there is a catch. By severely attenuating any blue transmission, you will find that your CCD simply cannot detect certain reflection nebulae such as the Iris nebula in Cepheus, or the reflection nebulae near the Horsehead nebula in Orion. By effectively cutting out the blue transmission, you will also find that you cannot detect the faint wisps of nebulosity around the Pleiades (seven sisters, Subaru, or Messier 45) either. So I'm afraid you can't cheat here and it is not possible to turn a sow's ear into a silk purse by this approach. However, there is one way you can win. We will discuss these issues in more detail a little later in this Chapter, but it is worth introducing H-alpha filters at this point. If you are forced to image in a heavily light polluted area, you will have to go down this route anyway, and these filters also allow you to image when the Moon is creating a lot of sky-glow (the sky is always beautifully clear when the Moon is full). A hydrogen alpha or H-alpha filter only allows through a very narrow range of light wavelengths in the red region of the visible spectrum. This narrow range of wavelengths corresponds to the emission of hydrogen atoms in most of the large emission nebulae we image. Moonlight, which is reflected sunlight, means there will be some light at the H-alpha wavelengths present, but the filter bandwidth is so narrow that the amount of H-alpha that gets through from Moonlight is very small and all the other wavelengths are very severely attenuated. An H-alpha filter therefore means we can image emission nebulae (and other objects, like stars) in poor visibility skies caused either by light pollution or Moon glow. There is an added bonus. Since only one very narrow band of wavelengths is getting through the H-alpha filter, we can now use our "cheap" refractor for very effective imaging. All the other wavelengths that would have been focused at different distances from the eyepiece, forming an out-of-focus image, are gone. We can get nice, pin-sharp, H-alpha images from the night sky with relatively cheap equipment, and with light pollution or (not too severe) Moonlight present. Sounds too good to be true, so what's the catch? The catch is the same as for the fringe-killer filter, but far more extreme. Instead of not being able to image just the blue region of the spectrum, now you cannot image any part of the spectrum, with the exception of a tiny band of wavelengths in the red. You cannot therefore take those pretty full-colour images of the night sky with just an H-alpha filter, but you can take very dramatic monochrome images, and it is easy to convert these into (red) colour images with image processing software that is readily available, such as Noel Carboni's astronomy tools for Photoshop.

I deviated a little from the most direct course there, but I felt it was necessary to point out some of the options, and the compromises, at this very important initial decision-making stage.

If your main imaging system is going to be a refractor, you need to buy a good quality apochromat to take those pretty full-colour images you see in the astronomy

magazines, or in this book. A refractor has other advantages over the alternative types of telescope. Since a refractor has no obstructing objects in the optical path, a refractor will give you better image contrast than a reflector; this is more important for planetary observation and imaging rather than for deep-sky work. The way a refractor is constructed also means that it tends to hold its alignment (of its optical elements) better than the reflectors, which means that (unlike with reflectors) you do not need to worry about collimation. Refractors also have disadvantages compared to reflecting telescopes. Depending on the region of sky you are working in, the eyepiece may be very awkward to get to. This is important only if you wish to view through the system, and it is totally irrelevant if you only want to image. However, if you want to both image, and occasionally view through your telescope, then this hindrance is worth bearing in mind. Light-grabbing power is all about aperture, which is down to the diameter of the objective lens in your refractor, or the diameter of the main primary mirror in your reflector. Per inch of aperture, the refractor is the most expensive telescope you can buy, especially if we are considering apochromats. I have seen very good imaging work carried out with refractors of just 85 mm (3.35 inch) aperture, but personally I would put this at the very minimum you should consider for serious imaging purposes. However, you also need to consider portability if you do not have the luxury of a permanent-base imaging site, so a large 6-inch refractor may not be feasible for your particular requirements. As mentioned earlier, aperture is everything (provided the quality is there), so you want the largest aperture apochromatic refractor you can afford, or carry.

Before moving on to reflectors, we have to talk about autoguiding. If we want to take individual images with an exposure time in the order of minutes, then not only do we need to be equatorially mounted and polar aligned, which we will discuss later, we also need to guide our main imaging scope. This is done by optically locking onto a guide star somewhere in the image we are taking, and then moving the imaging scope so that the guide star remains fixed in the field of view. There are three main ways this can be achieved. You either need a second CCD camera to act as the guide star detector, or there are some CCD cameras that allow you to both image and have a separate area for the autoguiding function. If we are using a separate CCD camera, it needs to see the same region of sky as the main imaging CCD, and this can be achieved in one of two ways. Either the autoguiding CCD is connected to a separate guide scope, or you can fit what is called an "off axis guider" in the eyepiece position of the telescope, allowing you to fit the main imaging CCD in-line with the telescope and the autoguiding CCD at 90 degrees to the imaging CCD. Light is "split off" from the main light path to the imaging CCD by a prism that re-directs a small portion of the light to the autoguiding CCD. If you are using a separate guide scope, then it is clear that this must be rigidly mounted like the main imaging scope so that both track the sky in the same manner. This method can be very complicated. The third option is to use a CCD that combines both an imager chip and a guider chip in the one integrated package. I personally have no experience using combined imaging/autoguiding CCD cameras, but I mention them here for your benefit and note that they do seem to operate very well. The only negative aspect I can see in having a combined imaging/guiding CCD is when you

are imaging in H-alpha, or using narrowband filters. Under these conditions, you severely limit the number of photons reaching the CCD, including the guider, and this means you may need very long integration times to see an appropriate guide star. Such long integration times will generally lead to poorer autoguiding.

Reflecting Telescope as the Main Imaging Scope

So now let us consider reflecting telescopes, which are telescopes with a mirror as the main light-collecting element. These come in lots of different flavours such as Newtonian, Schmidt-Cassegrain (S.C.), and Ritchey-Chrétien (R.C.) to name just three. Since the main collecting and focusing element is a mirror, the big advantage reflecting systems have over refractors is the much-reduced chromatic aberration (C.A.), and this is very important for imagers. There may well be chromatic aberration "downwind" of the mirror if you use glass elements (e.g. focal reducers or eyepieces), but these are usually very well designed and the C.A. is usually very slight if it is present at all. The Newtonian is a rather bulky instrument and was the most popular reflector. More compact reflectors are of the S.C. and R.C. design which "fold" the optical path leading to a shorter instrument than a typical Newtonian. I think it can be stated without contradiction that it is the commercial competition between the big two manufacturers, Celestron and Meade, that has led to the possibility of providing amateurs with extremely high quality instruments at what must be considered very reasonable prices; I would go as far as to say "cheap" given the precision engineering involved in creating these instruments both in the optics and the drive mechanics. This commercial competition also leads to innovative and improved design that also greatly benefits the customers. In considering reflectors, I will concentrate mainly on the Schmidt-Cassegrain, as this is the amateur scope of choice, but please do consider other designs as they may better suit your needs. For example, a well-designed R.C. will give a better edge-to-edge quality of viewing field image than a typical consumer S.C. and so it should, as it will be a lot more expensive.

Considering S.C. design reflectors, we see there are computer-controlled "goto" instruments, those on Altazimuth mounts, those on Equatorial mounts, and they also come in a variety of mirror diameters from six inches to sixteen inches, the latter not falling into the portable category. I would say that if portability is a requirement, you really shouldn't consider much beyond an eight-inch diameter mirror. Having said that, for the first two years of owning my eleven-inch S.C. scope, I regularly carried it in and out of doors. However, as the outcome of this exercise (in both meanings of the word) was a double hernia and two hospital operations, I would rather you didn't go down the same route as me in this instance. I strongly advise that an 11" or greater reflector is mounted permanently at your observing site.

I purchased the Celestron Nexstar GPS 11, which is an S.C. design with an eleven-inch diameter mirror and GPS (Global Positioning System). It has a "goto" capability, a large database of objects on its in-built computer, and it sits on an

Altazimuth mount (Equatorial mount options are available, but remember, initially I was only interested in observing and Altazimuth mounts are best for this). For visual observing, the Altazimuth mount gives the most comfortable viewing position, and also the fork arms and flat base lead to a rock-steady structure. When I started imaging with this beautiful scope, I used the Altazimuth mounting it came with, but I soon discovered that this was not the ideal type of mounting for CCD imaging. At this point, it makes sense to digress into a short discussion of telescope mounts.

The Altazimuth mount [https://en.wikipedia.org/wiki/Altazimuth_mount] is a very sturdy mount and ideal for visually observing objects as the eyepiece will be presented at a convenient height and angle for most objects you will observe. It must be a good mount; all the really big professional telescopes use this type of mount. However, when it comes to CCD imaging, this sturdy mount also gives us a major problem. If you look at the geometry of the mount it can of course pinpoint any object in the sky in an x-y kind of way, in that it can rotate on its base (rotational axis straight upwards) and move up and down to lock onto the object you want to view. But the Earth spins on its axis, and thus the stars appear to rotate as well, with the centre of rotation being somewhere near the Pole Star (Polaris) for us viewers in the Northern hemisphere, not straight up overhead. So what? Well, our Altazimuth x-y coordinate system scope cannot rotate around the same axis as the stars, and this means that over a period of time, although your star (or other object) is still slap bang in the middle of your field of view and you can see it very well, all the other stars around it have rotated a bit, the rotation distance being greater as you move away from the center of the field of view. This rotation is called "field rotation" and it is the rotation of your field of view over time due to the Altazimuth mounting's inability to follow the rotation about the polar axis. So what, again? Well, this field rotation doesn't matter at all when visually observing, that's why the Altazimuth mount is a great mount for observers. But if you are imaging, and if your exposure times are longer than say 30 seconds, then your final image captured by the CCD camera will show the characteristic trailing stars that accompany field rotation. So, one way around the problem is to take short exposures. This is fine provided you have a bright enough object that will allow you this luxury; normally you won't be able to take this way out. The reason I could take this option, for a short time at least, is that I had a "bolt-on" to the Celestron S.C. telescope called a Hyperstar lens. This lens takes the place of the secondary mirror in the S.C. design and turns the S.C. telescope into another design called a Schmidt camera. Technically, the Hyperstar lens is a times one corrector lens assembly giving a flatter view in the imaging plane than would occur without the lenses. It also shortens the focal length of the S.C. telescope and consequently reduces the f# considerably since f# is defined as the focal length of the telescope divided by the mirror diameter. Now, if you are into "ordinary" photography you will know that low f# lenses are called "fast" because they allow you to take pictures with a shorter exposure time than "slow" (large f#) lenses. The same is true to first order (if we want to get technical there is a difference between point objects like stars and extended objects like nebulae) in astrophotography. My Hyperstar lens allows me

to take much shorter exposures than using the telescope in its normal f#10 mode of operation, so short in fact that I can reduce the field rotation effects considerably – but only for relatively bright objects. Also, although the field rotation is reduced, it is not removed. When you start improving your imaging techniques and you become pickier you will find in fact that although small, the field rotation effects are not acceptable, even for exposure times of just a few seconds. You won't get "perfect" round stars – and perfect round stars are one of the main criteria we strive for in good astronomical images. So where does that leave us? Well the sad fact is that if you want to turn out good astronomical images, you simply must have an Equatorial mount [https://en.wikipedia.org/wiki/Equatorial_mount]. There is no simple way around this problem. But wait a minute; didn't I just say a while back that all the big professional scopes were Altazimuth mounted? And aren't they used almost exclusively for photography? The answer is yes to both questions, and the no-expense spared, big professional telescopes have no-expense spared solutions to the problem including very sophisticated software and cameras that can rotate to compensate the field rotation. Although such luxuries are available on the amateur market, the plain fact is that the Equatorial mounting solution is the simplest and most cost-effective solution to the field rotation problem.

If, like me, you have an Altazimuth mounted scope, you can now mount your scope on a wedge and set up the wedge so that the new rotational axis for the base points towards the same rotational axis as the stars. This can work fine, it certainly does for me, but there's no getting away from the fact that the whole system is far less sturdy and vibration-proof than the original Altazimuth mounting. Why should this be? You have cantilevered your scope over at some angle dependent upon your latitude, and it wasn't primarily designed to be as stable in this configuration. It is far better that you buy an equatorially mounted scope in the first place if your ultimate intention is imaging and be done with all these annoying little problems.

Returning to the S.C. telescope itself. Focusing is usually afforded by moving the main primary mirror, and the secondary mirror must be accurately aligned (collimated) to the primary to get the best results from your scope. Remember that the optically more robust refractor keeps its collimation rather well – the S.C. doesn't. This once again does not actually matter, as it becomes a matter of routine to occasionally check your scope collimation and make the necessary adjustments to the secondary mirror as required. For the definitive account on collimating your S.C. telescope please visit: http://legault.club.fr/collim.html this says everything you need to know about collimating your S.C. Adjusting three Philips screws fitted to the secondary mirror affords collimation of the secondary mirror. Trying to follow the CCD image on a monitor, whilst adjusting screws using a Philips screwdriver, which of course is located precariously close to the precious corrector plate, simply isn't a fun experience. I very quickly invested in a set of Bob's Knobs http://www.bobsknobs.com/which replace the Philips screws with a set of knurled knobs that can be finger tightened for collimation. Bob's Knobs are very good value for money, and basically an indispensable item if you want your reflector to be in tiptop collimation condition for crystal clear imaging.

So how far have we got in putting our imaging system together? We have either an equatorially mounted apochromatic refractor with an objective lens diameter of 85 mm or more, or we have an S.C. reflector with a mirror diameter greater than six inches, on an Equatorial mount. I shall not describe the different Equatorial mounts available, they all do the job required to varying degrees of accuracy directly proportional to cost, and when properly set up, they will remove the field rotation problem. What they won't remove, and what will be apparent in the cheaper mounts. is periodic error. Periodic error is due to the gears used to move the telescope in R.A. and Dec. not being absolutely precise. Consider the manufacturing difficulties here, precision gearing for very precise tracking and control, coupled with mass-production and a price affordable to the average income earner – we're looking at several mutually exclusive parameters here. Personally, I have not found the periodic error of my Nexstar 11 GPS to be any problem at all in my imaging, something that I find amazing in a mass-produced scope and give full credit to Celestron's engineering department. Do note that unless your periodic error is VERY bad, the autoguider will be able to take most of this error out. Periodic error should NOT be this bad in any good quality mount or complete system such as the Nexstar 11 GPS.

To summarise: As a beginner you will benefit from having the biggest aperture, smallest f-number system you can afford (or carry). This will be a "fast" system, and as such, you can keep the sub-exposure (individual exposure) times down, which makes the autoguiding process much simpler. A smaller f-number also means a shorter focal length for a given aperture, and this will give you a wider field of view (than a large f-number system), which makes finding and framing your chosen object a lot simpler too. Large aperture, small f-number systems are a win-win in astronomical imaging; this is why I chose the Hyperstar option with the 11" diameter Nexstar 11 GPS reflector. This combination gives you a reasonable aperture with an incredibly fast f#1.85 imaging capability.

Refractor as the Main Imaging Telescope

Although it is nice to have as large an aperture as you can afford for your main imaging telescope, in the case of refractors, they become very large (long) very quickly with increasing aperture. This means that for the larger aperture refractor, you will almost certainly need to consider a permanent setup (observatory) and a portable system becomes impractical. Of course you can use smaller aperture refractors for imaging, but you will by necessity be using a "slow" system and your sub-exposure times will typically be very much longer than for a larger aperture small f# reflector.

If the refractor really is to be your main imager, rather than the piggyback wide field guide scope sitting on a reflector, then you will want to invest in a 3-element apochromatic refractor so that you will not be bedevilled by unwanted coloured halos around very bright stars, or by "bloated" stars caused by the infrared region of the spectrum not being brought to the same focus as the rest of the colours (RGB). These refractors are expensive, but they also deliver the goods, it is a

difficult decision to know which route to take when you begin your imaging career, and I feel loathe encouraging you one way or the other. I can however give you my personal experience on this subject.

After imaging for maybe 6 months using the 11 GPS and Hyperstar, I felt that maybe I had made the wrong decision. The 11 GPS was certainly a beautiful instrument for observing, but I was having second thoughts about its perfection as an imager. I outlined the problems encountered with the Hyperstar system in Chapter 1, but even if you were eyepiece imaging at larger f-numbers, you would still have to make sure your collimation was spot on for the best images. Collimation is something you don't need to think about in a high quality refractor. Even though it is relatively quick and easy to collimate a SCT, it is still an unnecessary worry to consider every time you want to image. In the reflector's favour, you really don't need to worry about chromatic aberration with a good quality SCT, and your stars will always end up looking good (provided your collimation is good.). In maybe a further 6 months or so, I decided that the advantage provided by the bigger aperture really made the reflector a better main imager choice than a refractor, that plus the lack of any chromatic aberration. But again, I must stress, this is a personal feeling only, and there are many top quality amateur imagers out there whose main scope is a refractor, Steve Cannistra [http://www.starrywonders.com/] being one of the best imagers I know who mainly uses refracting telescopes. One final point in favour of the reflector is the flexibility in choosing the f-number you can work at. The Celestron systems are a bit special in that the Hyperstar is available to produce very fast imagers, although Starizona [http://starizona.com/acb/] is now producing Hyperstar lens assemblies for Meade SCTs. But think on this a little, the native large aperture SCT is f#10, and by using various reducer/correctors you can also image at f#6.3, maybe at f#3.3 if you're lucky, and f#1.85 if you spend a lot of effort getting the Hyperstar properly collimated (this is not so much of a chore anymore with the new Hyperstar III lenses as we shall see in the completely re-written chapter on Hyperstar imaging). You can also go the other way and image at f#20 or even f#30 using Barlow type adapters. This flexibility is simply not available with refractors. Yes, reducer/correctors are available, but the range of f-numbers at your disposal is nothing like that attainable using the SCTs. So, when considering what is to be your main imaging telescope, this is another factor you really must consider very carefully. The Schmidt-Cassegrain reflector is an immensely versatile imaging instrument.

Again, for autoguiding your refractor, you will have the same three options. A second guide scope (usually a smaller aperture refractor), an off-axis guider with its own guide CCD, or a combined imaging/guiding CCD mounted on your main imaging refractor. Recall that this last combination can give you trouble with H-alpha, or narrowband filter imaging as you may need long integration times for the guider part of the CCD to detect stars, and this may give an incompatibility with good autoguiding. Terry Platt, the CEO of Starlight Xpress Ltd., makers of the U.K. produced CCD cameras, uses the two-refractor configuration for his imaging work as can be seen in Figure 3.1. Terry is a World Class imager in his own right so I think we can all learn something from the route he has taken in putting his imaging system together.

Figure 3.1 A view of Terry Platt's all-refractor deep-sky imaging system.

Reflector/Refractor Imaging Combination

Unusually for this hobby, there is actually a win-win combination you might like to consider, provided your finances will allow it. You can have the large aperture reflector as your main imaging telescope at the larger f-numbers, typically your scope's native f-number will be around f#10 and this can be reduced using refractive optics to a comfortable f#6.3. You can then piggyback a good quality, short focal length refractor on your reflector and use this either as a guidescope for the reflector or as your main imaging scope. Clearly if your piggybacked refractor is being used for imaging, then your rather expensive large aperture reflector is being relegated to the role of a simple guidescope. It seems a little odd to do this, but it does allow wide field imaging using the refractor, and much narrower field imaging at high resolution for things like the smaller galaxies, with the reflector. As I mentioned, this is a very popular combination, and I think it really does offer the best of both worlds.

Polar Alignment

The drift method of polar alignment sounds like a very scary process, and I must admit to being pretty scared about the whole thing before trying it out for the first time. I was fortunate enough to have already found and downloaded Starizona's excellent procedure for polar aligning a scope by the drift method from here https://starizona.com/acb/ccd/settinguppolar.aspx. By simply following this procedure to the letter, I successfully polar aligned my wedge-mounted Nexstar 11 GPS over two evenings. The first evening was really just getting used to the procedure to be followed, and finding stars in roughly the right position in the sky. The second evening, I knew what I was doing and nailed the alignment pretty accurately (I didn't need to re-align for a full year after this first go at drift aligning).

Are there any practical tips that can shorten this process a little? I have only one tip to offer from my experience of the procedure. You don't need to wait 5 minutes to see how the star is moving in the reticule eyepiece, the moment you see any movement, make the necessary adjustment to your wedge to bring the star back to position. You will only need to wait a few minutes when your polar alignment is coming close to a good polar alignment. When you're quite a long way away from alignment (as you are likely to be when you first start), the stars will drift rather quickly in the eyepiece. Also, unless you intend to take VERY long sub-exposures, don't bother to get so close to polar alignment that it takes tens of minutes to see any drift, there's no point in trying to get this accuracy if you never take subs more than 5 minutes long. And does any of this matter anyway if you are using an auto guider? Yes, I'm afraid it does. If your polar alignment is way out, you will still seem to auto guide okay, but the dreaded field rotation will rear its ugly head with long exposures and you will get some star trailing in your images.

One last tip on the drift alignment procedure. After checking for drift with your telescope pointing south with the OTA at right angles to the fork arms, move the telescope to the East using the R.A. control only (don't touch the DEC). You will then be at around the right declination for drift aligning the DEC axis.

Collimation of an SCT

As mentioned earlier, the definitive explanation for the precise collimation of a Schmidt-Cassegrain telescope is given here by Thierry Legault http://legault.club.fr/collim.html. I cannot describe the procedure any better than this. However, there are a couple of practical tips that might make this process a little less tiresome for you. It is essential that the out-of-focus star you are trying to make symmetrical lies precisely in the center of your field of view when carrying out the adjustments. If there is only one reasonably bright star in the FOV, then this can already start to be a painful process, as you will have to keep moving this star back into the center of the FOV with each adjustment of the secondary mirror. Better to be collimating your telescope while pointing at an open cluster. This way, it is likely that you do not need to move the telescope very far in order to bring another star into the center

of the FOV after moving the secondary mirror. Secondly, I recommend that you view the out of focus stars on your monitor using your CCD camera, rather than using an eyepiece. Why? Because if you are using an eyepiece you will need to move around to the front of the scope each time you make an adjustment, and then move back to the eyepiece again to see the outcome of the adjustment. If you move your monitor so that you can see it while working at the front of the scope, then the adjustment process becomes that much quicker, especially if you are using Bob's Knobs to make the adjustments.

Like all precision operations, the first time you try to collimate your S.C. telescope, it will take an inordinate amount of time. However, with practice, you will quickly get a "feel" as to how you need to move the secondary mirror to get the central out of focus star pattern looking symmetric.

The CCD Camera

There are a large number of CCDs suitable for astronomical imaging on the market. There are sub-mega pixel, multi-mega pixel, black and white, single shot colour, imaging and autoguiding CCDs. It is very bewildering; especially when there's all this talk about the field of view you get with different telescope/CCD combinations and the even more puzzling question of how many "arcseconds per pixel" your system delivers. Do we need to know the "numbers" involved in fine detail, or can we just trust to luck, buy a CCD and see if it works? Well, although it is a pretty bad idea, I guess my decision strategy fell mostly into that last category – and I think I was very lucky to have come out relatively unscathed. I did receive (correct as it happens) advice on the best CCD in my list to go with the Hyperstar lens, but I think I should have been personally better informed. Nowadays you can download a superb "CCD calculator" that allows you to input your preferred telescope and CCD combination and see the performance for yourself: http://www.newastro.com/book_new/camera_app.html this program is provided free and it tells you everything you really need to know about the performance of your telescope/CCD combination.

Although the above program will give you the correct results for the correct input of telescope and CCD parameters, it might be best if you can calculate at least two of the important values for yourself, the field of view of the combination, and the sampling. The formulae are quite simple to use and I'll run through some examples so you get a feel for what different combinations offer. By the way, these are the only formulae and maths you'll see in this book.

The sampling of your combination, which is the number of arcseconds per pixel resolution your system delivers, is given by:

Sampling = arctan [pixel size in meters/telescope focal length in meter]. For deep-sky work, you want the sampling to be in the range of 1 to 4 arc seconds per pixel. For high resolution astrophotography, you want to work in the range 0.1 to 1 arc seconds per pixel, although the highest resolution end of the scale will probably be better than your local "seeing" conditions, and the resulting image resolution will not be better than the seeing. Arctan is a trigonometric function, it doesn't matter what it is, just hit the right button on your calculator.

The field of view of your telescope/CCD combination is given by:
Field of view = arctan [length of side of CCD in mm/telescope focal length in mm]
As the CCD is likely to be rectangular, rather than square, the lengths of the sides of the CCD will be different giving a field of view which is also rectangular.

Probably the best way to get a "feel" for what's going on here is to look at a couple of specific examples. Let's see what two different one-shot colour Starlight Xpress CCDs, the SXV-H9C and the SX-M25C do when hooked up to a Celestron Nexstar 11 GPS reflector, and a Sky 90 refractor. We shall also consider the 11 GPS working at different focal lengths by using either a reducer/corrector lens element, or the Hyperstar lens.

Celestron Nexstar 11 GPS SCT

For this reflector, the mirror diameter (11") is 280 mm, and the focal length in its normal mode of operation as a Schmidt-Cassegrain telescope is 2800 mm which gives us an f#10 system in the normal mode of operation.

We can put an f#6.3 reducer/corrector (R/C) on the eyepiece end of the telescope (Celestron make these R/C elements) and this will reduce the effective focal length to 1764 mm. There is also an f#3.3 R/C available (made by Meade) and this results in an effective focal length of 924 mm. Finally, the Hyperstar lens operating at around f#1.85 will give a short focal length of only 518 mm on the 11 GPS.

F# = Optical system focal length in mm./mirror diameter in mm.
The SXV-H9C colour CCD camera has the following parameters:
Physical size of the CCD array = 8.95 mm × 6.7 mm.
Number of pixels in the CCD array = 1392 × 1040 pixels.
Size of individual pixels = 6.45 um × 6.45 um, where a micron (um) is 10^{-6} m.
The SXV-M25C large format colour CCD camera has the following parameters:
Physical size of the CCD array = 23.4 mm × 15.6 mm.
Number of pixels in the CCD array = 3024 × 2016 pixels.
Size of individual pixels = 7.8 um × 7.8 um.

Putting all the above information together and using the two formulae given earlier, we can tabulate a set of results as follows:

CCD	F#	F.O.V. [arc minutes]	Sampling [arc seconds per pixel]
SXV-H9C	10	10.9 × 8.2	0.47
SXV-H9C	6.3	17.3 × 13	0.75
SXV-H9C	3.3	33.1 × 24.7	1.43
SXV-H9C	1.85	59 × 44.1	2.55
SXV-M25C	10	28.9 × 19.3	0.57
SXV-M25C	6.3	45.9 × 30.6	0.91
SXV-M25C	3.3	87.6 × 58.4	1.74
SXV-M25C	1.85	156.3 × 104.2	0.47

60 arc seconds = 1 arc minute.
60 arc minutes = 1 degree.

Although I have included a row for the SXV-M25C with the Hyperstar option, the CCD is actually too large for the diameter of the focal plane (20 mm) that the Hyperstar can provide (the Hyperstar III can however accommodate the new Trius M25C - no problem). Physically and experimentally, the SXV-H9C is just about the largest chip size that the (original) Hyperstar can accommodate. The new Hyperstar III works very well with the Trius M25C APS-sized chip.

What can we deduce from the above Table? The SXV-H9C performs well at all f# ratios, at f#3.3 this would make an ideal "galaxy" imager for the smaller galaxies, and at f#1.85 (Hyperstar) there is a reasonably wide field of view with a good sampling for deep-sky objects. The fast optics, good field size, and respectable sampling makes the Celestron Nexstar 11 GPS with Hyperstar and SXV-H9C, an extremely powerful combination indeed, I would say an almost perfect imaging system for the beginner.

The SXV-M25C of course increases both the field of view, and the sampling, but the sampling remains good for all f# ratios. At f#6.3 this becomes an almost ideal galaxy imager with a good field of view for all but the largest galaxies, together with a sub 1 arc second per pixel sampling – a very nice combination.

The CCD/telescope combination also looks very good for f#3.3 imaging, and the numbers do indicate that this would make a great general-purpose imager. However, experimentally I have found a problem with the Meade f#3.3 focal reducer and the Nexstar 11 GPS scope combination. Although I spent a great deal of time trying out different spacer distances I could not get the reducer to work at f#3.3 without significant coma and vignetting. Coma is where star shapes become elongated and look like little comets at the edge of the field, and vignetting is where the edge of the field is significantly darker than the centre of the field due to "clipping" of the light by an aperture that is too small for the f-ratio. I did manage to get respectable results at f#5 from the f#3.3 R/C, but this was so close to the f#6.3 R/C that I simply ended up using the f#6.3 reducer for eyepiece-end imaging on the Nexstar 11 GPS.

Takahashi Sky 90 Refractor

For the Sky 90 refractor there is the native f#5.6 telescope, or with the Takahashi reducer/corrector we can convert this to an f#4.5 refractor. The parameters for the various combinations are as below:

CCD	F#	F.O.V. [arc minutes]	Sampling [arc seconds per pixel]
SXV-H9C	5.6	60.7×45.3	2.62
SXV-H9C	4.5	75.5×56.4	3.26
SXV-M25C	5.6	160.7×107.1	3.19
SXV-M25C	4.5	200×133.3	3.97

We can see that the short focal length of the Sky 90 makes for a nice wide field imaging system. Wide field imaging at reasonable sampling make these combinations look appealing for those large deep-sky objects that are too large to consider

using the Nexstar 11 GPS combinations. The only negative comment would be that for the SXV-M25C camera at f#4.5, the sampling is getting a little close to our 4 arc seconds per pixel upper limit. This means our image may look a little "soft" and lack the sharpness of images taken at lower sampling. However, this is the trade-off we have to make; very wide field imaging implies larger sampling and these very wide field single frame images will always appear slightly soft. The only way around this problem is to work with a smaller field and sampling, and then to build up a mosaic of the object by stitching together a number of separate frames. This is painstaking work to put it mildly, but some expert imagers out there, notably Rob Gendler [http://www.robgendlerastropics.com/] do precisely this in order to get beautiful high-resolution images of large deep-sky objects. This approach requires so much time, effort, and dedication, that it makes a clear differentiator for your work, as not many people are willing to invest so much time and effort into producing these images. Chapter 14 in this book discusses how you can differentiate your astronomical imaging from the mainstream.

Sub-exposure Times

I don't believe I have come across a topic that causes more contention (and tension) on the various forums than the subject of optimum sub-exposure time, and with it the total exposure time needed for acquiring a great image.

For sub-exposure times, there are two boundary conditions: the lower bound and the upper bound. The lower bound is the shortest sub-exposure you can take before the CCD noise becomes the predominant source of noise. For the Hyperstar system and SXV-H9C camera with IDAS LP filter, CCD noise was clearly apparent with 5-second subs. I would therefore suggest that for this imaging combination, 10-second subs are the absolute minimum you should consider. The upper bound is a little bit more difficult to quantify as it depends on you local sky glow conditions. The longest sub-exposure time you take is one where the CCD noise is just a few percent; say 5%, of the sky background noise. If you go much beyond this time with your sub-exposure times, you do not gain much in the way of signal to noise ratio for the sub concerned (this is usually called going into the region of diminishing returns).

However, with CCD imaging and digital processing, we have a great weapon at our disposal, we can take LOTS and LOTS of subs and average them together in some statistical way, and we can then improve the signal to noise ratio of our final image by something like the square root of the number of subs we sum over. This means that if you sum over something of the order 100 subs, you will end up with a very nice "smooth" looking image. Nothing contentious so far I hope. Things only start getting contentious when we start discussing how long each sub-exposure should be. The sub-exposure length is an extremely important parameter for a number of reasons:

1) For longer subs, you will take fewer subs in an imaging session, so you may end up with a lower signal to noise ratio in your final image than if you used a large number of short subs (the image will not appear as smooth as one taken with a large number of shorter subs).

2) For longer subs it will become more inconvenient to lose an individual sub to a satellite, or plane, PEC or download glitch, or a bumped telescope.
3) For longer subs you will need to contend with the gradient (sky background) problem, which will become more apparent as the sub-exposure time increases.
4) For longer subs your polar alignment and guiding is much more critical than with short subs.
5) Conversely - for shorter subs you will not be able to go as deep as with longer subs, but don't forget your upper limit is defined by your local sky glow. You can't (unfortunately) image deeper and deeper objects by arbitrarily increasing your sub-exposure time; your sky background ultimately limits how deep you can go.

This final point (5) is a bit of a shame as it wrecks an otherwise "obvious" strategy. Points 1-4 suggest you take the shortest length subs you can get away with, and stack as many of them together as possible to get a good signal to noise ratio in the final image. This is in fact what I initially did with Hyperstar imaging. The Hyperstar is a "fast" f#1.85 system, so I can make my subs quite short, typically 60 seconds or even less. It doesn't take too long to collect 100 subs for averaging if the individual sub time is only 60 seconds, so the resulting images are smooth-looking with a good signal to noise ratio. However, your resulting "smooth" image doesn't go very "deep" if you stick to short sub exposure times, in other words you will not image the really faint stuff. I was actually disbelieving when a supernova hunting colleague commented on one of my Hyperstar images that he was surprised that it did not go particularly "deep" even though the total exposure time was a couple of hours or so. At first I thought he was just mistaken, but as I progressed with my imaging I realised he was absolutely correct, and the reason was I had used short subs of around a minute in acquiring the data.

So what then is the optimum sub exposure time for your optical imaging system? Since this is going to depend on your local viewing conditions, the "speed" of your optics, and the sensitivity and noise specification of your CCD, I cannot give you a simple numerical answer. This is something you need to determine for yourself experimentally. There are CCD "calculators" on the Internet that will calculate your optimum sub exposure time, for a given make of CCD and for your viewing conditions, but I personally have not found the calculators to be very useful. However, it is quite possible that you will do better than me, so a site can be found here http://www.ccdware.com/resources/subexposure.cfm. One reason I don't find such calculators useful is that your viewing conditions are likely to vary from night to night, so you will need to modify your sub exposure time dependent on the night's conditions (which of course may change while you are imaging). There is no single "good" value to be calculated.

I think that the way you work out the best sub-exposure times for your location is by simple trial and error and by getting to know your sky rather well. You will need to image in all parts of your sky and try out different sub-exposure times in all the regions you image in. From years of gained experience, you will then instinctively know what the best sub-exposure time is for you, on that particular evening. You will also work out that if you are going for star fields/clusters, then it is pointless going for long sub-exposure times as you are imaging bright sources,

and also overly long sub-exposures on globular clusters will simply "burn out" the core. Is there an annoying Moon about? Then it is pointless going for the faint stuff with long sub-exposures, so stick to star images. Is it a crystal clear night with no Moon? Well these things are SO very rare that you really need to capitalise on them to the full. These are the nights when you go for the faint stuff (especially dark nebulae and dust regions and the integrated flux nebula if your skyglow allows) with your maximum sub-exposure times. So again, we return to the same question: what value of sub-exposure should be used? For the Hyperstar III at f#2, I only go for the faint stuff. Bright stars give bad ghost flaring with the Hyperstar III so all bright star work is done with the refractors. The Hyperstar III can handle globular clusters o.k. though, so it is imaging this type of object that gives me the minimum sub-exposure time with the Hyperstar III, which is typically 4 - 5 minutes. For bright nebulae light the North America nebula region then 10-minute sub-exposures seem to be the optimum. For the really faint stuff I use 15-minute sub-exposures and this seems to be getting near my limit with the Hyperstar III as 20-minute sub-exposures do seem to be entering the diminishing returns region. My sky is rural - it is far from dark. On a "good" night you can see all the stars of Ursa Minor, on a "bad" night you can only see Polaris, so that gives you some idea of my skyglow. What about sub-exposure times with the Sky 90 refractors? Well at f#4.5 they are 5× slower than the Hyperstar III for extended objects like nebulae, but they are the only imagers I have that are useful for those single bright-star images. For reasonably bright star fields, I typically use 5-minute sub-exposures. For fainter star fields, for instance grabbing M11 with the Scutum star field background, then 10-minute sub-exposures seem optimum. For the brighter nebulae, the relatively slow f#4.5 means that 20-minutes is required. The Sky 90s are not particularly good for fainter nebulae and as I have the Hyperstar III system for those objects, I don't use the Sky 90s for those objects anyway. The longest sub-exposures I typically use with the Sky 90s are 30-minutes, and I don't seem to be entering the diminishing returns region with sub-exposures of that length. This does make sense since I can take 15-minute sub-exposures with the Hyperstar III which would equate to 75-minute sub-exposures with the Sky 90s. I have taken a few 1-hour long sub-exposures with the Sky 90s as an experiment and I would guesstimate that I am just about entering the diminishing returns region at that point. I apologize for this section being a bit "waffly" but of all the imaging parameters, the sub-exposure time is probably the most imprecise one to define.

However, I do not recommend necessarily going to the maximum sub exposure time you can possibly manage for reasons 1-4 given in the list above. Also, it is possible to use sub-exposures below the "optimum" time and simply stack more subs together to end up with an image of precisely the same signal to noise ratio, but lower "depth". So my advice would be to use subs of less than the optimum exposure time and stack more of them together. Again, just how much below the "optimum" value you can get away with is a matter for experimentation. Also, remember that the f-ratio equation given above is only strictly true for extended sources and does not apply to point sources. This being the case, you will find in your imaging that you can use much shorter subs for imaging star fields and clusters than you can in imaging nebulae and galaxies.

You will see that you can also increase your signal to noise ratio by increasing your sub-exposure time (up to a point and dependent on your local skyglow). This is true but the gain in signal to noise ratio in lengthening the exposure of a single sub-exposure is significantly LESS than the gain in signal to noise ratio in taking multiple subs. You only need to do the experiment to see how dramatic the difference is. Take a single 20-minute sub of the North America nebula. Now take 10 × 2-minute subs (and statistically add them together) and 5 × 4-minute subs and stack those together. The improvement in signal to noise ratio with increasing number of subs is very dramatic. You may also find the loss of "depth" in the image to be a lot less than you were expecting as well. You will not get the faint outer halo regions of a planetary nebula with short subs, but you will get a very clean (noise-free) image of the planetary nebula with short subs, and you will get the planetary nebula with short subs as the ones that are commonly imaged are all very bright (which of course helps a great deal).

As a final comment, I need to discuss the most contentious issue of all, and that is the question of f# and the "speed" of an optical system. You will see in various places on the web that the "speed", basically meaning the f# of an optical system, does not apply to systems using a CCD. This is, in my opinion, complete nonsense. There are several reasons for my statement. Firstly, it is the definition of f# number, namely the photon density reaching the image plane, that spells out that f# really is the "speed" of an optical system. It's how f# is defined, so it seems a little perverse to state that f# does not relate to speed. Since we are talking about the photon density reaching the image plane, it matters not a jot whether the detector is film, a CCD, your eye, or a currant bun. The lower f# system will be "faster" because more photons per unit area are reaching the image plane – end of story. It really DOES NOT matter what the aperture of your system is; the f# number normalises out the aperture with respect to the focal length, so the Hubble space telescope with a 2-metre diameter mirror operating at f#24 really is very much slower than my Sky 90 3.5" diameter refractor operating at f#4.5. It might not seem logical, but it is a fact. Why on earth would the main selling point of the Hyperstar system be the fact that it is a "fast" system if it were not true? I think there might be a number of very aggravated customers calling up the manufacturer of the Hyperstar if it did not live up to its expected high "speed". But of course it does. The f#1.85 Hyperstar on my Nexstar 11" GPS is a full twelve times faster than the same scope operating at f#6.3 using a reducer/corrector, and a full twenty-nine times faster than the 11" GPS operating at its native f#10. This is simple optics, and I have experimentally verified these figures at f#1.85 and f#6.3 (I have not ventured into the dizzy heights of f#10 imaging so far). But do consider the widely different fields of view you observe at these different f-ratios as well, maybe then it is not too surprising that f# really does equate to "speed".

What does all this mean for deep-sky imagers? It means that you would like the largest aperture at the smallest f# you can afford. This will give you a wider field than a longer focal length system, so a deep-sky setup will not be good for imaging the planets, and it will not give you good resolution on small deep-sky objects like planetary nebulae. You will need to very carefully select your CCD to match your optical imaging system. Remember, for reasonable resolution, you will want to

keep below about 4 arc seconds per pixel imaging scale, and you will want as big a CCD as you can afford (and that your telescope can handle in terms of focal plane diameter) to get the biggest field of view. Big apertures mean reflectors rather than refractors, and small f# reflector systems typically mean Schmidt cameras, Hyperstar systems, or Newtonians with lens reducer/correctors. These then are the tools of the deep-sky imager. High-quality, large aperture refractors are also serious contenders, and they may give a flatter coma-free image over a bigger image plane diameter allowing the use of bigger CCD chips. But they are invariably of smaller aperture than a similarly priced reflector and they will typically operate at a higher f-number. Reflector or refractor – it's a very difficult call. Given only one option, I would side with the reflector. My particular solution is to have both.

So you have a low noise and highly sensitive CCD, and you have a large aperture low f-ratio imaging system, but what you don't have is particularly good sky glow conditions. Is this the end of CCD imaging for you? If your sky pollution is particularly bad, then yes, it might be for that particular location. However, we have one final set of weapons at our disposal that allows imagers to take quality pictures under quite poor sky conditions, and these are the narrowband filters and light pollution filters.

Narrowband Imaging and Light Pollution Filters

As mentioned previously, I always have an IDAS LP filter in the optical train. This filter cuts out emissions from common light-polluting sources (sodium and mercury vapour lamps) and as a bonus, I find I do not need to radically alter the colour balance of my one-shot colour images. I have tried other "nebula" or "light pollution" filters and have found it necessary to make substantial colour balance changes to get a good colour-balanced image.

In the past, I was surrounded by Sodium street lights during imaging. The sky when imaged by a DSLR with a standard lens was a sickly orange. However, the Hutech IDAS light pollution filter very efficiently removes all trace of the Sodium lines. What this meant in practice was that with the Hutech IDAS LP filters in my optical train, my skies actually looked (as far as the camera was concerned) very dark and light pollution free. You can see from all my original Hyperstar work that it appears I was fortunate enough to be imaging from a nice dark sky site. But I wasn't. In fact, the skyglow from the Sodium lights was so bad that I couldn't do meteor photography from my garden with a DSLR camera and fish eye lens because the skyglow completely "wiped out" all but the brightest meteor trails. I started imaging in the winter of 2004, and with the IDAS filter, my skies were pretty dark. From something like 2012 to 2014, I noticed that my sky darkness was slowly deteriorating. What was happening? LED street lighting was shining my way. I thought that when LED lighting finally came to my surrounding streets that my deep-sky imaging would be finished and I would have to relocate, but it didn't quite turn out like that. When the LED street lights finally appeared on my doorstep (literally) in late 2014, my skyglow changed to what is seen in Figure 3.2.

Figure 3.2 A DSLR view of my sky in a NE direction with LED street lighting (left) and with Sodium street lighting (right) both images taken, as you can see, at roughly the same time of the year.

You might be thinking that with the LED street lighting, I had suddenly moved to an even better dark sky site than I had before. In some ways, I had, but in imaging terms, I didn't. Remember that I said that with the IDAS filter I had noticed that my sky darkness had deteriorated from 2012 to 2014. That was due to the encroachment of the LED street lights. The Hutech IDAS LED filters are of course ineffective against broadband LED light emission, and so my sky darkness deteriorated overall by about 2 magnitudes (I estimate) from 2012 to 2014. However, to the eye, it appears that the sky is a lot darker, which it is, but it is NOT a lot darker to a CCD camera with an IDAS filter. In fact, it is quite a bit brighter. Being darker to the eye DOES mean that I can now image meteors from my back garden with a DSLR and fisheye lens, but that is the only real bonus I have from the installed LED street lighting. As the Hutech IDAS LP filters are now effectively redundant, I have replaced them all with UV/IR cut filters which produce less "ghost flaring" from bright stars. The result of all this is that I no longer have the same dark sky conditions I used to have.

Also mentioned previously was the Hydrogen Alpha narrowband filter. The H-alpha filter works at a wavelength of 656.3 nm, where a nanometer (nm) is 10^{-9} m. This is in the red part of the visible spectrum and it is the emission line associated with singly ionised hydrogen (HII), which is the main light emitting species in emission nebulae such as the Orion nebula, the Monkey Head nebula, and the Rosette nebula. Since we are using just a very narrow band of wavelengths, we do not need to use refractors with a good degree of chromatic aberration compensation; this opens up the possibility of using good quality camera lenses instead of high cost apochromatic refractors. Also, since we are only collecting photons of a single wavelength, it becomes pointless to use a one-shot colour CCD for imaging, and we typically use monochrome CCD cameras for narrowband imaging. As an added bonus the monochrome camera provides higher resolution image than a one-shot colour camera based on the same CCD chip, but the gain in resolution to the eye, in the final image, is not as much as you might be expecting.

Again, recall that narrowband imaging allows us to image in areas that suffer from light pollution, providing that the pollution is not too severe, and we can also

image with the Moon up. This narrowband imaging really seems like a win-win situation, and in many ways, it is. There are downsides however. If you want to create a false colour image, you need to take several sets of data of the same image using different narrowband filters, and this pushes up your total imaging time. You also need to use long sub-exposure times as you have severely cut down the number of photons reaching your detector with the narrowband filter. This also greatly increases your total imaging time on an object. You will not get those "true colour" pretty pictures that you get with film or one-shot colour CCDs, but you can create nice "false colour" images. You can create false colour images by combining the data from several different narrowband filters. Other readily available narrowband filters include:

Hydrogen-Beta filters operating at 486.1 nm. This is in the blue region of the spectrum and this emission line is associated with doubly ionised hydrogen. Note this is NOT the blue emission you see from reflection nebulae which is a broadband blue associated with the scattering of starlight from a dust cloud. A classic example of reflection nebulosity is the blue nebulosity associated with the Pleiades star cluster M45.

Oxygen-III filters operating at 500.7 nm in the green part of the visible spectrum. O-III emission is associated with doubly ionised oxygen atoms and is often the dominant emission line from planetary nebulae.

Sulphur-II filters operating in the deep red region of the visible spectrum at 672.4 nm. Singly ionised sulphur is also a common emission line in deep-sky objects.

And finally, Nitrogen-II filters operating at 658.4 nm also in the red region of the visible spectrum - note we have 3 narrowband filters all operating in the red.

False colour images can be formed by using various combinations of the above narrowband filters as the Red Green and Blue channels of the image to be formed. These different possible "mixtures" are called palettes, and the Hubble "palette" is one of many possible alternatives. The Hubble tricolour palette assigns S-II to the Red channel, H-alpha to the Green channel, and O-III to the Blue channel. There are a number of iconic Hubble images using this particular false colour scheme, the "Pillars of Creation" being one very well known example.

So there in a nutshell are the basics of what's involved in narrowband imaging. You can carry out high-resolution, deep-sky imaging in a relatively light-polluted environment (you can of course always take even better images from a dark sky site). You can use lower specification equipment than that necessary for single shot colour imaging. This allows the use of short focal length camera lenses for those really wide field shots. You can also differentiate your work by creating your own "custom" colour palette.

What I haven't discussed in any detail is the fun and games you will have in overlaying and combining the different narrowband channels. You will find the stars in your separate images have slightly different diameters according to the narrowband filter used, and this will make the formation of the final false color image quite a processing challenge, and as I am not particularly keen on processing, this is not a challenge I will be accepting any time soon.

Chapter 4

Computational Considerations – Data Acquisition and Image Processing

As you learn to acquire and manipulate digital data in your new hobby, you will need to use one or more computers as an integral part of your overall imaging system. There are many ways of handling the computer hardware and software issues and I will outline just a couple in this chapter.

Many people, myself included, start off by taking their laptop out to the observatory and using it to download the CCD data and to look after the scope positioning and autoguiding. The software for downloading the CCD data, and autoguiding, can be the native camera software provided by the camera manufacturer, or it can be specialist software specifically written for carrying out the tasks, including image processing. I have used AstroArt [http://www.msb-astroart.com/] to great effect (AstroArt also has a great photometry package and many other goodies), but I currently use Maxim DL [http://www.cyanogen.com/] for all data acquisition, autoguiding, colour conversion and sub-exposure stacking. Returning to the hardware considerations, any current model laptop is going to be good enough to carry out these tasks provided it has a fast USB 2.0 interface available for downloading the data from your CCD camera. Any reasonable size hard drive will also be more than adequate for storing a night's imaging data – the screen brightness is readily reduced to save your night vision, and it is very easy to carry a laptop around your observatory for the best access in what are usually very cramped conditions. There is only one negative as far as I am concerned. I do not recommend taking a very expensive laptop to a freezing observatory during the winter and then bringing it back indoors to work on, or download the data. I know you can carefully wrap the laptop up in a plastic bag before bringing it indoors so that it can warm up slowly without filling itself with condensation, but I still feel it's a risky thing to do on a regular basis. I much prefer to have a very basic, small footprint computer, left full time in the observatory, which

is how my current arrangement works. I also think that an LCD monitor is preferable over the CRT variety in highly variable environmental conditions. Again from experience, a little 15" CRT monitor didn't last one season before giving up the ghost, whereas my current 17" LCD doesn't seem to be suffering any problems at all. The 17" LCD monitor is still going strong in 2016 even after 9 winters out in the observatory. Given the limited availability of CRT monitors nowadays, that last section may well be redundant information unless you already have one.

You can use a standard desktop configuration in the observatory and I now use Dell Optiplex machines in both the North and South domes. For the operating systems, I run a mixture of Windows XP, which is no longer supported, and Windows 7 Professional. I have Windows 10 on an indoor machine and it runs all the astronomy software that I use in the observatories with no issues. At some point, I will move all the machines over to Windows 10. I no longer use NexRemote and a wireless gamepad to run the Celestron C11; instead, I purchased a new Celestron hand controller and now use that.

Mains power to both domes comes from the house on two separate RCB circuits. The North dome, when fully powered up was tripping out the RCBs for both domes when they were both on the same house mains circuit, so each dome is now powered from a separate 13A house circuit. As there are many three-pin plugs for all the equipment in both domes, there are several 8-way distribution panels to accommodate all the electronics and these are of the Belkin surge-protection type. In both domes, all the equipment bar the dehumidifiers and the greenhouse heaters are powered via uninterruptible power supplies (UPS). The dome rotator in the North dome is also NOT connected via a UPS. Be warned, even though you go to all these lengths to protect your expensive electronics, a nearby lightning strike can still cause damage. I lost the electronics to an SX filter-wheel, and a CCD's firmware got scrambled by a close lightning strike (it wasn't even a direct hit). If your observatory is in a remote location I recommend you take the necessary precautions to prevent lightning strikes from damaging your valuable equipment.

In the early days (2005 - 2009) I used to collect the evening's CCD data on the local computer hard disk drive (HDD), and then transfer that data to the study "powerhouse" computer (for processing and printing) via a USB memory stick. Nowadays my life has been made a lot easier thanks to Tom How, an IT expert, who now has all the dome computers linked to the study computer via Gigabit Ethernet routers. This also means that I can now run both observatories during an imaging session from indoors, which at my age is a huge bonus as I couldn't take those long cold winter nights outside sitting in the observatory anymore. I will go into a little more detail on using the separate imaging systems in their own chapters, but for now I will continue just considering the very basics of the computer side of things.

The "Powerhouse" Indoor Computer System

My main image processing computer is an Intel Quadcore 2.5 GHz homebuilt system with 1.5 Tb of internal hard drives, and a further 14.0 Tb of external networked hard drives, plus 8 Gb of RAM, which is located in the house study. This "main"

computer is linked via Gigabit Ethernet routers to all the observatory computers and can control what's going on outside via the Remote Desktop software that is part of Windows. The main study computer has four 19" LED monitors so that I can see, and control, all the observatory systems, even if I am running both domes simultaneously. Why is there so much external storage? The main reason is that this is where I (eventually) put all my data. Once the data on the main study computer HDD reaches around 5 Gb I take the lot across to the external storage for safe keeping. The "safest" way of keeping your valuable data intact is to probably burn it all to blu-ray, but I am way too lazy to religiously keep all my data backed up that way, and no doubt I will pay the price for this laziness some day. I can confirm the need to keep you data backed up in *some* way, beyond only using your main computer, as way back in the beginning of my imaging I had a system meltdown and lost all the data that I hadn't burned to DVD. As there was a unique image of comet Machholtz passing very close to NGC1333 as one of those lost images, you can imagine I am more than a little sensitive when it comes to safely storing hard won data. My home computer system can be seen in Figure 4.1.

You can connect your observatory computer to your indoor desktop computer using either cable or wireless if the distance is not too great. This allows you to use your indoor computer as a remote desktop for your observatory computer so that you can see what is going on in the observatory and control operations from the luxury of your study armchair.

As well as collecting all the CCD data and controlling the outside observatories, the main "powerhouse" study computer also carries out all the image processing

Figure 4.1 The main study "powerhouse" computer used for image processing and to control all the observatory computers. There are 4 19" LCD monitors so that all useable combinations of the observatory imaging systems can be accommodated.

and printing. I carry out preliminary image processing using Maxim DL, but the main processing is done with Photoshop CS3 and Noel Carboni's astronomy actions. I go into image processing in detail in Chapter 11, but computer-wise, especially if you use a later version of Photoshop in your processing workflow, then get the fastest computer you can afford with the most RAM it can handle. Photoshop will gobble up all the computer resources going if you give it its head, and if you are working on a large deep-sky mosaic then you will be highly frustrated with an underpowered computer. Same goes for processing professional data that you download over the Internet. If you are using Photoshop for your image processing, get the best computer you can afford for a pleasant processing experience.

With the benefit of 9 years hindsight I can see that it is a rather pointless exercise in listing all the bits and pieces I have in my particular setups, and that I should have taken a more generic approach. I will attempt to do just that in this Second Edition.

The South Dome Computer System

The South dome houses the Hyperstar III imager (M25C SX OSC CCD) on a C11 SCT, plus guide scope and camera. As mentioned above the computer that drives all the electronics in the South dome is a Dell Inspiron. In the past 9 years computers have improved in capability in line with Moore's Law, so it is pretty much impossible to buy a new desktop machine that will not be up to the job of your observatory computer.

Taking the generic approach, your computer will need to download the data from your CCD. To this end you will need to run either the software that came with your camera, or some commercially available software written for the purpose such as AstroArt or MaximDL. You will need to also run the autoguider camera, and that too will be handled by AstroArt or MaximDL, it might not be handled by the CCD camera manufacturer's software. If you are buying commercial software you must take care to see if it will actually talk to your make of CCD camera. The last time I checked AstroArt was not configured to download data from the M26C one shot colour (OSC) CCDs.

On the Celestron C11/Hyperstar III, I use the Starizona-provided Feathertouch focuser together with their stepper motor driver unit for autofocusing. Your computer will need to run the proprietary Starizona focuser software for the Feathertouch which in turn talks to FocusMax software. You may be able to find (or you may indeed have) older versions of the FocusMax software, but the latest versions are no longer available for free. The Starizona autofocuser is a USB connected device, which is fine and straightforward for modern computers. The last time I checked, the RoboFocus units still required a serial port connection, and as modern day computers don't seem to know what a serial port is, that will cause you a complication that you don't really need.

The Celestron Nexstar C11 comes with a hand controller, so after an initial 2-star align your system is all ready to "goto" whatever object you want to call up using the hand controller. There is no need to have a planetarium program that also drives your telescope. However, nowadays I do run the C11 via a planetarium program as it tends to make life a lot simpler in setting everything up before an imaging run and for controlling the telescope during the evening. For this purpose the planetarium program I use is the Sky 6, the latest version now available is the Sky X. This is an extremely powerful planetarium program with all the extra bolt-on goody objects (comets, asteroids, etc.) that you could ever hope for. What I particularly like with this program is the ability to easily "synch" to objects, and I also really like to be able to click on a star on the monitor and immediately "goto" it. For initial "synching" you do your normal 2-star align using the hand controller, and then you take an image to see where the second alignment star appears on the monitor. It is likely to be a tiny bit off dead centre. No problem, manually move the second alignment star to precisely dead centre and then "synch" to the star using the Sky. In fact it is even easier than that. With Maxim DL you can click on the second alignment star and Maxim will move it to dead centre for you. You are now set up for the rest of the imaging session with the kit knowing exactly where it is pointing in the sky.

The computer, the CCD cameras, the C11 mount and the autofocuser are all powered via an uninterruptible power supply (UPS). If your mains supply trips out, or gets cut off for any other reason, then you can shut everything down safely. If it is only a "short" blip in the supply, something I seem to get more than enough of here in Brockenhurst, then the UPS keeps everything going, and you don't lose the alignment of your mount which is an extremely frustrating thing to happen to you in the middle of an imaging run.

As mentioned above, the Ethernet connection from the computer eventually finds its way up into the study indoors where I can control all the observatory's electronics in comfort.

The North Dome Computer System - the mini-WASP Array

The North dome of the New Forest Observatories houses the mini-WASP array. I will go into far more detail regarding the array in Chapter 10, but here I will briefly cover the computing requirements you need to consider if you wish to run an array of imagers.

The array consists of three Sky 90 refractors each with a reducer-corrector giving reasonably fast f#4.5 imaging. Two of the refractors have filter-wheels, and all three are automatically focused using RoboFocus autofocusers. Each refractor also has an M26C (non-Trius) OSC 10-Megapixel CCD.

On the top plate of the array are two Canon 200 mm prime lenses each with a Trius M26C OSC 10-Megapixel CCD. Autofocusing is carried out using a stepper-motor driven drive-belt system and control electronics built by Tom How. Unlike the serial port connection required for the RoboFocus units, Tom's units are (thankfully) USB port connected.

Unlike the South dome, the North dome has automatic dome rotation. The dome is rotated by a pair of powerful stepper motors that are normally used in CNC machines. The electronics and the motors were all integrated by Tom How and I shall discuss this system in a lot more detail in Chapter 10.

As there are five Starlight Xpress CCD cameras in the North dome there are also five computers, one computer for each camera. It is not strictly necessary to run the system in this way, but there is an advantage; if one (slave) computer or (slave) camera malfunctions, I can still carry on imaging for the night.

The computer system is configured as a master computer and 4 slave computers. The master computer connects to Sky 90(1) which has a filter-wheel and also connects to the autoguide camera. The Sky 6 runs from the master computer and as it takes co-ordinates from the Sky 6, the dome rotation system is also controlled from the master computer. The mount for the mini-WASP array is a Paramount ME which is controlled by the Sky 6 on the master computer. All the Sky 90s are auto-focused using the RoboFocus controller and as these are serial port devices all the Sky 90 computers have internal serial port connectors added. The master computer clearly does the bulk of the work in the North dome and if this computer fails, then I cannot image until the problem is fixed.

Each 200 mm lens/Trius M26C camera has its own Dell Inspiron desktop computer for control. The autofocuser and autofocuser software are proprietary (Tom How) and there is a USB connector for autofocuser control. The two Canon 200 mm lens control computers are both "slave" computers, so the master computer also has to be running when the Canon lenses are being used. Similarly Sky 90s 2 and 3 are also controlled by their own "slave" computers and they need the main computer to be running as well. I can only run the Sky 90s and the 200 mm lenses as independent systems, the reason for this is the dome aperture restriction and this is discussed in detail in Chapter 10.

All five computers and monitors, the Paramount ME, and all 5 M26C cameras are powered via UPSs.

I will go into some detail how you actually control multiple cameras for imaging, with dithering enabled, in Chapter 10.

Tip of the Day. Computer power is exceptionally cheap. If you have a problem that can be solved by buying an extra computer, this is likely to be the quickest and cheapest way of solving your problem.

Chapter 5

A Permanent Setup

You can have the greatest imaging system on the planet, but unless it can be up and running quickly, usually between breaks in the cloud, it may end up simply being a dust-magnet. The problems associated with not having a permanent base for your imaging system are huge, but they are certainly not insurmountable.

Many people do not have the luxury of an observatory in their garden, or at a local dark site. In these cases, they have to limit themselves to smaller aperture telescopes so that they can carry the whole assembly in and out of doors, or to the local dark site. This in itself is a pain, and you will find that you can't be bothered to go to all the trouble of lugging all your equipment outside unless the viewing conditions are perfect, and are likely to remain so all evening. Such conditions are very rare in the U.K. and you will find that your expensive imaging equipment will spend a lot of its life sitting in the corner of the lounge, unused. There are further complications with a non-permanent setup. Every time you take your kit out you will need to do a polar alignment before imaging, and this takes up valuable imaging time. Make no mistake, many people do this, and I have the greatest respect and admiration for their skills, especially since I do polar alignment so it takes me at least a couple of hours to get the alignment looking good. However, as stated, a lot of people do take this route, and many World-class images have resulted from their diligence.

The benefits of a permanent setup, given the above difficulties, are obvious. Your imaging system is already polar aligned just waiting for you to do the usual star alignment, and then you're ready to begin imaging. You can be up and running within ten minutes so you don't need to wait for perfect conditions, and you can be out and imaging at the first sign of a break in the clouds. You will also find yourself imaging through broken clouds, picking out those subs that imaged during the clear intervals – you don't normally do this when carrying the kit in and out of doors, just in case it decides to rain. Being outside, the telescope is temperature stabilised,

again ensuring a quick-start when you want to start imaging. There are very many advantages to having a permanent setup outside as you can see, and if your budget, and your location allow it, I strongly recommend that you construct some sort of observatory to house your gear.

There are many designs of observatory for housing your telescope and associated gear, and there is an excellent book you should refer to on the subject: "More Small Astronomical Observatories", Patrick Moore's Practical Astronomy Series, Ed. Patrick Moore, Springer, 2002, ISBN 1-85233-572-6. There is the added bonus of a CD with the first book "Small Astronomical Observatories." Within this book you will find just about every idea going for your observatory design. However, when all is said and done, the designs all usually fall into one of two categories, either a roll-off roof, or a dome construction. As its name implies, the roll-off roof is literally a shed where the roof can be rolled off to one side, or temporarily removed altogether for the observing session. Domes look like the big observatories seen on top of Mauna Kea, except they are on a much smaller scale. You will need to think very carefully about which design best suits your location, and your own particular requirements. The dome is much more compact than a roll-off roof in that you don't need to find floor area (well, roof area actually) next to your observatory to accommodate the rolled-off roof. However, completely removing the roof means that you do not have to consider rotating the dome every half an hour or so as your telescope tracks the stars (unless you have the added luxury of a motorised dome). The decision is not at all easy to make, and I personally spent over a year making many designs of my own before finding the above book. All my ideas had already been considered before (unsurprisingly) and mine were certainly no better than many others in the book. I considered modifying sheds to give me a roll-off roof observatory and felt that for what I wanted to do the cost involved would not be very different from buying a purpose-built fibreglass dome. In addition, the fibreglass dome was guaranteed waterproof and weather proof, and even more importantly needed no construction time. For these reasons I initially chose the 7 foot Pulsar Optical fibre glass dome http://www.pulsarobservatories.com/products.php?category=observatories which I am extremely happy with. You can find my review of this dome on Pulsar's website, but I will also make a few comments here. First, I was a little worried the Nexstar's GPS wouldn't work through the fibreglass dome as it certainly doesn't work from indoors. Unsubstantiated worry, the GPS system works without any problem at all within the dome. The dome is very well constructed and is certainly waterproof and has been tested as gale proof. The major environmental problem I had with my location within the New Forest area was with condensation. This was originally minimised by placing water absorbing "Water Snakes" all around the dome runner region, these are Silica Gel filled fabric "sausages" that simply reduce the amount of damp air entering the observatory through the opening between the rotating dome and the main wall. In addition to these I also run a dehumidifier in the observatory that keeps the interior quite dry. Without the dehumidifier I found that water vapour would enter the Hyperstar optics necessitating a session with the hair dryer to expel the condensed vapour, and occasionally a spell in the oven at 40 Celsius. Nowadays I have done away with the "Water Snakes" as they generated too much silica gel dust. I now put

rolls of bubble wrap in the gap between the dome and the vertical wall. Together with the dehumidifier I seem to maintain a very dry dome interior all year round. Are there any negative aspects associated with the 7-foot dome design? Well the aperture width is a little tight for an 11" reflector with a 90 mm refractor piggy-backed. When the refractor is either directly above or below the reflector (south or north pointing) there is no problem at all. If however the reflector is facing east or west, then the refractor lies to the side of the reflector and the aperture width then becomes a little on the tight side. This means you may need to physically move the dome a little more often to ensure you don't block the field of view of the imager, or the guider. That really is my only very minor quibble, and that is very quickly sorted out by buying the 10-foot version of the dome.

There are two other things you can learn from my mistakes. I put the dome down at the far end of my garden, which was not the best location with regard to the local street lighting, but it had to be down the end if I was to see Polaris over the roof of my house. I thought I needed to see Polaris in order to do a proper Polar alignment, but this was in fact incorrect. Since the method you will use to get good Polar alignment is the drift method http://starizona.com/acb/basics/using_polar.aspx all you really need to do is to get your setup roughly pointing north with the R.A. adjustment on your wedge, and the Dec angle set at your latitude (there is normally a vernier scale on the side of your wedge to facilitate this). This very rough "Polar alignment" is sufficient for you to now image stars to the south and to the east for precise Polar alignment. You really do not need to be able to see Polaris at all.

The second thing that you can learn from my mistakes is where to position the door of the dome. With the 7-foot Pulsar Optical dome there are runners that take the dome aperture down the back of the dome to leave the aperture clear, these can be seen in Figure 5.1. It can also be seen from Figure 5.1. that the runners extend below the rim of the dome and that they will prevent the door from being opened or closed properly if they are in front of the door. So this defines where you should place your door before bolting the dome down to its base. I did this all wrong. I wanted to be able to see the door from my house, so the door faces north. This means that when I am imaging close to due south, i.e. most of the time, I am unable to easily open or close the door – this is a great nuisance. As I cannot image to the west due to neighbouring trees, I should have placed the door opening facing the east. If I can summon up the energy and enthusiasm, one day I will remove the screws holding the observatory in position, remove the sealant that I have applied all round the base perimeter (internally and externally) and physically rotate the dome so that the door faces east. I think it will be quite some time before I undertake this exercise, and you can side step the problem by facing the door in the right direction first time off. Nine years on I still haven't rotated the wall of the dome, so I guess I am just going to live with this annoyance.

You can see from Figure 1.7 that my dome sits on raised wooden decking, so that I didn't need to pour a large concrete base. The aluminium pier is mounted on an eighteen-inch by eighteen-inch concrete slab that extends 3 feet into the ground. The decking does not touch the slab or pier so that vibration isolation is quite good, but it is by no means perfect. If you walk around the observatory, you will see the autoguider trying to compensate.

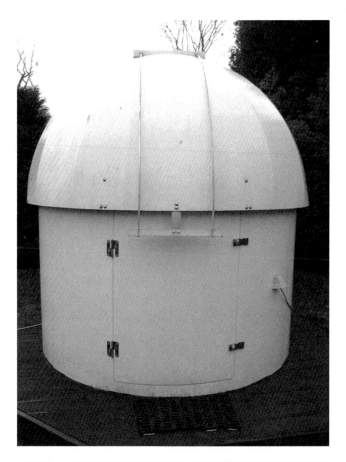

Figure 5.1 Illustrating how the dome aperture guiding rails can block the opening and closing of the door on the Pulsar Optical 7-foot dome. In this photograph I have the door facing north, and the aperture facing south where most of my imaging takes place.

The North dome that houses the mini-WASP array is a later Pulsar design. It is the 2.2 m full height observatory with a pair of accessory bays added and can be seen in Figure 5.2.

This observatory has many improvements over the original 7-foot dome. The dome itself is very easy to rotate; you can use just one finger, which is why it wasn't too much of an issue to incorporate an automatic dome rotation mechanism. The dome is higher and the aperture slightly wider. The ability to add the accessory bays to free up floor space is really great, even though I haven't managed to free up much in the way of floor space by putting five computers, and their monitors, in there. All in all, it is a huge improvement over the previous model and I am extremely happy with it. Like with everything I undertake however, I did make one mistake. I knew the height where the dome roof meets the wall and I designed my all

5 A Permanent Setup

Figure 5.2 The Pulsar 2.2 m full height observatory with two accessory bays which now houses the mini-WASP array.

Aluminium pillar accordingly. Now look at the picture of the 2.2 m dome in Figure 5.2. Notice that there is a section of fibreglass in the dome aperture that extends over a foot into the aperture space. Now this is done for a very good reason of course - it means that when the dome aperture is fully open, there is no overhang of the aperture over the back of the dome, unlike the situation with the 7-foot dome. So my designed pillar was around a foot too short and I needed to design and get built a pillar extension. It all worked out in the end.

In summary, a permanent setup will ensure good usage of your telescope, and will prevent a rather expensive investment from collecting dust. It will allow a fast turn-on time so that you can maximize your observing and imaging time. It will also prevent you from injuring yourself, or the equipment, by the continually carrying your gear in and out of doors. But most importantly, a dome in your garden will look really cool.

Chapter 6

First Light – Choosing your Objects

I cannot stress how important it is to prepare properly before any imaging session. If, by some miracle you have a clear Moonless night, then you really must get the most out of the evening as these are such rare occurrences, especially in the U.K.

Since we are discussing your very first images, we need to consider the "easier" subjects so that your initial results are good. This being the case, I really recommend that you do not try to image things like the Owl nebula (M97), the Bubble nebula (NGC7635), or the Iris nebula (Caldwell 4) in your initial outings as you are likely to end up feeling despondent and unhappy with your hard-won results. A difficult winter object such as the very dim Witch Head nebula (IC2118) is completely out-of-bounds. Leave the tough stuff to later sessions when you have learned more about your system and are more proficient in using your kit. So for now, let's look at objects that should give you a good result with your very first imaging session, your "first light".

Clearly, the objects that are going to be visible to you will depend upon the time of year and your location. You will need to know what is "up there" in the sky at the time, and to this end you will need a good quality star map. It is also a good idea to subscribe to an astronomy magazine such as Astronomy Now, or the Sky at Night, in the U.K. or Sky & Telescope in the U.S.A. as these will give you a star map for the month, together with information on the best objects for viewing or imaging during that month. These magazines will also tell you the phase of the Moon, which is very important, as you want Moonless nights for the best imaging results (and please remember, a full Moon ALWAYS means clear skies).

What area of the sky will you be imaging in? This depends on your location and your local sources of light pollution, but it's true to say that often the best (darkest) place to image is directly overhead – the Zenith. This also has the best "seeing"

as you are going through the thinnest amount of light-disturbing atmosphere. As you go to lower and lower declinations, you will be imaging through greater and greater thicknesses of the Earth's atmosphere, and you will be more susceptible to things like dust, fog and water vapour, which will end up giving you a poor final image. You are also more likely to start seeing the effects of local light pollution at lower declinations as well. So my advice on your first imaging session is to check what can be seen at the Zenith of the evening you wish to image.

Next, we need to consider the class of object that would be best for our first imaging attempts. We want large, bright objects (the Moon is too bright) and we would like them to fit the field of view of our imaging system nicely so that we don't get either an indiscernible point in the center, which was meant to be a galaxy, or a general region of uniform red, that was meant to be the North America nebula. Initial subjects that are good to image would be open or globular clusters, and any large bright nebula that might be in your sky at the time that fits your optical system's field of view (FOV). The most ideal bright nebula to experiment with is the Great Nebula in Orion M42, but you are restricted to the winter months only for that one from the U.K.

To summarise, we are looking for a bright object, galaxy, nebula or cluster, that nicely fits our imaging system's field of view and that is almost directly overhead during the time we wish to image it.

Some Possible Examples

For general examples of suitable targets I will consider two imaging setups, one will be a wide field imager like the Sky 90 and SXVF-M25C camera, and the second will be a smaller field of view as provided by the Nexstar 11 GPS scope at f#6.3, but again using the SXVF-M25C camera. The Sky 90 system will give a large field of view approximately 3.33 by 2.22 degrees at 3.96 arc seconds per pixel, and the Nexstar 11 GPS at f#6.3 will cover a smaller 0.5×0.75 degrees at 0.91 arc seconds per pixel which makes it an ideal galaxy imager. Let's look at what will be available in the 4-quarters of the year imagers working in the Northern Hemisphere.

Spring

Spring is known as the "galaxy season" for astronomers in the Northern Hemisphere, as it is at this time of the year that many galaxies are well placed for imaging and observing. As galaxies are going to be our main targets during the spring, our galaxy imaging system will be seeing more action at this time of year than our wide field setup.

So, some nice bright targets that will fit the field of view of the Nexstar 11GPS at f#6.3 and SXVF-M25C will be:

1) M51, the Whirlpool galaxy in Canes Venatici. A pair of interacting galaxies with lots of nice structure, and the subject of a Hyperstar image.

2) The famous "Leo Trio"– NGC3628, M65 and M66. You won't get all three objects in the F.O.V. but you could make a nice mosaic.
3) M106 is a beautiful bright galaxy in Canes Venatici that to me looks like it is made from Mother-of-Pearl. Many other smaller galaxies surround M106 and you should pick these up easily in your imaging system.
4) M100 is a nice bright spiral galaxy in Coma Berenices.
5) M104 is the rather small, but surprisingly bright Sombrero galaxy in Virgo, which would look great in with this imaging system's field of view.
6) M63, the Sunflower galaxy in Canes Venatici is a spectacular sight, reasonably bright with very nice fine structure.
7) M64, the Black Eye spiral galaxy in Coma Berenices is not as bright as M63 but has an interesting structure, with a clear dust lane running right through it.
8) M3 is a spectacular globular cluster in Canes Venatici, it is very bright and a good beginner's object.
9) Similarly M5 in Serpens is another bright globular cluster, perfect for the beginner.
10) M101, the Pinwheel galaxy in Ursa Major is a large, classic-looking spiral galaxy, but a little bit on the dim side. Not so easy to image as it has a low surface brightness. This is however an object that is worth persevering with as a beginner, just to learn how to deal with the slightly more difficult subjects.

I would suggest starting with 5-minute sub exposures for the above objects, and getting as many of them as you can. Move upwards from 5-minutes if you do not seem to be achieving sufficient depth.

For the Sky 90/SXVF-M25C combination there is a smaller selection to choose from.

1) Although it will come out a little on the small side, it would still be worth imaging the M101 area, as there are other small galaxies you will pick up in the wide field that would make a very nice frame overall.
2) The Leo Trio will be a very easy single frame using the wide field system.
3) The main spring target would have to be the Virgo Cluster region around Markarian's Chain. There are more than 2,500 galaxies in this region, and the tail end of Markarian's chain would make an ideal single frame object for the wide field imager. It would certainly be worth your while spending the time building up a 4-frame mosaic of this area which would allow you to capture the whole of Markarian's Chain, and a good bit of the surrounding galaxy-filled area.

I would suggest starting with 10-minute sub exposures, and again go for as many as you can obtain.

Summer

Summer is an extremely difficult time of the year for the astronomical imager at the latitude I work from [50 degrees 49 minutes 10 seconds North], especially for those of us that have day-jobs. In peak summer it never really gets dark and you find you

cannot start imaging much before 11.00 p.m. (it's just too light), and you have to pack up around 3.00 a.m. as the rising Sun will again start to cause you problems. It is a very frustrating time of the year, probably better spent in maintaining your observatory and equipment rather than imaging. Having said that, one of my finest Hyperstar mosaics was taken in those few available hours – a 4-frame mosaic of the North America/Pelican nebula region.

There are lots of narrow-field as well as wide-field targets you can obtain during the summer, and it is fortunate that you can still get many of them during the autumn months as well when the dark evenings start a little earlier.

For the 11GPS at f#6.3/SXVF-M25C combination, you could try:

1) M13 and M92, two absolutely stunning globular clusters in Hercules. M13 is often quoted as the best globular cluster in the Northern Hemisphere, and it is certainly an amazing sight.
2) M27 is a nice reasonably bright planetary nebula in Vulpecula with distinct blue and red regions.
3) IC5146 is the Cocoon nebula in Cygnus. Reasonably bright and with a nice surrounding dark nebulosity, which enhances the Cocoon.
4) NGC6946 is a beautifully coloured spiral galaxy in Cepheus, and it is unfortunately a little on the dim side. However, as it is the site of a number of supernova discoveries, it is probably also worth imaging occasionally, just on the off-chance :

For the Sky 90/SXVF-M25C combination, you are spoilt for choice. You have all the Cygnus goodies at your disposal – and they're BIG.

1) As mentioned in the introduction above, you have the spectacular North America nebula (NGC7000) and the Pelican nebula (IC5070) in Cygnus. This is a massive H-II region (ionised hydrogen emission at 656 nm in the deep red) and is truly beautiful, as well as being truly huge. The wide field imager will get the whole of NGC7000 in one frame if used in portrait mode, and will easily get the whole of the Pelican region in one frame as well. So in order to get the whole region imaged you will need to do a 2-frame mosaic – but it's well worth it. My original 4-frame Hyperstar mosaic covers less area than a single frame wide field mosaic using the Sky 90, such is the high price you pay for not having the best gear for the job at the time.
2) There is another superb huge nebulosity in Cygnus that is ideal for the wide field system, and that is the Veil nebula, NGC6960/6992/6995. Again, this is so big it will require a mosaic, even with the wide field imager. I took a nice image of part of the Veil (the Witch's Broom, NGC6960) with a narrow field using the original Hyperstar. It will require a 2-frame mosaic to capture the whole of this supernova remnant using the wide field setup.
3) There's even bigger stuff to be had in Cygnus, believe it or not. The Gamma Cygni nebulosity IC1318 surrounding the bright star Sadr at the centre of Cygnus is truly immense. Centre Sadr in the FOV and you will capture the whole of the Butterfly nebula, a fascinating H-II region with plenty of nice dark nebulosity. Move up to the NGC6914 region of IC1318 and you will get some blue reflection nebulosity breaking up the rather monotonous red that makes up the huge IC1318.

A 4-frame mosaic will be insufficient to capture the whole of the Gamma Cygni nebula, you will need at least 6 and more likely 8 frames to get the whole thing in – this is a major project.

4) There's another huge H-II region in the summer skies, IC1396, and strangely enough it doesn't have a "common name". It does however contain a region of dark nebulosity that does have a common name, namely the "Elephant's Trunk"nebula vdb142. IC1396 is possible as a 2-frame mosaic using the wide field system, or a very easy 4-frame mosaic using the same setup. Be warned however that although massive, IC1396 is a bit on the faint side.

Autumn

Autumn has a good mixture of narrow field and wide field objects to image. For the Celestron 11GPS at f6.3/SXVF-M25C try the following:

1) M15, a nice bright globular cluster in Pegasus.
2) While you are in Pegasus move across to NGC7331 a very nice spiral galaxy with plenty of structure. It has the added bonus of a group of nearby smaller galaxies (the Deer Lick group) that gives a very nice frame.
3) You can get the core region of the massive Andromeda galaxy, M31, in Andromeda.
4) You can also get a large part of the Triangulum Galaxy, M33 in Triangulum, but will need at least a 2-frame mosaic to get the whole thing. Be warned – the Triangulum galaxy has quite a low surface brightness, which makes it a lot more difficult to image than it first appears.
5) M74 in Pisces is a very nice spiral galaxy, but it is a little on the dim side.
6) The famous Double Cluster in Perseus, NGC 884 and NGC 869, makes a very fine image. This is likely to be a 2-frame mosaic with the narrow field imager.
7) NGC891 is a nice bright spiral galaxy that is almost edge-on to us, so it shows a dominant dark dust lane running right across its diameter. Very photogenic.

The wide field targets duplicate some of the narrow field objects suggested above.

1) M31, the Great Andromeda galaxy, can be framed along the diagonal of the wide field imager. M31 is surprisingly big at 3 degrees along its major axis. M31 benefits from LOTS of medium-length subs, so something like 100 subs of 6 minutes each would give a very good image of M31.
2) Another one from the above list, M33, the Triangulum galaxy is a very easy single frame object for the wide field imager.
3) NGC281 the Pacman nebula in Cassiopeia is a good size for a wide field single frame image.
4) This next target I suggested was not for the beginner, but it may well be worth having a go at it, even if it's just to see why it is a little tough. Try to get NGC7635, the Bubble nebula centred in the frame. If you do, you will also have the little open cluster M52 clearly visible in the frame, and if you go deep enough with

your sub-exposures, you'll see the whole area is covered in H-II regions. I think you'll need a minimum of 10-minute subs to get anything meaningful out of this one, that's why I don't think it's a good beginner's object. But it is very pretty.
5) Finally, the Double Cluster again. Very easy in the wide field, but not as impressive-looking as the 2-frame narrow field image.

Winter

Winter is the best time of year for us deep-sky imagers. Long nights, crisp, dark crystal-clear skies with (hopefully) no Moon, and of course the pièce de résistance – Orion. With Orion up in the sky, I rarely want to look at, or image, anything else. It has a magical power. It also contains just about every different type of deep-sky object you want to image. Orion is the ultimate playground for the deep-sky imager. I will try to include objects other than those just in Orion.

For the 11GPS at f#6.3/SXVF-M25C combination:

1) We may as well start with the winter showpiece, the Great nebula in Orion, M42 (and the closely associated M43). This region is bright. Take many short subs of 3-4 minutes each, and enjoy the result. It is almost impossible not to get something you like when you image Orion. I clearly remember the first few images I ever took with my brand new Hyperstar/SXV-H9C combination, of course they were all of Orion. I also remember how excited I was at the results which I thought were fantastic. Looking back I realise they were actually pretty miserable with extremely poor star shapes – but under all the blemishes, M42 shines through looking quite beautiful. You won't get the whole of M42 in a single narrow field frame, so pick bits of it; they all look good. If you feel ambitious enough, build up a mosaic, it will take around 3-4 frames.
2) Go slightly north of M42/M43 to get the famous "Running Man"nebula NGC1977 and associated open cluster. This is a little tough for the beginner, but should do well with as many 10-minute sub exposures as you can muster.
3) Move west towards Monoceros and get the core of the Rosette nebula (Caldwell 49, the Great nebula in Monoceros, or Swift's nebula) and the associated open cluster at its centre NGC2244. You will only get the central region of the Rosette, but this alone is worth it. A lovely deep-red H-II region that really lives up to its name.
4) Move across to the Pleiades (M45) in Taurus. It is of course very easy to image the bright stars that make up the Pleiades, and much more difficult to capture the faint blue reflection nebulosity that fills the whole region. You won't get the whole of the Pleiades in your FOV, but you can take some stunning images with each of the major stars centred in your FOV.
5) Move to the leftmost star in Orion's belt, Alnitak, and there you'll find the most imaged region of the sky. Here resides the Horsehead nebula B33. Your narrow field will get a nicely framed Horsehead, and you should be able to keep the ultra-bright Alnitak out of your field of view.

6) Move north of the Horsehead and you will come across the Flame nebula (NGC2024) and the associated bane of the astronomical image processor's life, Alnitak. The flame nebula is another H-II region but with an appearance nearer that of orange/burnt umber rather than the usual deep red.
7) Your narrow FOV should get most of the open cluster M35 and the little old cluster off to one side NGC 2158 in Gemini. This is one of those nice, rarely encountered, "double objects"where you get two for the price of one.
8) Another "double whammy"can be found in Puppis, this is the nice open cluster M46 and the pretty little planetary nebula NGC2438.
9) Although you won't get both galaxies together in the narrow field, M81 and M82 in Ursa Major are well worth spending some time on. M81 and M82 need a lot of exposure time, so they are probably not good beginner's objects, but if you can get the accumulated time on these objects you will be very well rewarded.

For the wide field combination, you are really spoilt for choice.

1) Orion again. M42, M43 and the Running Man – you'll get the lot in a single, wide field frame, and they look great together. Go for as deep an image as you can manage and you will see the whole area surrounding M42 is covered in nebulosity.
2) The Rosette nebula. Once again, your wide field imager will capture the whole thing. Go for as many 10-minute subs as you can manage.
3) The Horsehead and Flame region near Alnitak. Yet again, the wide field imager will capture the lot. Go as deep as you can to pull out as much of the huge sheet of H-II region as you can that lies behind the horse's head.
4) M45, the Pleiades or Subaru. The whole thing fits easily into your wide field FOV. Blue reflection nebulosity fills the whole region but it is very difficult to capture nicely. Go for as many 10-minute subs as you can get.
5) Finally M81 and M82 in Ursa Major. You will easily get this pair in your single frame FOV. Again, go for, as many long subs as you can manage for this region, there are lots more things to see than just M81 and M82 if you go deep enough. I'll let you discover what they are for yourself.

Other Things to Image

In the above sections, I have discussed imaging nebulae (dark, emission and reflection), clusters (open and globular) and galaxies of all types. The objects chosen have been suggested as good first targets for the beginner. Is there anything else? If you take a look at the Chapter 13 images, you'll see there is something else, but it takes a lot of image processing practice to make these objects look as good as they do here. These objects are single (or double) bright stars with a nice star field in the background.

This type of image will look far better using the narrow field setup. A well-centered, bright star with a nice background can make a really stunning image. The other good thing about these images is that the sub-exposure times can be reasonably short, about 3 minutes with a total of 50 subs altogether.

Single star images of Polaris, Aldebaran, Vega, Altair and Deneb can look very stunning indeed. A well-processed image of the double star Albireo, in Cygnus, can be especially striking.

If your sky conditions are not optimal one evening, or the Moon is being intrusive and you cannot do H-alpha imaging, don't forget the possibility of taking some nice single star images.

Chapter 7

First Light – your First Objects

I really envy you this moment. It doesn't matter how good, or bad, this first image of yours turns out, it is your first light with your new system and you will always remember this evening as something special.

For your first image, I strongly recommend you pick the largest, brightest object in the sky as discussed in the previous chapter. This might be a globular or open cluster, or a bright nebula like Orion.

Go through your star alignment routine if you are using a goto telescope and then move to your chosen object. Carefully center the object in the middle of the screen using the crosshairs if you have Maxim DL as the image capture software (right click on the image box and check crosshairs).

You will already have excellent polar alignment, so there is just a short checklist to sort out before you start imaging. Having centered your object, you should then carry out the following:

1) Make sure the object is in good focus using the acquisition software. Check the FWHM of the star chosen as focusing is the minimum you can get on this particular evening. Viewing conditions can vary greatly from night to night, on a very good night you might obtain an FWHM of 1.5 pixels or less, on an average night you may have difficulty getting below 2.0 pixels. Take your time during this step because it is the most important step of the evening and you may need to do it again if conditions change during your imaging session (i.e. temperature, viewing, humidity, mirror shift, etc.)
2) Choose a guide star using the guiding routine in your software and calibrate as the software describes. You will want to choose a relatively bright guide star close to the center of the field of view if possible. There should not be any other bright stars in close proximity to the one chosen or the calibration routine may

get confused. Choose an integration time of around 1 or 2 seconds for the image acquisition for your guide CCD if you are using a mount such as the one that comes with the Celestron C11, or an integration time of 5-seconds or so for a Paramount ME. Go to the options settings for your guide parameters; you will need to experiment with x-speed and y-speed settings to get the best guiding. You will also need to experiment with the aggressiveness settings for best guiding as well. Open up the tracking error graph so you can see how well your system is guiding and set the guide to track. If your guiding is good, you will be able to be on +/- 0.5 pixels full scale and all your tracking points will lie between +/- 0.2 pixels. Unfortunately this may take quite a bit of experimentation with your new system, and you may find your whole first session is spent just getting the autoguider calibrated without even taking an image. You may find the following program helpful in iterating to the best autoguider parameters http://www.ccdware.com/resources/autoguidercalcv4.cfm Again, take your time over this step, once you have sorted out the best settings for your system, you will use these for all future imaging sessions for the same arrangement of kit. Set the autoguider to track and now open the sequence window, as we will want to store a sequence of images.

3) With the sequence window open choose options and set up the sequence. If you are using a one-shot colour camera choose "light" and then you will need to choose an exposure time for your sub-exposures, and a figure for the total number of exposures. I simply put a large number in for the number of exposures (300 or more) as I will terminate the sequence manually at some point, usually dictated by poor weather turning up. Your main concern will be the length of the sub exposures. Now there is a good calculator for working out how long your sub exposures should be and it can be found here: http://www.ccdware.com/resources/subexposure.cfm It is well worth using this as a good first guide for your best sub-exposure times, but nothing beats experience. As you get more and more used to the quirks of your system you will get to know what the best length of sub-exposure to use is for the given object under the given "seeing" conditions. Faint objects will require longer sub-exposures, but if the Moon is up you will want to reduce sub-exposure times as much as possible to minimise gradient problems. This is very much a "black art" area where experience counts. For ballpark figures, if you are using a low f# system like my Hyperstar, try for 1 or 2-minute sub-exposures at first. If you are using a short focal length refractor like the Sky 90 at f#4.5, try for a sub-exposure time between 180 and 300 seconds. If you are imaging at f#6.3 using an 11" Schmidt-Cassegrain, try experimenting using sub-exposures between 240 and 420 seconds. Choose a file location to place your sub-exposures in and you are ready to use the auto-sequencer.

4) Before starting off the auto-sequencer, return once more to the expose window and take a quick exposure of your chosen sub-exposure length. Check that everything looks o.k. that it is in good focus, and that the brightest parts of the object you are trying to image are not "burnt out". You can check to see whether you have burnout by calling up the "Information Window" and placing the cursor over the region of concern. Don't worry about bright stars, they will be burnt

7 First Light – your First Objects

out, check the core region of globular clusters, or the bright regions in nebula (especially the Trapezium region in the Orion nebula). Once you are satisfied that the sub-exposure looks reasonable, return to the Sequence Window and start off the sequencer.

5) Now all you need do is go away if you have your scope in an observatory, and only return to rotate the dome every half an hour or so if you don't have a roll-off roof or a motorised dome.
6) Once all your sub-exposures have been taken, download all the saved FITS files to bring indoors for image processing.
7) Shut down your system and leave the telescope in its usual resting position.

For your first image, I wouldn't worry too much about the fine detail you will be concerned with once you gain more experience. So, for this first image I would try to aim for a total exposure time of around an hour. You will discover that the absolute minimum total exposure time to get any of those "good" images is always around an hour, and that is for bright objects using a fast f# imaging system. As you go hunting for dimmer, more difficult objects, two, three and even four hour total exposure times will become common. As an example using my Hyperstar system, I can obtain reasonably good images of the Orion nebula and NGC7000 (the North America nebula) using total imaging times of only 40 minutes using sub-exposures of 30 seconds. For bright clusters a total imaging time of only half an hour can be sufficient, so these are good subjects to go for on those nights when you are bothered with background Moonlight. To get the nebulosity around the Pleiades I would need at least an hour total exposure using subs of around 60 seconds or more. Now let's move onto the dimmer stuff. Something like the Bubble nebula, or the Iris nebula needs at least 2 hours total exposure and 3 hours (or more) is preferable. The Jellyfish nebula shown in this book was over four hours total exposure, and clearly this was still insufficient with the sub-exposure times I was using. You will have to experiment carefully in order to understand how to get the best out of your system, and quite often when I am imaging a new object, the first imaging session is usually only an experiment to see what the best imaging parameters should be in order to image the object properly at a later time. Treat all objects as entirely new cases, and carefully log all the conditions and parameters used for your imaging session; this will be an invaluable resource for you as you progress and improve.

You should be aware of a "trick" that you need to employ on these long total exposures. If you have very good tracking you will find that you will get CCD artefacts feeding through into the final image, especially in the darker (low photon signal) parts of the image. This can manifest itself as bright and dark vertical bands (not the same as the Venetian blind effect which appear horizontally if the CCD is used in the normal "portrait"mode), which can be caused by different columns having slightly different read-out characteristics. With good sub-pixel tracking each sub with its own "CCD signature" will add together giving pronounced banding. To prevent this (if your mount control software does not incorporate a "dither" function) you can simply use turn off the autoguiding and auto-sequencer after say an hour, slightly move the telescope using the X-Y controls, then reconfigure the autoguider and start imaging again using the auto-sequencer. The same effect can

be achieved using the "dither"function in Maxim DL. When you combine all the individual sub-exposures using either sigma clip combine, or SD mask combine, the vertical banding will be removed in the combine process.

Reading the above it is apparent that a whole evening's imaging should be dedicated to just one object if you want to obtain a really good image. In fact you will find that you may actually need to dedicate several evenings imaging to just one object, especially if it is faint. At the beginning of your imaging career you are unlikely to want to do this, there's just too much up there you want to see and capture. After all, if you spend less than an hour on an object you have the possibility of getting three or more objects "done" in one night. That's fine – get it out of your system as early as possible, because the results will not be the images that you admire from the likes of Rob Gendler or Steve Cannistra. To move into the big league you have to go the extra mile, and spending many hours imaging a single object is the price you have to pay to get those great images.

Stop Press!

Here's yet another late addition to the imaging armoury, only brought on board in the last few weeks. The SXVF-M25C is a large chip to be sure. It is so large that there is provision for adjusting the flatness of the chip to the optical system using three adjuster screws. Now if the chip isn't quite square to the imaging scope's optical axis you will see central stars nicely focused, and stars towards an edge of the field of view will be out of focus to varying degrees. Practically, how do we square up the chip to the scope? Well one way I suppose is to take an image, slightly adjust the CCD, take another image and see if it looks any better. I am sure this approach will work, eventually, but I don't fancy my chances of ending up with a perfectly flat chip even after much iteration.

It is very fortunate that there is some powerful software out there, purpose-built to take all the pain out of this exercise. Produced by CCDWare the software is called CCDInspector http://www.ccdware.com/products/ccdinspector/features.cfm and it makes big-chip alignment a doddle. It gives a lot more information about your optical system as well (see the above website), and will be as invaluable on the Schmidt-Cassegrain for collimation adjustment as it is on a wide field refractor setup for squaring up a big CCD chip. Until I had actually used this product, I didn't believe for a second it would turn out to be as useful, in fact invaluable, as it now is.

I shall go into more detail in setting up the collimation for refractors like the Sky 90 and Hyperstar III systems in Chapters 8 and 9.

Chapter 8

Wide-Field Imaging with a Short Focal Length Refractor

A very popular combination used in DSO imaging is a long focal length reflector, usually a Schmidt-Cassegrain, with a good quality short focal length refractor piggybacked on the reflector. This system allows high-resolution images of small objects, such as galaxies, to be taken using the reflector, and wide-field images of large nebulae to be acquired by the refractor. Clearly when the refractor is being used for imaging, the reflector is relegated to the role of guidescope which may appear a little perverse considering the cost of the "guidescope". When the reflector is being used for imaging, the piggybacked refractor is used in its "normal" mode as a guidescope.

There are a number of things to consider when choosing the imaging refractor, not least the added weight that you are going to put on your reflector's drive train. On the Nexstar 11 GPS, I initially used a Celestron 80 mm wide field telescope as a guidescope. At f#5 and weighing in at only 1.8 kg, this was an almost ideal telescope to use for guiding the f#1.85 Hyperstar. The extremely light weight meant that the 11 GPS barely noticed it was there, and f#7.5 guiding with f#1.85 imaging meant that standard deviations in both R.A. and DEC. were typically below 0.2 pixels throughout an imaging session. All this changes when a high-quality refractor is to be piggybacked for imaging.

For a number of reasons, I chose to piggyback the Takahashi Sky 90 refractor for guiding and wide field imaging as shown in Figure 1.6. The native Sky 90 comes in at 3.2 kg, has a 90 mm objective lens, is a doublet, and has an f-number of 5.6. The Takahashi reducer/corrector brings the f-number down to 4.5, giving a focal length of 405 mm and provides superb wide-field coverage. Add to this the fact that the reducer/corrector gives a nice flat field over an APS-size sensor and you can see that this is an imager to be reckoned with. The only slight negative is being a doublet rather than a triplet means that some very slight chromatic aberration must be

suffered, though this is typically minimal away from very bright stars, or planets. At 3.2 kg, the Sky 90 is no heavyweight, and I needed to add another 1.5 kg counterweight to the C11 making the counterweight look decidedly "clunky". Things were a little worse than just looking clunky however. On trying to autoguide the new system, I found the autoguider couldn't handle it, the system simply wouldn't iterate to a stable control point, and this at first seemed very strange. I had of course re-balanced the telescope in the horizontal and vertical directions as previously described, so the balance was not in question. It was only when I looked at the telescope from the side that I saw a possible problem. The counterweight was sitting towards the front end of the reflector. Well, what does this matter if the whole thing balances nicely? It means that the counterweight lies quite some distance from the DEC axis bearings, so that there is quite an inertial mass sitting away from the DEC axis. I then pulled the counterweight back until it sat exactly underneath the DEC axis bearings and pushed the whole refractor assembly forward to regain balance. By manually pushing the system up and down in the DEC direction, I could "feel"that the inertia around the DEC axis bearings had been enormously reduced. When I then tried to autoguide the system, once again things behaved as they should and once again I had good control of the system. So please keep this in mind, there are in fact **three** things to take into account when balancing your SCT Alt-Az on a wedge system:

1) Balance the system in the horizontal direction.
2) Balance the system in the vertical direction.
3) Make sure the counterweight lies directly beneath the DEC axis bearings (or as close to this position as possible) in order to minimise the inertia about the DEC axis.

As things were clearly becoming a little bit heavy for the Celestron 11 GPS drives to handle, I would suggest that somewhere around the 3.5 kg is the maximum refractor weight you should consider mounting on a reflector such as the 11 GPS. This weight limit consideration automatically reduces the number of options of suitable refractors considerably.

What else do you require of the refractor? Well, you want the biggest objective diameter you can afford, bearing in mind the weight limitation (there is of course no such strict weight limitation if you put the refractor on its own mount), and you want the shortest focal length to get the biggest field of view. Taking all the parameters into account there are very few refractors that will actually fit the bill, but the Sky 90 is one that does the job admirably. It is also comforting to see that one of the World's finest amateur imagers, Steve Cannistra http://www.starrywonders.com/uses a Sky 90 extensively for his work. Takahashi has discontinued manufacturing the Sky 90, but you can now purchase the Takahashi FSQ 85 ED http://www.takahashi-europe.com/en/FSQ-85ED.php and this together with the 0.73 x reducer/corrector gives you a nice wide field refractor (shame about the loss of that 5 mm on the objective diameter though).

With the reducer/corrector fitted to the Sky 90 and a reduced focal length of 405 mm, we now have a system with a shorter focal length than the 500 mm of the Hyperstar, and thus we have an imager with a 40% bigger imaging area.

8 Wide-Field Imaging with a Short Focal Length Refractor

This is clearly quite a powerful imager. However, let us not forget that the Sky 90 is an f#4.5 telescope whereas the Hyperstar III is a very fast f#2 optic, so we can expect the sub-exposures, and total exposure time of the Sky 90 to be greater than those of the Hyperstar III by a factor of 5. This is the main drawback of all non-Hyperstar systems; they are incredibly slow by comparison. This is then one of several compromises you have to consider when you image using these systems.

The Sky 90 being slower than the Hyperstar III has several knock-on effects that you must consider seriously:

1) Your sub-exposure times and the total imaging time will be dramatically increased.
2) This means that the time required to image an object will now, more than likely, require several night's work on just the one object. So your rate of image production per year will decrease seriously from the production-line days of Hyperstar III imaging.
3) The increased sub-exposure time means your autoguiding precision needs to be far greater than you were used to with f#2 imaging.
4) The increased sub-exposure time means that you will suddenly discover you have a great deal more hot pixels than you thought you had.
5) Dust doughnuts become a problem once again.

Let's face it, low f-number imaging makes life very easy, and if you want an easy life you want a low f-number optical system. However, you may not want the large field of view that accompanies a fast system, especially if you want to take high-resolution images of small galaxies, or carry out supernova searches. Once again, there are practical imaging issues to consider depending on the sort of imaging you want to do. This is why we often see the short focal length refractor piggy-backed on the larger f-number larger aperture reflector, using this combination you can address wide-field imaging and high resolution imaging of small galaxies using the one setup. You can of course have the refractor set up on its own mount as a completely separate imaging system as well. This has the major advantage that you can image with **both** systems on the same evening, but has the disadvantage of needing a second mount a second guide-scope/guide-camera, and a second computer to run the rig. It also requires some severe multiplexing on your part if you run both systems simultaneously.

Let us assume that you have your imaging refractor set up on its mount, whether an independent mount or the mount of an instrument it is piggy-backed on. We will also assume you have a guidescope and guide camera attached or a guide camera fixed to an off axis adapter.

The very first thing you must do with this new system is get the mount polar aligned so that you can take long sub-exposures. I can tell you from many years of experience that the *only* sensible way of doing this is by using the drift-alignment method. Download the article from the Starizona site http://starizona.com/acb/basics/using_polar.aspx and follow to the letter the drift alignment procedure. Do not panic if it takes you more than one evening (and you are losing good imaging time) to get good polar alignment, it is all worth it in the end. Also, once you have drift aligned your mount a few times you will get faster and faster at getting good alignment.

You now have to make sure that your autoguiding is spot on. I use Maxim DL and it is pretty straightforward to get your autoguiding sorted out in a couple of hours. I don't have any helpful "tricks" with this procedure other than don't choose a star this is too bright as a guide star and make sure that the star you do choose isn't a double star that could confuse your autoguider software. On both the Hyperstar III and mini-WASP array rigs, I have the vertical scale on Maxim DL's set at +/- 0.5 pixels and the mini-WASP array (Paramount ME) keeps between +/- 0.1 pixels during autoguiding, and the C11 mount keeps between around +/- 0.3 pixels during guiding. The guide camera integration time on the Hyperstar III is 1 second (this gives best autoguiding for the C11 mount) and the guide camera exposure time for the Paramount ME is 5 seconds (shorter exposure times do not help with guiding accuracy).

If you have an autofocuser, you now need to train that system for your scope. I use the FocusMax software and the FocusMax tutorials to help me with setting up for my 3 different systems. For the Sky 90s (I have 3 of these), I use Robofocus for the hardware side of things. You can read about the Robofocus system at http://www.robofocus.com/products.htm. A few things to note before you order your Robofocus from Technical Innovations in the States. For some reason, it is *still* a serial port connection for the Robofocus at a time when the computer world seems to have forgotten what a serial port is, and, to make matters worse, U.K. Customs will whack you for Tax on the import. On the plus side, there are Robofocus equivalents for sale within the U.K., but I have no experience of them. As the Robofocus worked perfectly straight out of the box, and had continued to work perfectly for a number of years, I don't feel inclined to try out another system. However, if this is your first venture into autofocusing, you probably should. You can manually focus (electric focuser/manual control) the refractor, but you will get to good focus and therefore start imaging much quicker if you have an autofocuser fitted.

So we have our imaging system accurately polar aligned, and the autoguiding is capable of keeping the guide star within very tight bounds. We are almost ready to begin imaging. Do your 2 star alignment (or whatever alignment routine you use) so that your mount knows where it is pointing the scope, and then go to the object you want to image for the evening.

Take a short 10 to 20 second sub-exposure of the region. Check the object you want to image is there, and that it is centred on the monitor. Now get highly accurately focused on a suitable guide star. Here is where you can hit your first problem because there may not be a decent guide star in your FOV. In that case, you will have to slightly shift your imaging object away from dead centre until you do find a suitable guide star in the frame.

Now make sure you are in good focus and run your autofocus routine. Check at the end of the routine that you actually have a nice small FWHM number for the star you ran the focus routine on. The star must not be too bright or you won't get best focus. You may also have to re-focus maybe an hour into your imaging session if your refractor's focus tends to drift (mine does), otherwise your later slightly out of focus subs will not add (positively) to your initial data and you will need to throw them away. If you are going to have to re-focus after each hour of imaging,

then it makes sense to put the focus star dead center in your FOV, and also to make this star your autoguiding star. It just makes life a lot easier.

Is your CCD camera flat to the focal plane and do you have good collimation? The software you need to check this is CCDInspector and I go into much more detail about this software in the Hyperstar chapter. However, if your CCD camera has a large chip, and also has flatness adjustment screws, then you can take a few subs and using CCDInspector adjust the flatness screws on your camera to get the optical system flat in the X and Y planes as best you can. With a refractor there is not a lot you can do about the collimation (of the refractor) so if you find that you have good chip flatness but the collimation reading from CCDInspector is poor, then the scope will need to be sent off to be expertly collimated. If you have a Sky 90 with the collimation screw adjusters, then you can do this yourself, but it is a pretty tricky process and I would recommend sending it off to a professional. If you have a scope in reasonably good collimation, and you have taken your time to get the CCD chip flat to the focal plane, then you should get a CCDInspector result similar to that seen in Figure 8.1.

There are several things to note in the CCDInspector result. A large number of stars have been analysed to produce this result (1279), so you can therefore be assured that CCDInspector has returned with some pretty accurate numbers. I haven't gotten the camera precisely flat in the X and Y planes, but it is close enough to zero to be unnoticeable in the final image. The Sky 90/M26C combination gives me around 3 arc-seconds per pixel, so 2.2 pixels for the collimation in

Figure 8.1 CCDInspector result for a Sky 90 M26X OSC CCD combination.

the CCDInspector result means around 6 arc-seconds for the collimation. Again, this is small enough to be unnoticeable, but it is always worth the effort, and the time, to do better in setting the camera up at this stage if you can.

You are now ready to start imaging your object for the evening. As you have an autoguider going, then use the "dither" function on your CCD imager software. This moves your mount by a set number of pixels after each sub-exposure so that by using an "outlier rejection" stacking routine on your subs (like SD Mask in Maxim DL) you will get rid of any hot pixels in the stacking process. With your autoguider running and looking good, then set off the imaging camera with the sub-exposure length you have chosen for the evening. Save the subs as FITS format and to the bit length of your camera. Stop imaging after an hour (if necessary) to refocus the scope, and then carry on. If you have a GEM mount, you may come up to the meridian at some point during your imaging and then you will have to carry out a meridian flip. Consult your planetarium program to check what time your object transits the meridian so you can plan out your imaging session accordingly. There is a HUGE amount to think about just to get a few subs down, and unless you have everything planned out and executed precisely, you won't have much of a fun time. Be prepared to have little fun during your first few sessions, but don't be put off. When you have carried out the meridian flip and have the same guide star centred in your FOV, then be aware the image on your monitor is upside down to what it was pre-meridian flip. Accordingly, don't forget to vertical mirror flip all your post meridian flip images before stacking the whole night's sub-exposures together.

Once you have collected the evening's worth of subs and you are ready to shut down, turn off the autoguider and the CCD imager download program and park your scope. Turn off all systems and take all your hard won subs indoors for the image processing part of the procedure.

Chapter 9

Hyperstar III Imaging

Prior to imaging with the new Hyperstar III, I had been imaging with the relatively slow Sky 90 (at f#4.5) and the M25C 6-megapixel OSC CCD. During the year that I was imaging with this combination, I was not really bothered about how slow it was as I was on a year's Sabbatical and I could stay up all night without worrying about going in to the day job. However, my year was coming to an end and I was panicking about what I was going to do with my imaging. Along came a series of good luck. First Starizona brought out the Hyperstar III which would not only cover my M25C CCD chip, but it also came along with collimation and camera rotation adjusters. Perfect! Then out of the blue, the University sent me out to Arizona on business. Arizona means Starizona and the guys at Starizona sent me a Hyperstar III for my C11 SCT as well as their superb autofocuser for the feathertouch focuser I already had on the C11. I got back from Arizona, very jet-lagged, but still wanted to get the Hyperstar set up, which was a bad idea. Even the missus said not to do it, but of course I did not listen. Highly excited, I went out to the observatory, Hyperstar III in hand and tried to fit it in the secondary cell. But it wouldn't fit! I wondered if the Starizona guys had sent me the wrong model of Hyperstar, but quickly discarded the idea. A quick e-mail to Dean at Starizona came back with "Have you taken the protector off the end of the Hyperstar?" After I realized my mistake, I fitted the absolutely beautiful new Hyperstar III lens to the Nexstar C11 GPS and I was ready for business.

So what exactly is this Hyperstar? Your native C11 Schmidt-Cassegrain telescope comes along with an ultra-slow f#10 due to the long focal length. As you know, the light path is very long because light comes in the front, through the corrector plate, to the primary mirror at the back, where it is reflected to the secondary mirror at the front. The secondary mirror at the front then sends the light back though a central hole in the primary mirror to the eyepiece, or imager. This involves

a very long focal length, hence the large f-number. It's great for high resolution imaging of small objects (like small galaxies), but it's also a slow process. Now what happens if you take the secondary mirror out and try and do your imaging there? At this point, I should make it clear that this secondary mirror position is actually prime focus for an SCT, but that is by the by. Imaging at prime focus in this way is the basic idea behind the well-known Schmidt-camera design of telescope. The world famous 48" Samuel Oschin Schmidt telescope http://www.astro.caltech.edu/palomar/about/telescopes/oschin.html is probably the best known Schmidt-Camera on the planet. There is a problem with imaging at the prime focus of an SCT and that is that the wavefront of the light coming up from the primary mirror is curved. In the old Schmidt Cameras where they used film for recording, this curved wavefront was dealt with by mounting the film on a curved plate, basically counteracting the wavefront curvature. But we can't manufacture CCD chips with curved surfaces, and even if we did we would require a different design of chip for each SCT. Starizona produces the Hyperstar series of lenses which are a times one (no magnification) wavefront corrector. The sole job of the Hyperstar lens is to flatten the wavefront to give an undistorted image on the CCD sensor and it does this job extremely well.

So the Hyperstar lens assembly sits in place of the SCT's secondary mirror converting the curved wavefront from the primary mirror into a nice flat wavefront suitable for an imaging CCD chip. But by positioning the Hyperstar at prime focus, we have also significantly cut down the light path (focal length) of the conventional SCT where the eyepiece is at the back end of the scope. In fact, the focal length has been so shortened that the native f#10 instrument now operates at an amazing f#2, a 25 times increase in "speed". If we wish to be pedantic, this speed increase (decrease in subexposure time) is for extended objects only, not point objects like stars where aperture is king. But for all practical purposes, what you will notice with Hyperstar imaging is how fantastically fast it is, and how relatively quick and easy it is to image nebulae.

I have been asked many times "How exactly do you set the HSIII up for imaging? What is your routine for an evening's imaging?" This is where I will address those questions.

The very first thing you must do is make sure your CCD chip is perfectly perpendicular to the incoming light by flattening the chip (not to be confused with "flats" in processing or flat wavefronts). To "flatten" your CCD camera (it must of course have adjustment screws to allow you to do this, or you need to buy an adjustable plate to go on the front of your camera to do the same job), you bounce a laser off the front of the chip and alter the adjustment screws until rotating the camera in its holder gives no movement of the reflected laser spot. This process is difficult to describe but fortunately Starlight Xpress has written up very easy to follow instructions here: http://www.sxccd.com/maintenance_info/Aligning_CCD.pdf I have made two changes to the method they describe. Instead of mounting the CCD on its side, I use a vertical geometry to shine the laser up from the floor to the CCD which is sitting on a table. Secondly, I use a much longer path length for the laser than SX show. In my setup, the distance from the laser to the CCD chip is about a meter. If you now set up the screw adjusters so that the reflected laser spot does not move with a 360 degree rotation of the camera then you will know your CCD chip is flat, and you are ready for the next step.

9 Hyperstar III Imaging

Having flattened your CCD chip, now screw it onto the front face of your HSIII. Your system will look a bit like mine, shown in Figure 9.1, with a couple of differences. As you can see, I have 4 support rods running down from the CCD to the SCT. These support rods are *precisely* at 90 degrees to each other so that they will produce nice 4-pointed diffraction spikes around bright stars. If the rods are not precisely at 90 degrees to one another, then your diffraction spikes will be a bit of a mess. I attached the 4-cables coming out of the CCD to these rods. The four cables are the Power cord, the USB connection (data) to the computer, the cable to the SX autoguider camera, and the autoguider cable which goes to the C11 mount. You might also be able to see that I have an "outer" aperture on the front of the corrector plate. The reason for this is that I think I have a slightly rounded edge to my C11 mirror, so keeping the light away from this rounded edge gives me much better looking stars. If you have a "good" mirror, then you won't need to put this aperture in.

After our camera has been fitted to the front of the HSIII and all electrical cables have been connected, we are ready to start the fairly long process of tuning our system in. Make sure you have managed to get your scope focused and that you have trained your autofocuser. The critical focus zone for the HSIII on the C11 is something like 7-microns, and as the diameter of a human hair is around 70-microns, you can see how precisely you have to alter the focuser to hit good focus. Although I did manage to manually focus the original Hyperstar, and then went on to manually focus (using just the push buttons) on a motorized focuser, I strongly suggest that you don't even think about doing that, but go straight for an autofocuser.

Take your first sub. You need to be imaging in an area where there are plenty of stars, not bright constellation stars, and no nebulae or galaxies. Any nebulosity or galaxies in your sub will throw the CCDInspector results. Any very bright stars which produce ghost flaring in the sub will also throw the CCD inspector results.

Figure 9.1 The Hyperstar III unit sitting in the secondary mirror position on a C11. The camera on the front of the HSIII is a Starlight Xpress M25C.

Go for a nice fairly dim star field, no globular clusters. Unless you are incredibly fortunate your system will be out of collimation and the stars will be a mess (comets at best) in the corner of the field of view. Don't Panic! This is easy to fix now that the HSIII comes along with collimation adjusters. We will now highly collimate the optics, but first we need an invaluable piece of software. You will need to invest in a copy of CCDInspector. You can buy CCDInspector from here http://www.ccdware.com/products/ccdinspector/and basically, if you want to do Hyperstar imaging, you must have this software (actually I have no idea how people manage any type of imaging without it). Nevertheless, you have CCDInspector running and it will tell you that your collimation, either in pixels, or in arc-seconds, is pretty rotten. No matter. We now systematically work our way around the Hyperstar collimation adjuster screws to zero in on perfect collimation. You need a notebook and pen handy for this stage of the process. Move one of the adjusters half a turn, it doesn't matter which adjuster, and note down how the collimation has changed. At this point you have to refocus! Note that as you are going to have to refocus after each collimation adjustment, this is going to be an awful pain unless you have an autofocuser. If your collimation got worse with the adjustment, move the adjuster in the opposite direction by one turn. If your collimation got better, then move again in the same direction, but maybe this time by a quarter of a turn rather than half a turn. By this iterative process, you will minimise the collimation number given in CCDInspector, but it is very unlikely to be near zero. You then have to move onto *another* collimation adjustment screw and go through the same process again. This is why the notebook is vital; you cannot keep your head around how the adjustments of each screw alter the collimation. Once you have adjusted each screw, several times, you will quickly see from your notebook results exactly what you need to do in order to zero in on perfect collimation for your system (perfect collimation is unlikely to be zero in CCDInspector, that will depend on many things on the night, but I have had the magic 0, 0, 0 for chip flatness and collimation on more than one occasion). Please note that even if you do manage to get the magic 0.0 collimation, it is unlikely to stay at that value for the whole imaging run (Figure 9.2).

Although there are only 80 stars measured in the above Figure (that really isn't enough and you should go for more), the region I was imaging in for this was a dusty region with few stars, so I just had to go with it. In other words, this wasn't the main initial collimation setup using CCDInspector results for the first time. This was the result of a little tweaking before an actual imaging run.

So you have good collimation, and good focus. It's time to start imaging. Go to your object for the evening, set it precisely in the frame and then refocus. Set the autoguider going and take your set of subs. If you are imaging for more than an hour, then I suggest you stop imaging at the end of an hour and refocus again, especially if the temperature is dropping rapidly. Remember we've only got 7-microns critical focus and it doesn't take much to shift optical components by a lot more than that during an evening. Figure 9.3 shows you my Very First Light with the Hyperstar III having just set it up in the manner described above.

This is only 50-minutes of total exposure time using the HSIII. Two 10-minute subs and the rest made up using 2-minute subs. Notice what Noel Carboni calls

9 Hyperstar III Imaging

Figure 9.2 Collimation of the Hyperstar III shown in both arc-seconds (left) and pixels (right) using CCDInspector.

Figure 9.3 First Light for the Hyperstar III on the C11 - central NGC7000 - the North America nebula.

"Diamond Dust" stars in this image. All those tiny stars are not only very small, but also perfectly shaped, signs of good collimation. Needless to say, for a First Light image, I was extremely pleased with that result and it was the start of a new love affair with the Hyperstar. The Hyperstar had finally returned to the New Forest Observatory.

It's now time for some imaging fun and to make good use of that impressive Hyperstar speed, so what sub-exposures should you go for? As usual, it depends very much on the object. For dim star fields, 3 to 5 minutes is plenty. For bright nebulae like my First Light North America nebula, 10 minutes seems a pretty good value. For the faint stuff and for dark nebulae, I usually try for 15-minute sub-exposures, and I used these for the Iris nebula you can see in the images section. If 10-minute subs don't sound all that long for the North America nebula, do remember that this is equivalent to 50-minute subs using the reasonably fast f#4.5 Sky 90 refractor. That's the whole point of Hyperstar imaging. It is unbelievably fast and if you have been used to imaging at f-numbers above 5, then you have to do a massive mental recalibration to get used to working with the incredibly fast Hyperstar III.

Chapter 10

Parallel Imaging with an Array

History of the imaging systems at the New Forest Observatory

In order to understand how I arrived at the mini-WASP array design, it is necessary to go right back to the beginning of my imaging history. If you are not interested in the reasoning behind this decision, then just go straight to the next section.

I started off imaging with an original Hyperstar (no collimation adjusters, or camera rotation adjustment) and a tiny little Starlight Xpress 1.4 Megapixel H9C one shot colour (OSC) CCD camera. These optics gave me amazingly fast imaging at f#1.85, and as it was my first imaging system, I didn't realise how easy I had made things for myself by choosing this particular setup. However, this combination of original Hyperstar and H9C gave me a rather small field of view, and I wanted to image bigger areas of sky in a single frame. As I was starting to get frustrated with the small field of view, Starlight Xpress brought out the M25C OSC CCD. Now the M25C really was a step up from the tiny H9C. The M25C had 6-Megapixels, with pixel size 7.8 um square, in a 23.4 × 15.6 mm array, that is an APS-C-size chip (there used to be an Advanced Photo System film of this size). There was only one problem, the M25C sensor was too big for the original Hyperstar to accommodate – the chip diagonal was much bigger than the Hyperstar's focal plane diameter. So to circumvent this issue, I bought a Sky 90 refractor with the f#4.5 reducer/corrector which could adequately cover the M25C's large sensor. This meant that my precious Celestron C11 SCT was now relegated to being used as a simple guide scope, which is not a very satisfactory state of affairs.

Imaging with the Sky 90/M25C was at the same time superb and frustrating. Superb due to the massive field of view of 3.33 × 2.22 degrees and the complete

lack of any ghost flaring from the brighter stars. This meant I could take nice single framers of the main constellation stars and not have to spend ages in the image processing cleaning out all the pesky ghost flares. It was frustrating because imaging at f#4.5 is five times slower than imaging at f#2, and it really did take the Sky 90 five-times longer than the original Hyperstar to get Hyperstar quality images. As a second bonus, the Sky 90/M25C gave an added quality to the deep-sky images that appeared lacking in the Hyperstar/H9C images. I really don't know what the added quality factor was, but whatever it was, I really liked the images the Sky 90/M25C combination produced. However, after a year or so, I really started to get frustrated with all the extra time it was taking me to get high-quality images and I began to miss the speed of the Hyperstar.

At this point a miracle happens. Starizona brings out a new series of Hyperstars with fantastic properties: the same fast f#2 imaging plus an increased focal plane diameter that will cover the M25C sensor and collimation screw adjusters (and also camera rotation adjusters). I can now precisely set up the new Hyperstar III to give perfectly shaped stars, corner to corner, across the large M25C chip. Thank you, Starizona. So Starizona sent me the new Hyperstar III and also their superb autofocus system for the Feathertouch focuser (I already had the focuser itself), and I was back into fast Hyperstar imaging heaven once again. A much bigger FOV, fast imaging, diamond dust stars corner to corner across a big chip – what more could I need? Well, that "magic quality" of the Sky 90/M25C was still missing, plus the fact that the ghost flaring around bright stars using the Hyperstar III was a major pain. So the Hyperstar III/M25C was a perfect nebula/faint object imager, but it was not good for those single bright star images, or for star fields with a number of bright stars, or for the matter nebulae which have bright stars scattered within them. What could I do to get the best of both worlds?

The obvious answer to my problem was to set up a second imaging system with just a Sky 90 and an M25C. But I knew I would eventually be frustrated with the slowness of that combination. I then looked at bigger refractors and even the possibility of making my own 8" folded refractor, but these did not turn out to give me systems that even came close to the performance of the Hyperstar III on the C11. Thinking outside the box, and also knowing about the SuperWASP array for exoplanet searches, the solution came to me. I would build an imaging array to increase the effective speed of the Sky 90 refractors, by using several in parallel, and also get the "magic" image quality from that combination of optics. I was aware that even if I put together five Sky 90s, all imaging the same object, that this would only just match the Hyperstar III/C11 in speed, the Hyperstar III/C11 performance really does take some beating. So I was aware that I was not going to be able to match the Hyperstar III/C11 on a straight point-for-point comparison, but at least I could seriously cut down on the number of "real" imaging hours per object by running several Sky 90s in parallel. This is *not* how the SuperWASP array is run in practice. The eight Canon lenses in the SuperWASP array all have their fields of view slightly overlapping so that together they cover a large area of the sky. In my mini-WASP array, I would have all the refractors imaging the same region of space so that if I have N imaging refractors, then I would get N hours of data on an object per hour of actual imaging time, but only the same field of view as a single refractor.

The Sky 90 imaging array

Figure 10.1 The imaging head of the mini-WASP array at the New Forest Observatory. The head accommodates 3× Sky 90 refractors, a Megrez 80 guide scope, and on the top plate two Canon 200 mm prime lenses for wide field imaging and a finder scope with web cam.

I spent over a year going over many possible designs, and in that year Starlight Xpress came out with a new camera, the 10-Megapixel M26C OSC CCD which having the same sensor size as the 6-Megapixel M25C (APS-C size sensor) was the way for me to go. If the local light pollution had been any worse, then I would have chosen three mono CCDs and three Sky 90s together with H-alpha, OIII and SII filters so that I could get all the narrowband data downloaded at the same time. However, as my skyglow remained reasonable with the coming of the white light LED streetlights, I decided to stick with the basic setup I have most experience with and kept with the OSC CCDs. This meant I had 3× Sky 90s each with their own M26C OSC CCDs, and a Megrez 80 mm guide scope with a Starlight Xpress guide camera for autoguiding. All four scopes were mounted in an all Aluminium frame I designed for the purpose and the arrangement is shown in Figure 10.1.

So that is the long history (2004 - 2012) behind the creation of the dual imaging systems of the Hyperstar III/C11 and the mini-WASP array.

The Sky 90 imaging array

Given the 24-inch aperture size of the 2.2 m Pulsar glass fibre observatory dome I wanted to install in the garden, I was limited to a maximum of four refractors on the imaging head. Since one refractor was supposed to be used as a guide scope that meant I only had three imaging reactors for my parallel imaging array.

The imaging head of the mini-WASP array is custom designed from thick Aluminium plate and it houses:

1) Sky 90(1) with filter-wheel and an M26C OSC CCD.
2) Sky 90(2) with filter-wheel and an M26C OSC CCD.
3) Sky 90(3) with an M26C OSC CCD.
4) Megrez 80 guide scope with Starlight Xpress guide camera.
5) Canon 200 mm prime lens(1) and a Trius M26C OSC CCD (top plate).
6) Canon 200 mm prime lens(2) and a Trius M26C OSC CCD (top plate).
7) Finder scope plus web cam (top plate)

The Canon EF 200 mm f#2.8 prime lens wide field imagers, and how they got incorporated into the mini-WASP array will be discussed in the next section.

With over 100 pounds of kit sitting in or on the imaging head, a very substantial mount is required to move and guide that lot across the sky. At the time of putting the rig together, there was only one possible contender: the Paramount ME which is what I ended up buying for the job.

I designed the physical size of the imaging head to fit the 24-inch aperture of the Pulsar 2.2 m dome. The refractors are held firmly in place by three adjuster bolts at both ends of the refractor, with nylon protection heads on the bolts. There is no need for lock nuts on the adjusters as I have made one-hour long exposures with no sign of any flexure. The original design was for $3\times$ Sky 90s only, not for the 2×200 mm Canon lenses on the top. What this means in practice is that the dome aperture is not wide enough to allow both Sky 90 and 200 mm lens imaging at the same time. Each has to be run as an independent system. As the Pulsar 2.2 m dome is much lighter and much easier to move than the Hyperstar 7 foot dome, an automatic dome rotation system has also been fitted. Driven by stepper motors, and Tom How designed electronics and software, the automatic dome rotator keeps the maximum effective width of the aperture in front of the imaging array at all times. Tom How also included an extra bolt-on goody into the design: an electronic compass. The dome position is checked against the electronic compass reading to make sure it is precisely in the right place. I take great delight in pushing the dome a little off the set position and then watching it step back to the correct position. Closing the control loop in this way is a brilliant innovation in dome control, so if you want to implement this in your own design, then contact Tom How to see how it is done.

In the mini-WASP observatory there is one computer per imaging CCD, so five computers in all: 3 for the Sky 90s and 2 for the Canon EF 200 mm prime lenses. All five computers can be controlled from indoors, but the maximum number of mini-WASP computers that are required to run during any imaging session is 3, for the three Sky 90s. If I am running the 3 Sky 90s in the north dome, and the Hyperstar III in the south dome, then I need to control a maximum of four computers from indoors, and that is why I have a four monitor system in the study.

If you look at the back of the imaging head, it looks a bit of a mess with the wiring from the cameras with all the wires hanging loose at the back as can be seen in Figure 10.2

The Sky 90 imaging array

Figure 10.2 Rear-view of the mini-WASP array imaging head.

The reason the cables to the CCDs have been left loose is because the power to the M26C cameras' Peltier coolers, which comes from a switch mode power supply, comes down these cables. Tying all the CCD cables together leads to unacceptable cross-talk noise due to the high-current pulses feeding the Peltier coolers. As a result, sometimes keeping your cables neat and tidied up is not a good idea.

Three Sky 90s operating in parallel allows me to capture three hours of deep-sky object data in just one hour of actual imaging time. So for a typical 3-hour imaging session, I am able to capture 9-hours of actual data. From my earlier work with the single Sky 90/M25C, I knew that I could get a very good quality image using something exceeding 8-hours of good data. Using 3 Sky 90s in parallel meant I could get the sort of high-quality image I want in just a single evening, which was the major point of the whole exercise of course.

The 3 Sky 90s taken together as a single imaging system are equivalent to a 150 mm (6-inch) refractor operating at f#2.6, which is quite a beast. The field of view of the mini-WASP array using the 10-Megapixel M26C CCDs (APS-C size sensor) is a highly respectable 3.33×2.22 degrees.

Setting up for an evening's imaging using the three Sky 90s follows much the same procedure as given in Chapter 8. The CCDInspector result is of course identical to that shown in Chapter 8 as the result is for a Sky 90/M26 combination. With the Megrez guide scope locked onto a suitable guide star it's simply a matter of collecting the subs, at three times the rate of using a single Sky 90/M26C.

As I mentioned earlier, the idea for the mini-WASP parallel imaging array came from the original SuperWASP concept. I was surprised to see that only just recently the basic idea had surfaced yet again, in a slightly different guise, this time as the Dragonfly Telephoto Array built by astronomers at Yale University and the University of Toronto. The Dragonfly Array uses ten Canon 400 mm f#2.8 IS (Image Stabilised) USM (UltraSonic Motor) DSLR lenses together with SBIG 8300 CCD cameras. The Dragonfly imaging array has been optimised for the detection of very low brightness structures in the haloes of galaxies, and the system taken as a whole is the equivalent of a 0.4 metre f#1.0 refractor with a 2.6×1.9 degree field of view.

If you are considering going down the parallel imaging route, I highly recommend that you read and thoroughly digest the paper written by Pieter van Dokkum of Yale, and Toronto's Roberto Abraham about the Dragonfly Array which can be found at http://arxiv.org/pdf/1401.5473v1.pdf, as it covers everything you need to know about putting your own parallel imaging array together.

The Canon EF 200 mm f#2.8 prime lens imagers on the mini-WASP array

Where can you purchase a 200 mm f#2.8 wide-field refractor with a focal plane diameter that will comfortably cover a 35 mm sensor? Include in the specification that the refractor focus does not change when left unused for weeks on end, even when the environment has undergone temperature changes of over 10C between day and night. After weeks of neglect you can just turn your system on and start imaging without first having to run a focus routine. And finally, where can you buy such a refractor for only £569? You will know that it is impossible to buy a refractor with those impressive specs for that sort of money, but what you can do is buy the Canon 200 mm f#2.8 prime lens, and those are the highly impressive specs that this lens will provide.

There was also some history to the use of the Canon 200 mm lenses before they were finally attached to the mini-WASP array. When I purchased the first lens, I had no idea whether it would be suitable for deep-sky imaging, or not. Using DSLR lenses in the past I have had very mixed results. So my initial setup was the Canon 200 mm lens fitted to a Canon 5D MkII DSLR and I piggy-backed the lot on the poor C11/Hyperstar III rig. The Canon 5D MkII DSLR was connected to the south dome PC using Canon Remote View software and this made the control of the 5D MkII for deep-sky imaging very easy indeed. Putting the Live View image up on the PC monitor with a bright star centralised on the camera chip and zooming in to 10× it was very simple indeed to manually focus the DSLR by getting the smallest star size on the monitor. With a Hutech IDAS LP filter on the front of the 200 mm lens I set up the exposure time using the Canon Remote software, and with the autoguider running, it was all ready to go. With the lens set to f#4 it was just a case of firing off the subs using the Canon Remote software. I also ran the dither routine with the autoguider at the same time and this was easily accommodated by making the imaging time on the autoguider a minute or two longer than the sub-exposure time on the DSLR, and then setting everything off manually. I was truly staggered at the first light results from this very simple system. At f#4, the star shapes were perfect corner to corner across the massive 35 mm sensor of the 5D MkII. The star colour needed some tweaking in Photoshop because the camera was unmodified, and this also meant the rig was not too good for imaging emission nebulae. However, the massive 10×6.8 degree field of view was jaw-dropping, and even though the sampling was only 6.54 arcseconds per pixel, the images produced did not seem to suffer too much in terms of perceived resolution. You can see a couple of images taken using the Canon EF 200 mm lens on the 5D MkII in Chapter 13.

All this sounds far too good to be true, so are there any problems in imaging with a standard DSLR lens? There were two things I wasn't too happy with, one I could sort out, and another I couldn't. Working at f#4 on the native f#2.8 lens means you are going to aperture down the lens a touch. Apart from making the lens a little slower, you will also get 8-pointed diffraction spikes (from the lens iris) around the brighter stars, and I personally did not like the look of those at all. Secondly, there was ghost flaring from the brighter stars in the frame, this is hardly surprising given the amount of glass Canon has managed to squeeze into the lens, but the ghost flaring was significant. Now, this is where the Takahashi Sky 90 really comes into its own. The Sky 90 doesn't give *any* ghost flaring even when imaging the brightest star in the sky, Sirius. There is of course a lot less glass in the Sky 90 than the Canon 200 mm lens, so maybe this is not too surprising. The Canon 200 mm lens does not excel at everything a high quality refractor does, but then given the price, it would be very surprising if it did.

I took some massive star field images with the Canon EF 200 mm/5D MkII combination, a few of which you can see in Chapter 13, but I was unhappy with the poor colour response of the un-modified 5D MkII. It was now time to get a proper astronomical CCD on the back of that superb lens.

Geoptik produce a beautifully made Canon EOS lens to SX CCD adapter which is perfect for the job, and I also had a Starlight Xpress Trius M26C 10-Megapixel OSC CCD to hand as well. A spacer is needed on the CCD side of the Geoptik adapter to put the CCD sensor the correct distance behind the 200 mm lens. For my imaging rig, the "correct" spacer size should be 8 mm, but I used a 7.5 mm spacer instead. The reason for doing this was that a shorter spacer gave me some extra focusing distance at the infinity end of the 200 mm lens. In other words, the actual "true" infinity focusing of the lens to the CCD was at an indicated position (on the lens) less than the actual infinity position. This gives me some adjustment of the lens focus "beyond infinity," which I need to have in order to produce a nice symmetrical V-curve when using the FocusMax software during autofocusing.

The Trius M26C did not give me the luxury of Live View that the 5D MkII did, so I had to fit a drive-belt autofocuser to the lens. Tom How of the Curdridge Observatory built the electronics box, and wrote the software to drive a Radiospares stepper motor which in turn drove the belt-drive attached to the EF 200 mm lens. The electronics box talked to the FocusMax focusing software and the system was able to automatically focus the Canon EF 200 mm in just over a minute.

The next thing I needed to sort out was the 8-pointed diffraction spikes around bright stars. There is a straightforward way of getting rid of the diffraction spikes from DSLR lenses: you open the lens right up to f#2.8 and then you place a circular aperture over the front of the lens of the right diameter. I did some experimenting over a few nights to find out what would be the best aperture size for the job. The first night I tried no aperture at all, so native f#2.8 imaging with no filter on the front of the lens either. This turned out to be a failure for two reasons. Firstly, there were very poor stars shapes (as expected) especially towards the corners of the CCD where star shapes actually became triangular. Secondly, no filter meant both infrared and ultraviolet light could get through to the CCD sensor and this led to a

huge amount of star "bloating". So if I was going to use a circular front aperture to get rid of the diffraction spikes, then the circular front aperture needed to be either a Hutech IDAS LP filter, or a UV/IR cut filter. I purchased both a 62 mm and a 52 mm UV/IR cut filter for the second part of the experiment. The 62 mm filter gave me f#3.22 imaging while the 52 mm filter provided me with f#3.85 imaging. The next clear night, I ran the EF 200 mm lens with the 62 mm filter, with the lens open at f#2.8, and although the star shapes were much improved over f#2.8 imaging, they will still getting pretty poor in shape towards the far corners of the sensor. That was a pity as f#3.22 imaging is pretty quick and quite a bit faster than the Sky 90 at f#4.5. So on the next clear night (these experiments cost me a lot of good imaging time as you can see), I tried the 52 mm diameter UV/IR cut filter which gave me f#3.85 imaging. This time, I got perfect star shapes from corner to corner across the M26C, and of course, no diffraction spikes at all. Success! In Chapter 13, Figure 13.43 shows the first light taken with this rig. It is a single frame of the Tarazed region with the dark nebula Barnard's "E" in the centre of the field of view. Perversely, having gone to all the trouble of removing the 8-diffraction spikes from the 200 mm lens aperture, I have instead added 4-diffraction spikes using Noel Carboni's Star Spike actions.

It was now time to remove the EF200mm imaging train from the C11 and fit it to the top plate of the mini-WASP array, but there was one last, but very important thing to check. As I could only image *either* with the 3× Sky 90s *or* with the EF200mm lens (and not both together), I needed to check that my overall imaging speed would not be severely slugged by the performance of a single EF 200 mm lens. Imaging with 3× Sky 90s in parallel gives me an effective f#2.6 imaging system. However, a single EF200mm lens with 52 mm diameter filter gives me f#3.85 imaging, which is too slow. 2× EF200mm lenses working in parallel gives me an effective f-number of f#2.7 – almost identical to the 3× Sky 90s - problem solved. So I bought another Canon EF 200 mm prime lens, another Trius M26C OSC CCD, and Tom How made me up yet another automatic focusing box. The twin EF200mm imaging array was fitted to the top plate of the mini-WASP imaging head and you can see the result in Figure 10.3.

As I discussed in the Hyperstar Imaging chapter, I use CCDInspector to check that my CCD cameras are flat to the imaging plane. I have no collimation adjustment on the EF200mm lenses, but I can tweak the M26C flatness adjustment screws to get the cameras as flat as possible. Figure 10.4 shows the CCDInspector screen for an EF200mm/M26C combination with the camera nicely flattened.

First light for the twin EF200mm/Trius M26C rig on the mini-WASP array was an ambitious 2-frame mosaic of the Virgo/Coma region which contains 13 Messier objects and can be seen in Figure 13.44 in Chapter 13. I typically use 10-minute subs with the twin EF200mm lenses, and I try for at least 20 subs per frame in an imaging session. Note that this only requires 100-minutes of actual imaging time.

To summarise, the Canon EF200mm f#2.8 lens when stopped down to f#3.85 provides a very high performance wide-field imager with perfect star shapes corner-to-corner across a full 35 mm sensor, and at a price that is simply unbeatable.

The Canon EF 200 mm f#2.8 prime lens imagers on the mini-WASP array 83

Figure 10.3 The twin EF200mm lenses with Trius M26C OSC CCDs and autofocusers fitted to the top plate of the mini-WASP array head.

Figure 10.4 CCDInspector result for an M26C perfectly flattened to the EF200mm lens. Notice the magic 0, 0, 0 result. Perfectly flat in the X and Y planes, and perfect collimation. No wonder this is such a powerful wide-field imaging system.

Chapter 11

Fundamentals of Image Processing

The image processing side of things is far more fluid than data acquisition. This is because the mechanics of data acquisition are relatively well-defined and understood – you can write down a sequence for taking a night's images and that sequence will last you a good many years before you need to make any changes. This is not true with image processing. The number one thing you must get in your head is that where image processing is concerned, every image you take is unique and it must be processed a specific way. Yes, overall there are steps you will follow and that I will show you in this chapter, but don't think that you can write down a series of steps for image processing. If you are inflexible in your approach to processing data, you will not end up with the best image.

The two examples I am going to show in this chapter are a star field and a large nebula. The processing steps are similar, and it's only in the fine detail that they differ at all. For the star field, I am going to process the V1331 Cygni region, which has a mass of stars, some tiny bits of emission nebulosity, and a fair bit of dark nebulosity. The large nebula I will be processing is the California nebula as this takes up most of the field of view of the Sky 90/M26C combination. At the end of the chapter, I will give you a quick demonstration of what Registar can do for you.

Very first step: sift the data

You have downloaded all your very hard won subs in a file and the first thing you need to do is check the quality of each and every sub. If you stack even one poor quality sub in a total of 50 subs, you will *clearly* see the detrimental effect of that single sub in the final result, so get rid of it before you even start. I know this is an

extreme pain if your subs are 15-minutes or even longer, but it will lead to a better final image quality. Don't worry too much about satellite trails, an outlier rejection stacking algorithm like SD Mask mostly takes care of them, although you will still see traces of them if you aggressively use curves in your process. What about a plane, lights blazing, is crossing your image? Well, again, the outlier rejection algorithm will do its best, but if the plane is right across the middle of your image (they usually are) then it's best to simply cry into your beer and delete the sub. Bournemouth airport uses Brockenhurst as their main flight path, so I frequently cry into my beer. Since I use a one-shot colour CCD, all the processing below is based on RGB one shot data. I have already taken a set of (artificial) flats and bias frames for the appropriate scope/camera combination, so I use the Maxim DL calibration process for applying the flats and the bias frames to the (sifted) RAW FITS data. I have never taken a dark, ever. After calibration, you can then de-Bayer the subs (again using Maxim) to get the RGB FITS subs ready for further processing.

Processing a star field

Starting with the V1331 data – using Maxim DL, I downloaded 15 × 10-minute subs and 14 × 15-minute subs of the region over two nights. In total, this data comprises 6 and a quarter hours of RGB data taken with the M26C 10-Megapixel OSC CCD. The subs were sifted, calibrated and de-Bayered as discussed above and then the individual subs were saved as FIT files using Maxim DL. I dither all my data so that by using an outlier rejection algorithm for stacking, all the hot pixels miraculously disappear.

The first step in the process is to stack the 29 sifted, calibrated and de-Bayered sub-exposures together. In Maxim DL, I use the "manual 2-star" align procedure to do this, which I will explain step by step. Having loaded all your subs into Maxim and then moved onto 2-star align, highlight the first sub in the group and note that the image appears on screen. If you move the cursor over the image, you will see cross hairs for aligning your two alignment stars. Pick a star near one edge of the field of view that is not too bright, and if possible, that is not too close to many other stars so it will be easy to pick out on all the subs. Center the star in the cursor and left click. Maxim will then move onto the next sub where you will need to centre the star in the cursor and left click again. Proceed in this way until you have gone through all the subs you have taken, in my case, there are 29 subs in V1331. The cursor will now have a number 2 next to it showing that you now need to pick a second alignment star. Move to the other edge of your field of view, pick a suitable star, and then centre that star in the cursor and left click through all the subs again. Maxim now knows how to stack all the subs together. For the final part of the stacking procedure, you now choose your stacking method. Click on the "Combine" tab and then choose SD Mask, and then click "Go". Maxim DL goes away and it statistically combines all your subs together and all your hot pixels magically disappear in the process. You now have a stacked set of all your subs in

Processing a star field

Figure 11.1 The Maxim DL stacked and DD filtered set of 29 sub-exposures of the V1331 region in Cygnus.

a single FIT file. At this point, I perform one last step in Maxim DL because it makes later processing easier. I run the "Digital Development Filter". Choose the "Kernel - User Filter" and the 3×3 "Kernel Size" and enter a 1 in the centre box of the 3×3 matrix. Click "OK" to run the filter and save the resulting file as a 16-bit TIF file to work on in Photoshop. Figure 11.1 shows you what the image should look like after these steps.

Open your TIF image in Photoshop and crop any "mess" off around the very edge. If you have dithered the subs then there will be a few pixels around the edge where things have gotten messy, and you need to get rid of these by cropping the edges off. You may now need to "flatten" the image, which basically means removing any gradients, such as light pollution from the moon that may be present. If you have Photoshop skills, it is quite possible to do this using the image itself (if it is a star field image) by creating your own "flat". As I am not a Photoshop expert and I much prefer one-click processing, I use Russ Croman's Gradient Xterminator at http://www.rc-astro.com/resources/GradientXTerminator/to do the job for me. Next, I brighten up and contrast the image a bit. To brighten the image, I go into "Curves", grab the mid-point of the Curves line and pull it up a little, and then I apply the Curve. Now, the black point on your histogram (the left hand side of the X-axis) is a little too far to the right, so grab the Curve at the very bottom left hand edge and drag it along the X-axis, to the right, and stop before the histogram (of your data) takes off vertically. You may see some black histogram points on the

Figure 11.2 The working Photoshop screen showing in the centre the form of the Histogram at this point.

X-axis to the left of where the histogram takes off, and it's there that you should place the bottom of the Curve's black point. Accept the curve and go through the same routine again, until the overall exposure looks "right" to your eye. I try to aim for RGB values of (33, 33, 33) in the four corners of the image at this stage. In order to see the RGB values, move from the Histogram view in Photoshop to the Info view, and then put the cursor into the four corners of your image to see the RGB values. At this stage of the process, your histogram should look something like Figure 11.2.

And your image should look similar to Figure 11.3.

I now start to make use of Noel Carboni's Astronomy Actions for Photoshop http://www.prodigitalsoftware.com/Astronomy_Tools_For_Full_Version.html. I start off with "Make stars smaller", since long exposures with the Sky 90 causes the stars to bloat a little. If the background dark areas look a little noisy, I run "Deep Space Noise Reduction" followed by "Local Contrast Enhancement". As there are some faint nebula regions in this particular image, I use "Enhance DSO and Reduce Stars" to further bring out the HII regions, and to enhance the dark nebulosity a bit more. Finally, by increasing the saturation to 25 in Photoshop, the star color improves a little, as shown in Figure 11.4.

At this very last stage of the process, you may want to use Noel Carboni's Star Spikes Pro 4 plug in to add diffraction spikes and other effects (like the Akira Fujii effect) to the brighter stars. In the Akira Fujii effect, what we do is essentially bloat the brighter stars (having taken a great deal of effort not to do this previously in the processing) whilst leaving the smaller stars untouched. This processing step does

Processing a star field

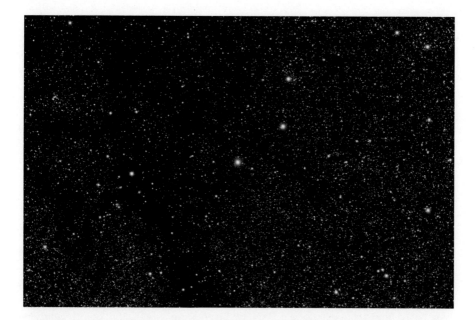

Figure 11.3 The data after cropping, flattening and use of Curves.

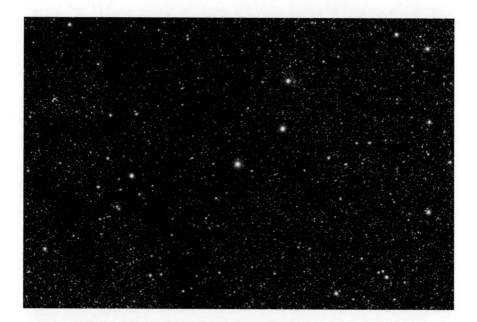

Figure 11.4 The final image prior to any addition of Star Spikes, or Akira Fujii effects.

lead to a rather pleasant image of things like constellations, where the brighter constellation stars stand out much more clearly against the starry background. For an example of the Akira Fujii effect in action, check out Figure 13.8 showing the whole of central Delphinus. Like most "add on" effects, it's either something you like, or something you don't, and it's entirely up to you whether you include it in your overall process.

Processing a nebula

The second image I want to look at is some Sky 90/M26C data of the California nebula. This data comprises 69 sifted, calibrated and de-Bayered sub-exposures for a total exposure time of 22 hours using the mini-WASP array over three nights. In Figure 11.5, you can see the image after pre-processing in Maxim DL following *exactly* the same steps as we used for the star field in the above example.

As before, the first step in processing any image is to flatten it properly, and I use Gradient Xterminator for doing this. For the case where you have nebulosity, you lasso the nebula and then "Select Inverse" in Photoshop before applying

Figure 11.5 The California nebula after stacking in Maxim DL and applying the Digital Development Filter. This image is also (rather heavily) cropped around the edge as this is from 3 night's data and I didn't re-align the scope to precisely the same point in space each night.

Figure 11.6 The image after flattening using Gradient Xterminator.

Gradient Xterminator. Follow Russ's instructions to the letter on how to flatten an image where there is a lot of nebulosity present. Figure 11.6 shows the California nebula data after flattening using Gradient Xterminator.

From the flattened image it took quite a bit of work to get the best out of this one. I first ran Noel's "Make Stars Smaller" and then applied some curves (in the same way as they were applied in the star field image) to brighten up the nebula and also to add in some contrast. I then ran Noel's "Enhance DSO and Reduce Stars" to bring out even more of the faint regions of the nebula. The image appeared to be lacking in contrast, so I ran "Local Contrast Enhancement", and finally to brighten up the star colour (and nebulosity) a bit, I upped the saturation in Photoshop to 25. There also appeared to be some unwanted greenish tints in this image, so I ran Rogelio's "Hasta la Vista Green" plugin http://www.deepskycolors.com/tools.html and that cleared things up very nicely. I should point out that the HLVG plugin is used as part of the process *every time* when I process data from the Canon 200 mm lenses. So after about half an hour of applying Noel's Actions and Rogelio's plugin, I finally ended up with a result in Figure 11.7.

I just noticed that I also removed a couple of faint satellite trails that didn't seem to be dealt with properly by the SD Mask stacking. This is done by running the "Burn" tool in Photoshop along the trail. Use a hard brush at around 2% with a brush width that just covers the trail. Shift click the Burn tool on either end of the trail and watch it disappear.

Figure 11.7 A fully-processed California nebula using Noel's Astronomy Actions for Photoshop and Rogelio's "Hasta la Vista Green" plugin.

Creating a mosaic

You can create a mosaic using Maxim DL, but nowadays, I only use Registar by Auriga Imaging at https://www.aurigaimaging.com/ for forming mosaics, and for combining data from different sources. Registar is pure magic! Take a look at Figure 13.24 in the pretty pictures chapter. This is a 4-frame mosaic of the Kemble's Cascade region in Camelopardalis. Each individual (overlapping) frame was taken with the Sky 90/M26C mini-WASP array, and processed exactly as given in the above processing schedule for star fields. I took some care to make sure the overall background brightness was the same in all frames so that the calibration process in Registar didn't work too hard to match the individual frames. I then simply used Registar to first stitch the top pair of frames together, stitch the bottom pair of frames together, and then finally stitch the two pairs of frames together. It did the process seamlessly as you can see in the final result.

But Registar is far more powerful than that. Using Registar, you can combine data from different sources, and that includes systems of different focal length. Registar will scan and re-scale the data so that it all fits perfectly together. This is an incredibly powerful and useful piece of software, and the latest version of Registar works in 64-bit as well, which makes it even more invaluable.

Creating a mosaic 93

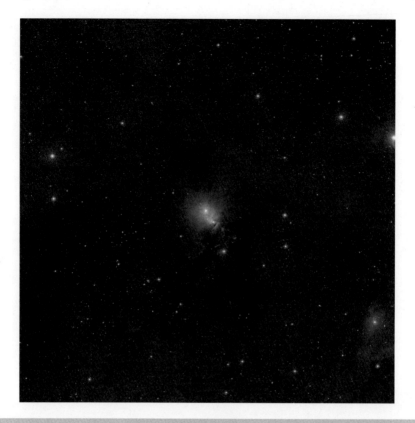

Figure 11.8 The NGC1333 region from DSS2 processed data (artificial green channel).

Here's an example of how you can combine your own data with DSS2 data (please see Chapter 12 on how you process professional deep-sky survey data) to produce stunning images. In Figure 11.8, you can see some DSS2 data of the NGC1333 region I processed using the techniques discussed in Chapter 12.

The image is nice and deep, but somewhat lacking in sparkle with a noisy background. I had previously taken a lot of Hyperstar data of this same region which had nicer color, and a lot less noise, as there were many subs in the stacked Hyperstar data. So now it's simply a case of opening up the DSS2 data and the Hyperstar III data in Registar and letting Registar combining the information. Figure 11.9 shows what can be achieved by using this approach.

Although it might be tempting to use this technique to create your own spectacular images, it is not advisable to post it up as your own work. It is also a definite no-no with regards to entering such composite images into a competition.

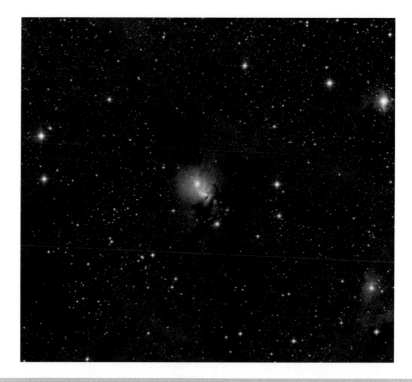

Figure 11.9 A composite image of NGC1333 using DSS2 data and Hyperstar III data combined together using Registar.

Chapter 12

Processing Professional Data

Today, we can create beautiful deep-sky images without capturing a single photon of our own. Some professional observatories put their data online and allow people to access it for free. So all we need to do in order to create our own professional-quality deep-sky images is download this freely available data and then process it for ourselves. However, this puts us in a very difficult position. Why should we spend our hard-earned money and put in hundreds of hours of blood, sweat and tears to get our own imaging system together, if we can produce the pretty pictures without collecting the photons ourselves? After reading this chapter, a few people who had initially thought about building their own imaging system, will be able to bypass this step and simply use freely-available professional data. They would be showing a great deal more common sense than I have.

On the other hand, there is a lot of satisfaction to be gained from putting together your own imager, dealing with the myriad of problems it throws at you, and ultimately downloading your own hard-won data to make your own, highly personalized images. You will find that when you get good at imaging, and processing, you can actually produce pretty pictures of some objects that turn out ***better*** using your own data rather than the online Deep-Sky Survey (DSS) data from professional telescopes. It is hard to beat DSS data, but you can do it, because you can put a ***lot more exposure time*** into imaging the object than the DSS data has acquired. You cannot, however, beat the quality of Hubble data. But the Hubble has not covered the whole sky, so not every object is available for you to process from raw Hubble data. It is perhaps satisfying to know that if you put enough time and effort into processing DSS2 data, you can do better using your own imaging system.

Our first port of call is a site where we can download FITS data for processing. I use the SkyView Query Form found at http://skyview.gsfc.nasa.gov/current/cgi/

query.pl on the "SkyView: The Internet's Virtual Telescope" site. You can see the layout of the form in Fig. 12.1.

As you can see from the form, there are many different datasets you can download, and I haven't even begun to look at the possibilities of what can be created from these. All I do is download red and blue data channels and work on those to produce pretty pictures, but as you can see, you can also download infrared, ultraviolet and even X-ray data that you could incorporate into your image. In this chapter, I will show you how to put together a 2-frame mosaic of the Bubble nebula region in Cepheus. Why a 2-frame mosaic? Because this can be used as a basic template you can then add more frames to and put together a mosaic as big as your computer memory will allow.

First off, you will need to fill in the "Coordinates or Source" box. This box is flexible with what you input, including the R.A. and DEC of the object, the Messier or NGC classification, and even the common name. Try various options to see what the program recognizes. As I am usually working from a planetarium program, it is easier for me to get the coordinates from the planetarium program (the Sky 6) and put those into the "Coordinates or Source" box. You could also get the object coordinates from the free planetarium program Sky-Map at www.sky-map.org. Now as we are going to make a pretty (true colour) picture we go to the DSS box and we highlight DSS2 red, and DSS2 blue. When we come to downloading this DSS2 data we will be downloading red and blue FITS channels. I will discuss the green channel needed to make a true color RGB image later. For now, scroll down near the bottom of the Sky View query form and go to the box that asks you for the image size (in pixels) you want to download as a FITS file. You can try out different pixel widths (and heights as it downloads square FOVs) here, but I am often trying to process big nebulae so I usually select the biggest size the site will allow me to download which is around 6,500 × 6,500 pixels. Once you have selected your settings, click on "Submit Request" and Sky View will download the two FITS channels you have chosen to your monitor. Note that at this stage it ***does not*** download the FITS data itself. When both the red and blue channel images have completely downloaded, move to the bottom of each image and click on "Download FITS file" and save the files for processing later.

We have now downloaded four FITS files of the Bubble nebula region, a red and a green channel file for one frame, and the same for the second frame, what do we do now? We want to combine the colour channels in Photoshop, but Photoshop doesn't understand the FITS format, fortunately the FITS Liberator program does. To open and pre-process (stretch) the FITS files, I use the ESA/ESO/NASA FITS Liberator program at http://www.spacetelescope.org/projects/fits_liberator/but not the latest stand-alone version 3 that you will see on the site. I use the earlier version 2 which sits inside Photoshop and which is more convenient to apply when using Noel Carboni's Astronomy Actions. You can use the standalone version of FITS Liberator for what follows, but I will run through the rest of the process here using the version that is embedded in Photoshop.

Open Photoshop and with the latest version of Noel Carboni's Astronomy Tools open in the "Actions" window, click on "Construct RGB Image from Channel Files". You will be asked for the first file to open which will be the DSS2 red

12 Processing Professional Data

Figure 12.1 The SkyView query form which you need to fill in appropriately to download the FITS data for the object you wish to process into a high-quality deep-sky image.

Figure 12.2 The FITS Liberator interface window.

channel data file for the first frame. Noel's Actions will then fire up FITS Liberator and you will see your red channel data displayed in the FITS Liberator window, in black and white, as shown in Figure 12.2.

At first sight, the FITS Liberator window looks complicated and scary, but if you follow the settings I use you shouldn't have too much trouble. I work in 16-bit mode (depending on your computer system and your version of Photoshop, you may want to work to a different bit depth), and I use the ArcSinh (ArcSinh(x)) stretching function, again this is an area where you might want to experiment with the other stretching functions provided by FITS Liberator. Note the black level and white level markers will not be as shown in Figure 12.2, but are likely to be somewhere at the ends of the histogram. First, move the black level marker to where the data comes crashing down to the x-axis on the left hand side of the histogram, and then click on the update button located on the right hand side of the "Background Level" box, this will update the value shown in the box. Similarly, move the white level marker to the far right of the histogram and hit the "Peak Level" update button. Using DSS2 data, I have found that a "Scaled Peak" value of 10.00 produces acceptable results, but you should still experiment with other values to see what works best for you. You are now ready for FITS Liberator to do its thing so hit the "O.K." button. Noel's Actions go off and do some work for a few seconds and the program comes back with the red channel data being shown in its own window and there is now a prompt for you to select the file containing the green channel data.

Figure 12.3 Blue DSS2 channel data entered into the Green FITS channel as asked for by Noel Carboni's Actions. Note the level pointers haven't been adjusted yet so we see "black clipping" in this Figure.

Since we don't have any green channel data, the SkyView DSS2 data does not provide us with a green channel, so instead we click on the file containing the blue channel data. FITS Liberator opens the file up and we see the blue channel data file shown in black and white in the FITS Liberator window, and once again we have to set and update the black and white levels for this new dataset (Figure 12.3).

With the black and white levels set correctly, hit "O.K." again and wait a few seconds while Noel's Actions go to work. A new window will pop up, this time showing the combined red and green data (where the "green" is actually our DSS2 blue dataset) and you will be prompted to enter the blue channel dataset. This time you click on the DSS2 blue channel datafile (again) and FITS Liberator will open up the file (again) and show it as a black and white image in its own window. As you have already set the levels for this data, you just hit "O.K." at this point. When the processing is finished, you will see your full colour image displayed in its own window as seen in Figure 12.4 and also a box as shown in Figure 12.5 with three settings including, the gamma setting, which will be set at 0.67. In my processing, I set the gamma to 1.0 and then click "O.K." You will then be left with an RBB colour image of your DSS2 data which already looks fairly close to the "real" thing, and a final "Levels" window (Figure 12.6) with a histogram of your image for which you just click "O.K.".

On your monitor, you should now see an RBB DSS2 image (Figure 12.4) displayed which looks quite close to a reasonable RGB image, but the H-alpha regions have that Salmon pink colour typical for an object that doesn't have the colour bal-

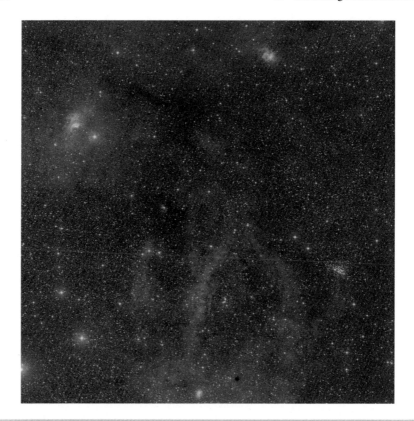

Figure 12.4 The RBB image created using Noel's Photoshop Actions

Figure 12.5 Setting the Gamma Correction

ance properly sorted. The final step in creating an RGB equivalent image is to now hit "Synthesise Green Channel from Red and Blue" in Noel's Actions. Again, a levels box will come up, just hit "O.K." again, and you will finally be left with your RGB colour image, the G being provided by a synthetic green channel, Figure 12.7.

Figure 12.6 The Levels setting window

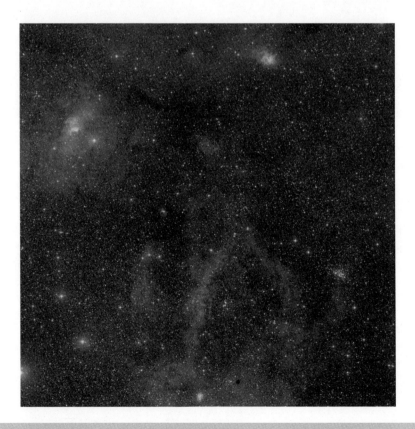

Figure 12.7 R synthG B image from DSS2 FITS data

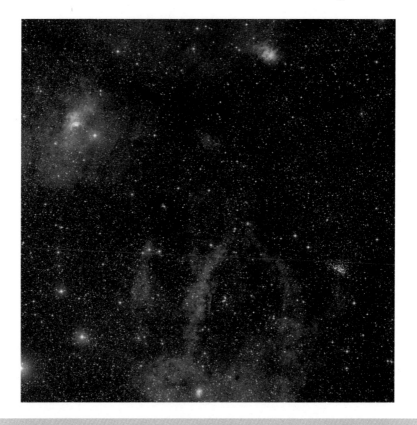

Figure 12.8 Darker/Normal/Bold contrast setting in Paint Shop Pro

The following few steps can be carried out in Photoshop, but I am a great fan of "one-click" image processing, so at this stage I take the R synthG B image into Paint Shop Pro which has a few very powerful and very useful processing functions. Under "Effects" and then "Enhance Photo" we have "Automatic Contrast Enhancement" and "Automatic Saturation Enhancement". In "Automatic Contrast Enhancement," I usually choose the "Darker," "Normal" and "Bold" settings, which give the result seen in Figure 12.8.

I then set the "More Colourful" and "Strong" settings under "Automatic Saturation Enhancement" to produce the image seen in Figure 12.9.

Although the DSS2 data has very nice spikes, another step you might want to take is to bring the image back into Photoshop and add some artificial star spikes of your own using Noel Carboni's "Star Spikes Pro4" software. A spike modified image is shown in Figure 12.10.

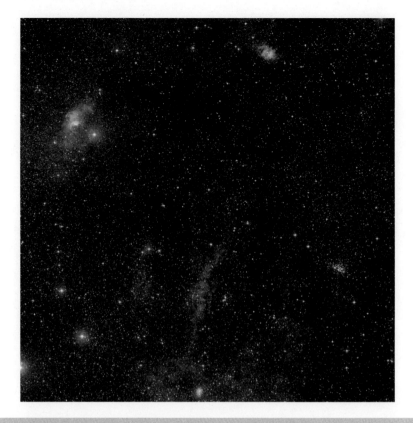

Figure 12.9 More Colourful/Strong saturation setting in Paint Shop Pro

To create the two-frame mosaic for the downloaded DSS2 data, you go through the above processing schedule for the second frame red and blue channel datasets. You now want to add this second frame to the first frame already processed, and the quickest and easiest way to do this is to use a program called "Registar" by Auriga Imaging at www.aurigaimaging.com. This is a powerful software that will seamlessly bolt together images of wildly different resolution. However, we hardly stress the program at all by creating a mosaic using the DSS2 data because the resolution of each frame is the same. Also, as the processing has been the same for each frame, RegiStar can blend the two frames together for you as well giving a seamless result. You can of course stitch the two frames together in Photoshop without using Registar at all. The result of stitching the two Bubble nebula frames together can be seen in Figure 12.11.

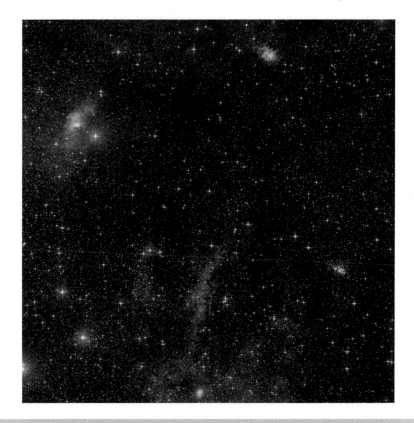

Figure 12.10 Spike modification using Noel Carboni's "Star Spikes Pro2" software.

Now it's only a matter of how many frames you want to process and stitch together in this way. My computer gave up using RegiStar when I got to ten 6,500 × 6,500 pixel frames on a region in Cygnus – but that was using a 32-bit version of RegiStar and now there is a 64-bit version, so I could go a lot further.

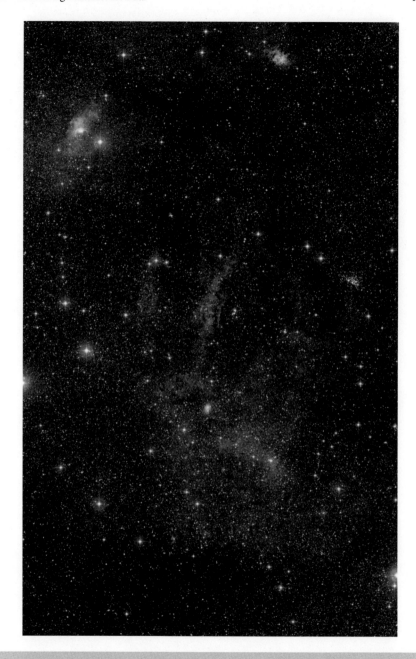

Figure 12.11 A RegiStar assembled 2-frame mosaic of the Bubble nebula region in Cepheus.

Chapter 13

The Deep-Sky Images

This chapter is filled with pictures that have been taken using some of the settings and techniques I have described in the book. Its main aim is to show you what can be achieved in a relatively short amount of time, if you are able to put serious effort into the hobby. The second aim is to inspire you to go out and do this for yourself, and to amaze your friends with these beautiful deep-sky images that are on show every night of the year (even if most nights they are beyond the clouds). And finally, it is to make yourself think, "Well, I reckon I can do better than that", which would be really great.

I get asked on a fairly regular basis, "Which is your favorite image?" Nowadays, I don't have a favorite. What I do have is about a dozen images that I am pretty happy with and that I don't think I can improve on that much given the sky conditions at the time and the amount of time I have already spent on them. On February 3, 2016, I took $6 \times 2,500$ second subs on the Rosette nebula using the Sky 90 array, to add to the substantial amount of data I had already collected on this object. I had hoped that because it was a perfectly clear, Moonless night, some very long subs would significantly improve my existing image of the Rosette nebula. But I was wrong! Yes, it did add a little, but the percentage mix of the new data to the old data for optimum overall noise was very small. So I am in the region of diminishing returns with this object given my sky conditions. This means that as far as I am concerned, the Rosette nebula image is now ***done***. There are better Rosette images than mine taken with bigger telescopes under better sky conditions and with longer integration times, and I cannot hope match them. The quality of your work is ultimately determined by your equipment and the current sky conditions.

Over the past few years, I have become more interested in imaging Carbon stars. I am well and truly addicted to imaging these rubies in the sky. From my latitude alone, I work through a list of just over 100 Carbon stars! The following images will only show a couple of Carbon stars because they are quite unimpressive to view on a small scale.

Figure 13.1 Single frame Sky 90/M26C image of Tarazed and Barnard's "E". North is to the right. As you can see there is a star-studded Milky Way background in this region of Aquila. This is a deep image of the region with in excess of 6-hours of data using 10-minute sub-exposures.

13 The Deep-Sky Images

Figure 13.2 Horizontal 2-frame mosaic of Castor and Pollux using the Canon 200 mm lenses and Trius M26C cameras on the array. North is up. 3-hours of 10-minute sub-exposures per frame.

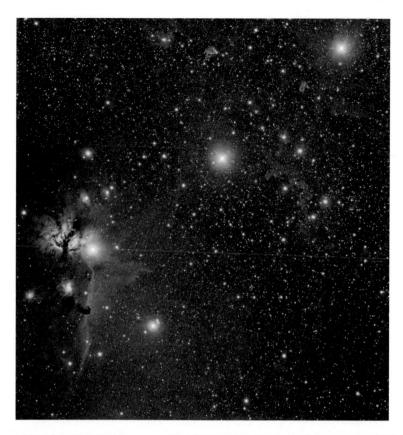

Figure 13.3 Vertical 2-frame mosaic of Orion's Belt and the Horsehead nebula region using a Sky 90 and M25C camera. This image incorporates broadband RGB data as well as narrowband H-alpha and H-beta data. Well over 24 hours of total integration time in this image using 20-minute subs for the narrowband data and 10 - 15 minute subs for the RGB data. You can see more about this image here http://epod.usra.edu/blog/2016/01/the-great-nebula-in-the-sword-of-orion.html

13 The Deep-Sky Images

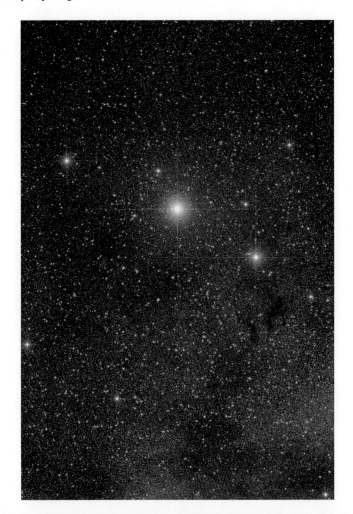

Figure 13.4 A very wide field image of Altair, Tarazed, Alshain and Barnard's "E" in Aquila. North is to the right. This is a single frame taken with the Canon 200 mm lens and Canon 5D MkII DSLR camera. Around 2-hours of 5-minute sub-exposures went into this one. The imaging rig was piggy-backed on the C11 for this image. You can see more about this image here http://epod.usra.edu/blog/2014/10/altair-and-bernards-e.html

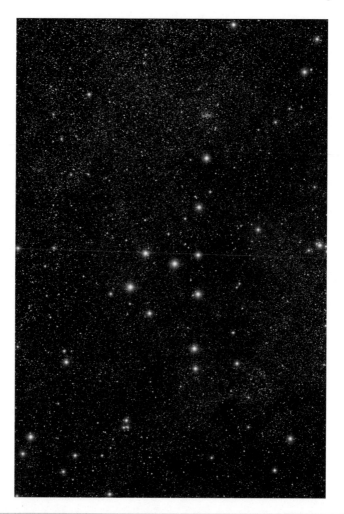

Figure 13.5 This is a composite image of the Coathanger cluster (Al Sufi's cluster, Brocchi's cluster) in Vulpecula. North is to the right. This is a composite of Hyperstar III/M25C data (4 hours of 10-minute subs) and Sky 90/M25C data (4 hours of 20-minute subs). This image made an APOD in 2008 http://apod.nasa.gov/apod/ap081223.html

13 The Deep-Sky Images

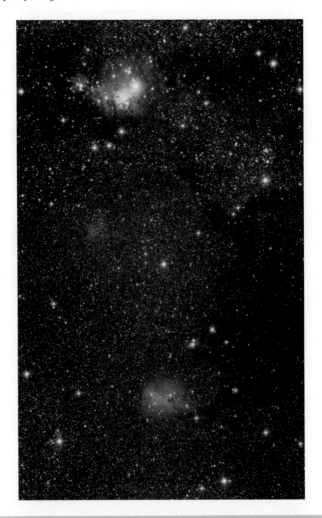

Figure 13.6 A horizontal 3-frame Hyperstar III/M25C mosaic of the Cone/Christmas tree, Trumpler 5, IC2169 region of Monoceros. North is to the right. This is a mixture of 10 & 15-minute sub-exposures for a total integration time of approximately 12-hours.

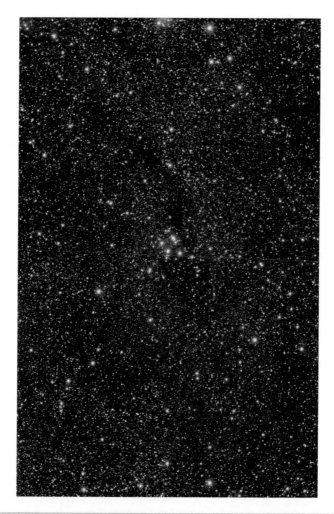

Figure 13.7 A single frame Sky 90/M26C array image of the Pazmino's cluster region. North is to the right. Good clear Moonless conditions for this one and 30 × 1,000 second subs to boot. So why is it so noisy and in need of a lot more exposure time? Not sure, but more time needs to be spent on this one.

13 The Deep-Sky Images

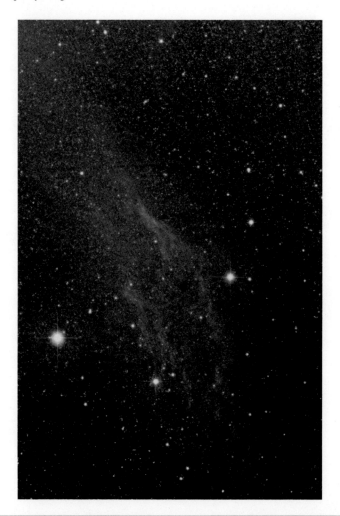

Figure 13.8 A single frame Sky 90/M26C array image of the California nebula. North is to the right. A massive 18-hours of 20-minute subs has gone into this, and still it could do with more. This is a very good example of where the speed of the Hyperstar III pays dividends over the relatively slow f#4.5 Sky 90s.

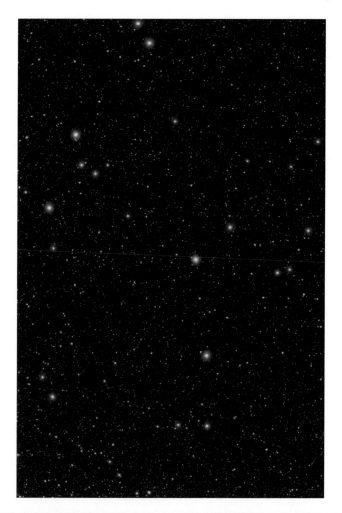

Figure 13.9 A single frame Canon 200 mm lens/Trius M26C mini-WASP array image of the "La Superba" region in Canes Venatici. North is to the right. La Superba is the very red *carbon star* sitting near the middle of the FOV. Around 2-hours of 10-minute sub-exposures. I applied the Akira Fujii effect to this image. https://en.wikipedia.org/wiki/Akira_Fujii

13 The Deep-Sky Images

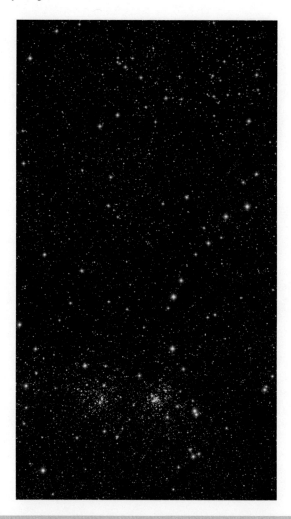

Figure 13.10 A vertical 2-frame mosaic of the Stock2/Double cluster region in Perseus taken with the Sky 90/M25C combination. North is to the top. Around 4 - 6 hours for each frame using 10-minute sub-exposures. Stock 2 (the horizontal "stick man" at the top of the image is rarely captured due to his much more famous neighbour.

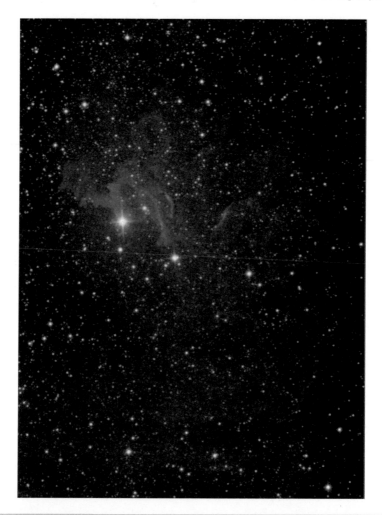

Figure 13.11 A single (original) Hyperstar/H9C frame of the Flaming Star nebula in Auriga. The beautiful Flaming Star nebula [Caldwell 31, IC405] lies at a distance of 1,600 light years in the constellation Auriga. North is to the right. This image shows the bright red emission nebulosity together with bright blue reflection nebulosity. This image consists of 86 sub exposures of 70 seconds per sub.

13 The Deep-Sky Images

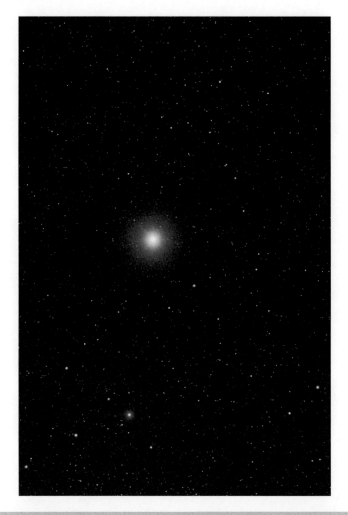

Figure 13.12 A single frame image of Spica (alpha Virginis) taken with the Sky 90/M26C array. North is to the right. The brightest/bluest star in the sky http://epod.usra.edu/blog/2016/05/spica-the-brightest-bluest-star-in-the-sky.html Once again - the Akira Fujii effect has been added - to Spica alone. Approximately 3-hours of 10-minute sub-exposures.

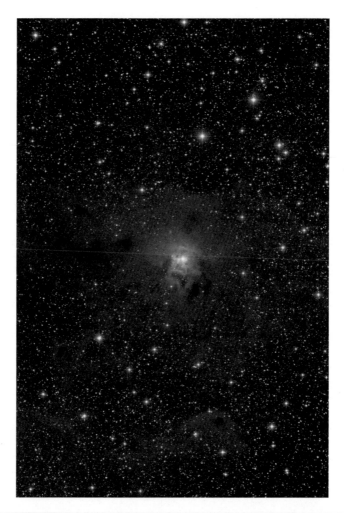

Figure 13.13 Single frame Hyperstar III/M25C image of the Iris nebula in Cepheus. NGC7023, also called Caldwell 4, or the Iris nebula in Cepheus is beautiful reflection nebulosity. North is to the right. This image comprises 4-hours total integration time using 15-minute subs.

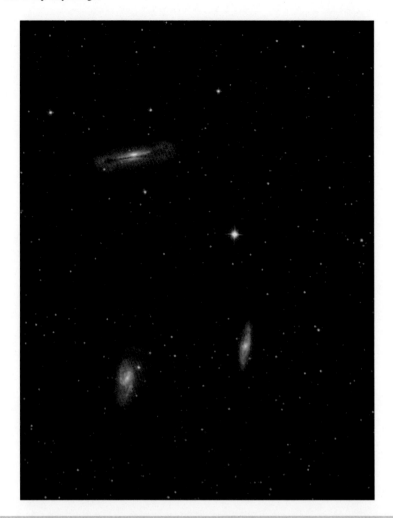

Figure 13.14 A vertical two-frame original Hyperstar mosaic of the Leo Trio of galaxies. North is to the top. This is a very famous galaxy grouping in the constellation Leo. In the U.K. "galaxy season" is during the springtime when the Leo/Virgo galaxies are in the best position for imaging. NGC3628 is a large edge-on galaxy and you can clearly see the dark dust lane running through its centre. Messier 65 is a spiral galaxy lying at a distance of 24 million light years, and M66 which has the appearance of Mother-of-Pearl is another spiral galaxy lying 21.5 million light years away. This image is composed of 74 sub exposures at 90 seconds per sub for the NGC3628 side, and the M65/M66 side is composed of 71 sub exposures again at 90 seconds per sub. The total imaging time for this picture was therefore just over three and a half hours. A much wider field can be seen here http://epod.usra.edu/blog/2011/05/leo-trio.html

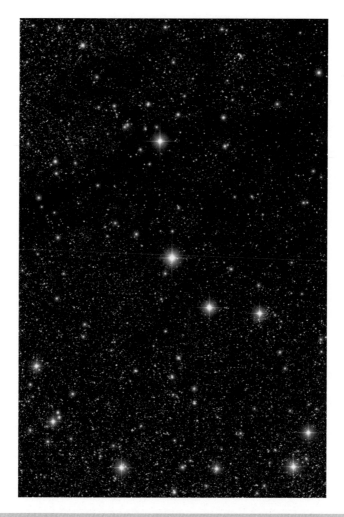

Figure 13.15 This is an experimental single frame image with the Sky 90/M26C array. North is to the right. This is a region in Cygnus containing a remarkable star V1331 and a mass of dark nebulosity. A composite of 14 × 15-minute subs taken one night added to 15 × 10-minute subs added a second night. The image could do with still more data even though 6-hours of precious imaging time had already gone into this one.

13 The Deep-Sky Images 123

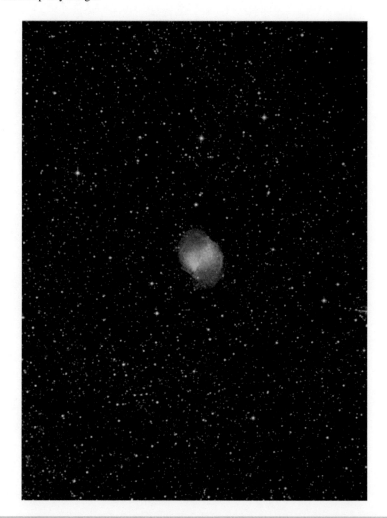

Figure 13.16 A single frame original Hyperstar/H9C image of the Dumbbell nebula in Vulpecula. The Dumbbell nebula is a bright planetary nebula, the result of the final stages of stellar evolution with the 48,000-year-old white dwarf star at its centre. This image is composed of 100 sub exposures of 55 seconds per sub giving a total exposure time of just over an hour and a half. Being bright, and reasonably sized at 8 by 6 arc minutes, this is a pretty good object for the beginner. It is however quite a difficult object to process properly as the colours are very subtle and there is a bright patch running through the nebula that is very easy to saturate during the "curves" stretching routine.

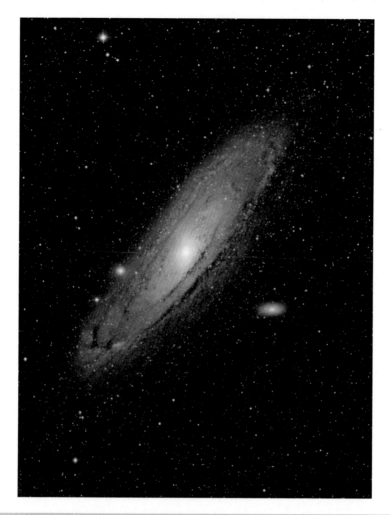

Figure 13.17 A wide field Sky 90/M25C image of the Great Andromeda galaxy M31 in Andromeda. North is to the right. The huge spiral galaxy M31 is around 3-degees along its major axis. You need a big field of view to get this in a single frame, and fortunately the Sky 90 with M25C camera is just about big enough. This single frame image is composed of 5 and 10-minute sub-exposures totaling approximately 8 hours and was first light for the M25C. It still needs more data.

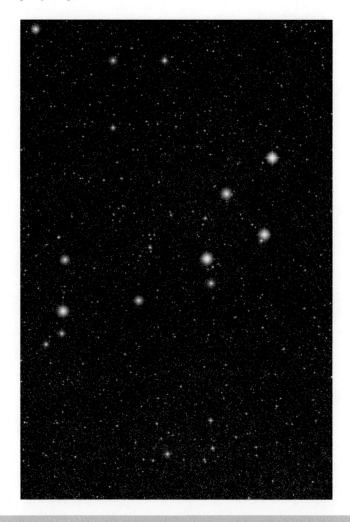

Figure 13.18 A very wide field, single frame image, of the central Delphinus region taken with the Canon 200 mm prime lens and a Canon 5D MkII DSLR. North is to the right. This image comprises 26×4-minute subs at ISO 400 and f#4. The DSLR imaging rig was piggy-backed on the C11 for this image.

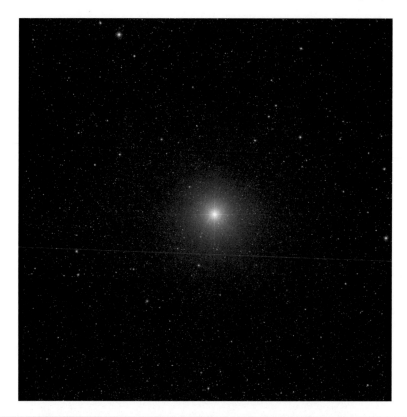

Figure 13.19 A vertical 2-frame image of Sirius taken with the Sky 90/M26C array. North is to the top. For the brightest star in the sky, subs were limited to just 2-minutes with around 2-hours of total integration time for each frame. This image also made an EPOD http://epod.usra.edu/blog/2013/01/the-brightest-star.html

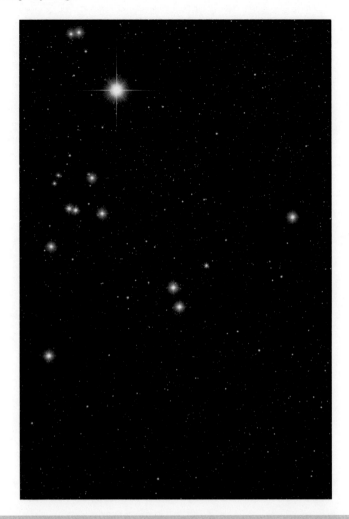

Figure 13.20 A very wide field single frame image of the Aldebaran and the Hyades region taken with the Canon 200 mm prime lens and a Canon 5D MkII DSLR. North is to the right. This image is composed of 12 × 5-minute subs, and the rig was piggy-backed on the C11. I have added the Akira Fujii-effect to this image, and also minimised the native 8 diffraction spikes with artificial 4-spikes. You can also see more about this image here http://epod.usra.edu/blog/2015/04/the-hyades-star-cluster-and-aldebaran.html

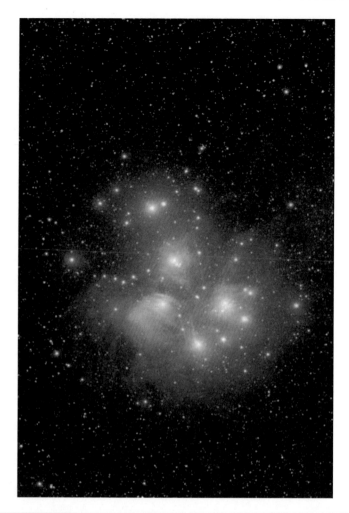

Figure 13.21 A wide field single frame Sky 90/M25C image of the Pleiades (M45) region. North is to the right. A lot of the pain in imaging this large region of space is removed if you go to short focal length, wide field imaging systems. This image is composed of 6-minute, 10-minute and 20-minute sub exposures totalling some 5 hours and 48 minutes in all. You can begin to see the faint reflection nebulosity that flows out well-beyond the perimeter of the Pleiades star cluster itself. This image made an EPOD here http://epod.usra.edu/blog/2007/02/pleiades-cluster.html

Figure 13.22 A horizontal 2-frame image of the Beehive cluster (M44) region taken with the Canon 200 mm lens/Trius M26C combination on the mini-WASP array. North is up. Left hand frame is 18 × 10-minute subs and the right hand frame is 16 × 10-minute subs. Central to the image is M44 and to the left hand side are two carbon stars T & X Cancri. I have added the Akira Fujii-effect to this image which can also be seen here http://epod.usra.edu/blog/2016/06/beehive-cluster-in-perspective.html

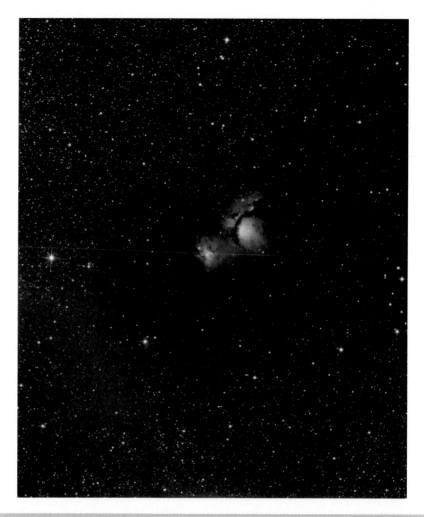

Figure 13.23 A composite Sky 90/M25C/original Hyperstar/H9C image of the nebula M78 in Orion and a part of "Barnard's Loop". North is to the left. This beautiful, awe-inspiring, reflection/dark nebula doesn't have its own name but is only known by its Messier [78] and NGC [2068] numbers. An associated nebula to the northeast is NGC 2071. This is a composite image using original Hyperstar/H9C data (114 sub exposures of 60 seconds per sub) and a Sky 90/M25C frame using 4-hours of 15-minute subs.

13 The Deep-Sky Images

Figure 13.24 This is a 4-frame Sky 90/Trius M26C mini-WASP array mosaic of the beautiful Kemble's Cascade in Camelopardalis. North is to the right. Each frame is composed of 18 x 10-minute sub-exposures giving a total integration time for the whole image of 12-hours. I particularly like this region as there are two carbon stars, and an S-type star in the field of view which you can read more about here http://epod.usra.edu/blog/2015/03/carbon-stars-of-kembles-cascade.html

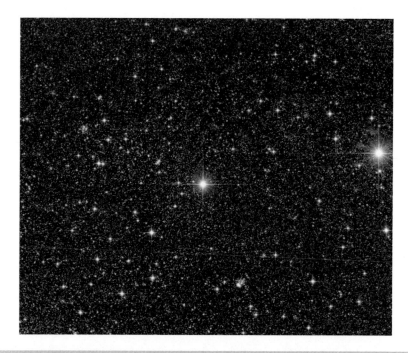

Figure 13.25 A horizontal 2-frame 200 mm/Trius M26C mini-WASP array image of the Ruchbah region in Cassiopeia. North is up. Each frame is composed of 25 × 10-minute subs, but as this was taken using parallel imaging (2 scopes) only 2 hours of actual imaging time was used. To the right we see Gamma Cassiopeiae and its associated nebula. There are several well-known open clusters within this large 6.5 × 6.5 degree FOV.

13 The Deep-Sky Images

Figure 13.26 This is a composite image of M33 the pinwheel galaxy in Triangulum. North is to the right. This image comprises a vertical 2-frame mosaic taken with the original Hyperstar/ H9C (1-hour and 4-minutes of 2-minute subs per frame) and around 5-hours of 10 - 15-minute subs with the Sky 90/M25C camera. I need to return to this object with the Hyperstar III/M25C which is a perfect FOV match to this object and take a lot more data.

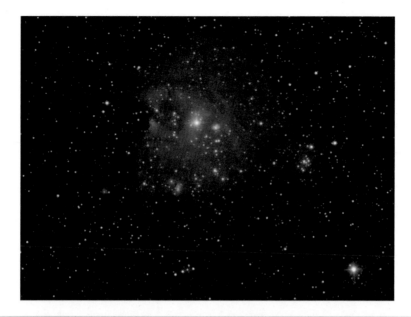

Figure 13.27 A single frame original Hyperstar/H9C image of the Monkey Head nebula in Orion. This rather faint emission nebula in Orion has been printed upside-down (north is downwards in this image) so that the "Monkey Head" can be more clearly seen. Often mistakenly called NGC2174 (which is in fact a smaller nebulosity within the Monkey Head itself), this is a region of strong H-alpha emission, and its size is an almost perfect match for the field-of-view of the Hyperstar lens with the Nexstar 11 GPS scope and SXV-H9C camera. This single Hyperstar frame consists of 157 sub exposures at 60 seconds per sub, giving a total exposure time of over two and a half hours.

13 The Deep-Sky Images

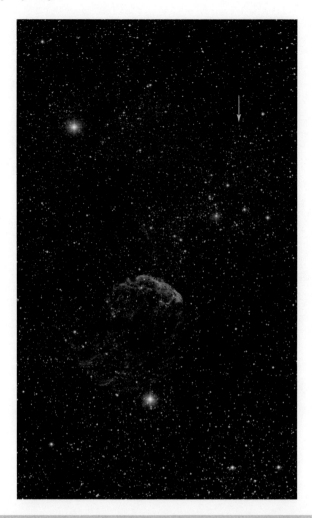

Figure 13.28 This is a single frame, composite image using the Sky 90/M25C, of the Jellyfish nebula region in Gemini. North is to the right. The arrow points to a planetary nebula that emits strongly in the infrared that was discovered only 6 months before this image was taken. The image comprises 3 hours of RGB, 9 hours and 40 minutes of H-alpha, and 3 hours and 40 minutes of S11 data. You can see more here http://epod.usra.edu/blog/2008/11/jellyfish-nebula.html

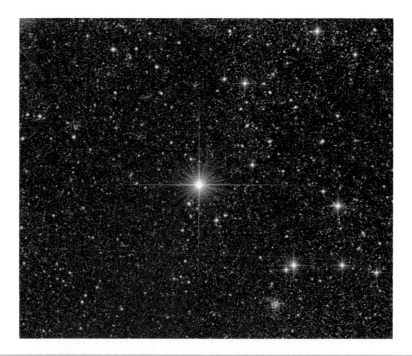

Figure 13.29 Here is a horizontal 2-frame 200 mm lens/Trius M26C mini-WASP array image of the Caph region of Cassiopeia. North is up. Each frame is composed of 25 × 10-minute subs. Notice that the huge 6.5 × 6.5 degree FOV contains the beautiful open cluster NGC7789 at the lower right.

13 The Deep-Sky Images

Figure 13.30 This is Greg's "3" asterism in Leo. North is to the right. This is not a groundbreaking image in any way, but it does show that "new" very prominent asterisms can still be found. The centre of the "3" is at RA: 09 h 37 m 21.17 s Dec: +15 deg 20 min 43.49 sec. Check it out next time Leo is well-placed in your night sky.

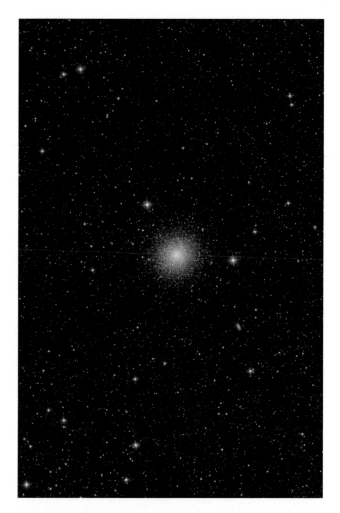

Figure 13.31 A single frame composite Hyperstar III image of M13, the Great Globular Cluster in Hercules. North is to the right. As you can see, this is a very deep image of the region incorporating Hyperstar III data exceeding 6-hours with sub-exposures up to 10-minutes.

13 The Deep-Sky Images

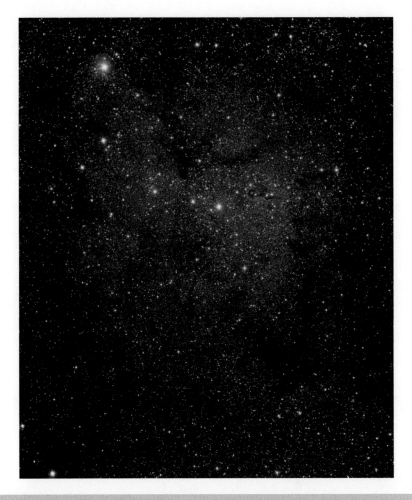

Figure 13.32 A vertical 2-frame mosaic of the huge emission nebula IC1396 in Cepheus using the Sky 90/M25C combination. North is to the top. A total integration time of 7-hours and 22-minutes in RGB and 11-hours and 40-minutes in H-alpha created this image, and the lower frame could have still benefitted from more exposure time. The famous "Garnet Star" is at top left.

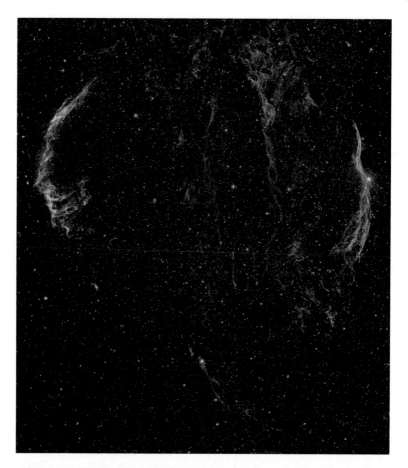

Figure 13.33 Another vertical 2-frame mosaic using the Sky 90/M25C combination, this time of the whole Veil nebula in Cygnus. North is to the top. The total integration time for this image was 32-hours and included RGB, H-alpha and OIII data.

13 The Deep-Sky Images

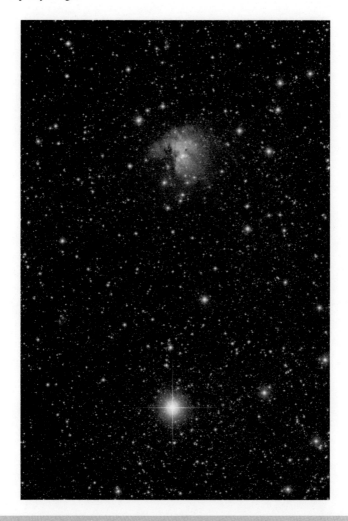

Figure 13.34 This is a single frame Sky 90/M26C mini-WASP array image of Schedar and the PacMan nebula in Cassiopeia. North is to the right in this image. This was one of an early set of experimental results using the mini-WASP array and this image is the result of 9 hours of total integration time using 30-minute sub-exposures.

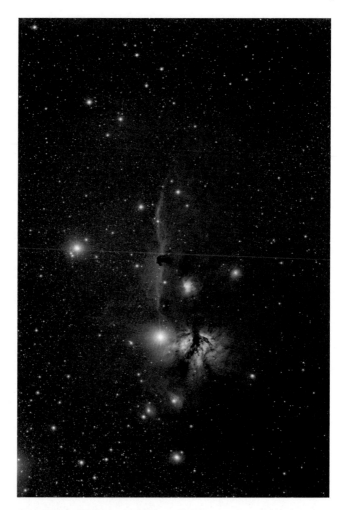

Figure 13.35 This is another single frame image using the Sky 90/M25C combination, the target this time is the Horsehead nebula in Orion. North is to the top of the page. A total exposure time of 6-hours for the RGB data and 4-hours for the H-alpha data was used together with 20-minute sub-exposures.

13 The Deep-Sky Images

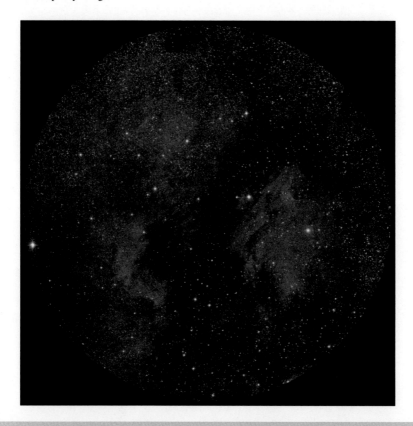

Figure 13.36 A 6-frame Hyperstar III mosaic of the NGC7000/IC5070 region in Cygnus. The North America nebula (to the left) is also Caldwell object 20, and the much dimmer Pelican nebula (to the right) is designated IC5070. As the frames were overlapped in a non-conventional way, the image was processed to give a circular FOV to maximise the picture area. North is up. A total integration time in excess of 12-hours using 10-minute sub-exposures went into the creation of this image.

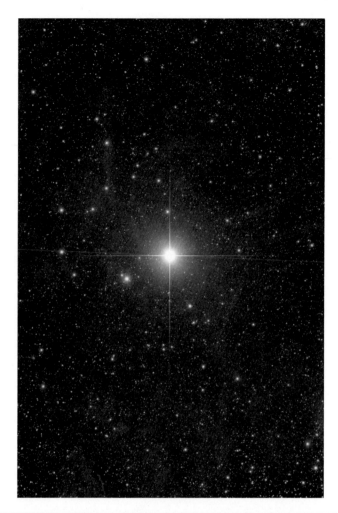

Figure 13.37 A single frame Sky 90/M26C mini-WASP array image of Polaris. North is to the right. You can tell this is a very deep image as you can see traces of the Integrated Flux Nebula (IFN) in the region. A clear Moonless night helped pick up the IFN. This image is composed of 36×5-minute sub-exposures.

Figure 13.38 A single frame original Hyperstar image of the core of the Rosette nebula in Monoceros using the tiny 1.4 Megapixel H9C camera. North is up. The Rosette nebula in Monoceros is a huge emission nebula with a nice open cluster, NGC2244, at its centre. You can see many dark regions in this nebula known as "Bok globules". The Rosette nebula is a massive 1-degree by 1.33 degrees in size, with a full Moon only coming in at half a degree in diameter. This image is made up from 84 sub exposures of 60 seconds per sub, so less than an hour and a half of total imaging time.

Figure 13.39 A composite image of the Rosette nebula in Monoceros combining Sky 90/M25C data and Sky 90/M26C mini-WASP array data. North is to the right. It was too big for the original Hyperstar and SXV-H9C, but it is just about perfect in the Sky 90/SXVF-M25(6)C combination. M25C data was 4-hours RGB, 5-hours and 30-minutes of H-alpha, and 3-hours of OIII. The M26C data was 6×2,500-second of RGB data taken in February 2016. The latest data only added a few percent to the overall image, so we are entering the diminishing returns region with this one, and I now consider it done.

13 The Deep-Sky Images 147

Figure 13.40 A single frame Hyperstar composite image of the Running Man nebula region in Orion. North is up. This region of rich nebulosity to the north of the Great Nebula in Orion is aptly named the Running Man nebula - can you see him? With three NGC designations, this region has nebulae and a very pretty open cluster that can be seen towards the top of the image. See how the whole region is surrounded by a dark nebula cutting out the background stars all around the edge of the image. This is an original Hyperstar single frame with a total exposure time of approximately two hours using 55-second subs, plus Hyperstar III/M25C totaling another 4-hours using 10-minute subs.

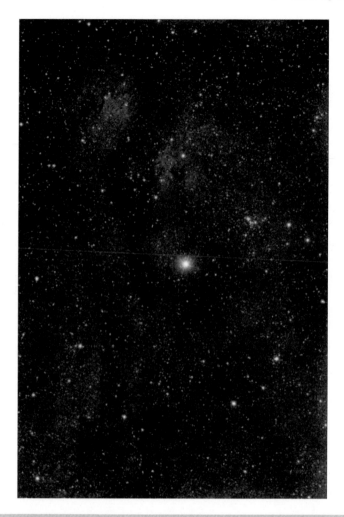

Figure 13.41 My first APOD. This is a Sky 90/M25C image showing the Sadr region of Cygnus and the Gamma Cygni nebulosity. North is to the right. This is just a tiny part of the massive Gamma Cygni nebulosity IC1318 that lies in Cygnus. The region you see here has the star Sadr centralised in the frame (Sadr is also the central star in Cygnus). The image is composed of 33 subs using 6-minute sub exposure times. Can you see the little open cluster NGC6910 towards the top of the frame?

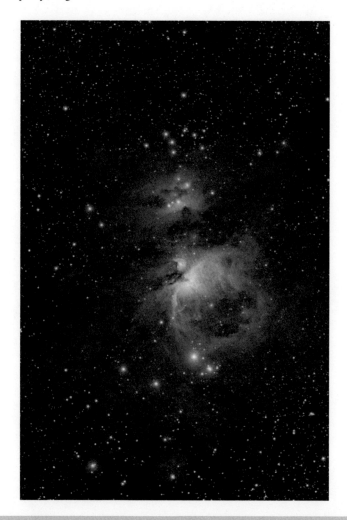

Figure 13.42 Another Sky 90/M25C image showing the whole of the M42 region in Orion. North is towards the top of the page. The Orion region is full of interesting objects, one of the brightest and most imaged being M42 the Great Nebula in Orion. The huge FOV of the wide field refractor system not only gets the whole of M42/M43, but the Running Man as well, and plenty of the surrounding space too. Notice how the "empty" region surrounding M42 is actually full of "brown-looking" nebulosity. This image is a composite of H-alpha, RGB and earlier original Hyperstar RGB work and is a total of over 12 hours of exposure.

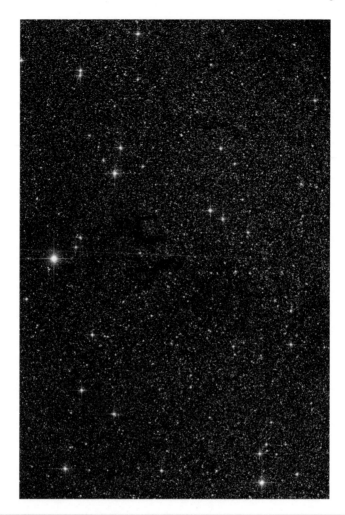

Figure 13.43 Tarazed and Barnard's "E" - north is to the top. This is the first light image for the Canon EF 200 mm lens and the Trius M26C OSC CCD.

13 The Deep-Sky Images

Figure 13.44 A two frame (horizontal) mosaic of the Virgo/Coma supercluster of galaxies - north is to the top. This is first light for the 2×Canon EF 200 mm lenses and 2×Trius M26C OSC CCDs.

Chapter 14

Differentiating your Work

Now that you have mastered the basics of astronomical imaging with your setup, how are you going to differentiate your work from others? Why should you even bother? If you are happy to take very nice images that you are personally pleased with, there's nothing wrong with that at all. But, the people that seem to get involved with this hobby are typically pathfinders rather than followers. So you will find if you sit on the Forums long enough, that there is always someone who pushes the envelope that little bit further, which gives you (and all the others of course) a big incentive to improve your own imaging technique, and to try just that little bit harder to acquire that really stunning, and unusual image.

With so many people engaged in this hobby, how can it be possible to differentiate your work? If I drop the false modesty for a second, I think that during the period late 2004 until mid-2006 my work was highly differentiated by being just about the only person on the planet getting high quality images from the original Hyperstar lens assembly. We have seen the reasons for the difficulty in obtaining good images from the original Hyperstar. Even with the collimatable Hyperstar III, Hyperstar imaging is still not trivial if you want to acquire high quality images, so a very easy way to differentiate your work is to become a "good" Hyperstar imager. But there are LOTS of other possibilities of course. One way of being able to differentiate your work is to throw more money at the hobby than most people can afford. I have no strong feeling as to whether this is a good or a bad thing for amateur astrophotography, but would suggest that if an extremely wealthy person has the high intelligence to want to take up this fascinating hobby, it can only be a good thing. So, you can differentiate your work, providing you have the funds, by buying the biggest aperture, fastest telescope your budget will allow, setting it up in a permanent dark site, and sticking the biggest most efficient CCD system you can

find on the back end. Couple this with a nice powerful workstation to grab the data and run the observatory for you and you'll have done a good job in differentiating your work from the rest of us that suffer from permanent thin-wallet syndrome. But is it at all possible to differentiate your work nowadays without having access to large reserves of cash? Of course it is, and one answer is, as it is with most things, is to work really hard.

Mosaics as we have already seen take a great deal of time effort and patience to produce, especially big ones, i.e. mosaics with a large number of individual frames. That's a very good differentiator to start with. There are a few stalwarts out there, who make this type of imaging their forte, but their numbers are very low indeed, so there's plenty of room for more to join them. Push the envelope, take things that bit further, make a mosaic of a large object, for example the North America and Pelican nebula region, *and do so at very high resolution.* Now you will have differentiated you and your work even further, even less people form high-resolution mosaics than those that create mosaics in the first place. One expert in creating large, high-resolution mosaics is the astrophotography innovator Rob Gendler http://www.robgendler-astropics.com/check out some of his iconic masterpieces including his mouth-watering rendition of M31, the great Andromeda galaxy. I hope you are beginning to get the picture; the possibilities really are almost endless and virtually untapped.

What else can we do? Well, it's a good idea to get off the Messier and Caldwell lists, useful as they are, and find objects that have been imaged to a much lesser extent. The NGC list is a good place to hunt down rarely imaged objects, but so are the Arps (peculiar galaxy) lists and the Abell list of galaxy groups. We then have all the dark nebulae out there (check out the Sharpless list), the strange integrated flux nebulae http://www.galaxyimages.com/UNP_IFNebula.html and many other little-studied wonders. Do some Internet research and see what you can find, there's plenty of stuff out there that's hardly ever been imaged at all. What I am saying here is to find objects that you can't get at by simply hitting the goto on your computer controlled telescope – anyone can do that. What you need to do is find some relatively obscure list with a nice looking object on it (and not duplicated on one of the other well-known lists), get the R.A. and Dec. co-ordinates, then use your scope's "goto R.A./DEC" function to go to the object for imaging.

This is precisely what I did when I imaged the "brightest object in the Universe", according to the Guinness Book of Records (at the time) anyway. That object was APM08279+5255, which can be found at R.A. 08 hours 31 minutes 41.60 seconds, and DEC. +52 degrees 45 minutes 16.80 seconds. Any telescope with "goto" capabilities can be easily programmed to slew to this object. The object is of course a quasar, or quasi-stellar object, but it appears to be just a dim, very red star. Nobody really knows what quasars are but it is hypothesized that they are black holes emitting tremendous amounts of energy (from beyond the event horizon) as they capture huge quantities of matter from nearby stars. APM08279+5255 is a very deep red and was a candidate for a so-called carbon star that was thought to lie within our own galaxy. The reason this quasar is so red is due to its enormous red shift of 3.87, which basically means that it lays a very long way away from us. To be more precise APM08279+5255 lays 12.9 billion light years away in the constellation Lynx

in the Northern Hemisphere. Consider that our Universe erupted out of the big bang only something like 13.7 billion years ago and you can start to appreciate what a totally amazing object this quasar is, and how incredible it is that you can image something this far away from your own backyard using amateur equipment.

Although APM08279+5255 only appears to be a magnitude 15.2 star, far too dim to be seen with the naked eye, it was still bright enough for people to think it was in our own galaxy. The reason it appears "so bright" to us is due to yet another strange coincidence regarding this object. Between the quasar and Earth lies a large galaxy with the huge gravitational field usually associated with such a collection of stars, and it is the "gravitational lensing" provided by this galaxy that "magnifies" the weak light from the distant quasar making it more easily detected by our Earth-bound telescopes.

I took a color image of this quasar on the Celestron Nexstar 11 GPS reflecting telescope using the (original) Hyperstar lens attachment with 46 sub-exposures of 50 seconds each, giving a total imaging time of only 38 minutes; see Figure 14.1. This is a very nice object to differentiate your work. Get a really long focal length image of this one in colour; it hasn't been done yet (2016). An object 12.9 billion light years away, captured as a colour image, by an amateur astrophotographer using commercially available equipment. It is mind-boggling really, isn't it!

Is there anything else? Well, move away from thinking about the type of objects you want to image and go back to the hardware, but without moving into the mega-buck region. You can specialise in filtered imaging, using narrow bandwidth filters

Figure 14.1 The Quasar APM08279+5255. Brightest object in the Universe laying 12.9 billion light years away in the constellation Lynx.

to look at specific emission lines from objects. You may need to do this anyway if you have to image from a light polluted site, but how about getting your own (blue) broadband filters specially designed so that you could image the integrated flux nebulae mentioned above? Increase the budget requirement somewhat, but not beyond the realms of a high end Ritchey-Chrétien scope and what about putting together your own mini-WASP facility? This is nowhere near as way-out as it sounds. Buy the same Canon lenses as in the Super-WASP array http://www.super-wasp.org/, couple them into large CCD cameras like the SBIG 11000 or the SXV-M25C, add a cheap guide scope and guider CCD and off you go. Huge field imaging and a resource that could be used for serious near earth object research. Your minio-WASP array will also require a substantial computational resource as well to download and handle the vast amounts of data you will generate in an observing session. Check out this site to see the type of data handling problem you will need to address http://www.star.le.ac.uk/~pjw/wasp/wasp_escience.html. This is a perfect differentiator for the amateur imager if ever I saw one, and of course, I now run one. It has proven to be a popular idea and there are now several amateurs out there who have entered the world of "parallel imaging".

What about imaging in the Polar region? As stated in Chapter 3, it is not easy for wedge-mounted Alt-Az scopes to work near the Pole, and for this reason, the Pole region is relatively "un-imaged". It is also not easy for GEMs to image near the pole either as it is a "singular" point that upsets the guiding enormously. In fact you will find that you cannot autoguide near the pole as the parameters you set into the guiding program basically won't let you. What do I mean by this? Suppose you are using Maxim DL to guide your telescope and suppose you are attempting to image Polaris (which is actually easier to image than getting even closer to the pole). Well you will find that Maxim DL will want the star you pick to guide on to move at least 5-pixels during the guide camera exposure time. Should be no problem - but it is. The way the guide program is set up in Maxim only allows you to expose up to 2-minutes on the guide camera - and you will find your star has moved less than 5-pixels (in DEC) during this time. Basically you cannot use the autoguider near the Pole. So what do you do? You turn the autoguider off - and then you are restricted to sub-exposure times that are governed by how good your polar alignment is set up. Imaging near the Pole is tough. The Hyperstar III allows you to image at the Pole, as there is no large optical train at the eyepiece end of the telescope that will strike the base when the scope is pointing towards the Pole, but you still have the same autoguiding problem. If you are not using a Hyperstar you can by judicious use of a high-quality diagonal, be able to fit your optical train at the eyepiece end and still clear the base when imaging near Polaris. German Equatorial mounts don't suffer from this particular problem, but many large scopes are wedge-mounted Alt-Az designs, so consequently there are not that many high quality images of the Polar region to be found. Check out how many good images you can find of Caldwell 1 [NGC188], the most northerly Caldwell object, surprisingly few I think you'll find. Now look for images of Polarissima Borealis, a little galaxy and the NGC object closest to the Pole – how many images of this one can you find? There are in fact many (faint) galaxies closer to the Pole than Polarissima Borealis - how many images of these can you find?

As another possible suggestion, instead of building your own imaging array, what about putting together your own unique telescope? A big aperture, low f-number telescope, with a large flat focus field designed specifically for very fast CCD imaging. Design it, and build it. It is far too specialised an instrument for the major manufacturers to get involved in, simply because the market isn't there for the manufacturer to get a good return on their investment. But that doesn't stop a dedicated amateur with lots of perspiration and dedication from building the "perfect" CCD imaging system.

Then if you have the luxury of a really dark site, you could go for the longest possible integration times and hunt down the faintest objects in the Universe. You could even have a crack at the amateur record for the faintest object ever imaged; currently I believe this is around magnitude 24.5.

What about very long focal length imaging of deep-sky objects, that is imaging at f #10, f #20, or even f #30 with a large aperture telescope? This is something that I haven't covered in this book as the mount and guiding problems become very severe, and it is usually the realm of the planet or comet imager, rather than the deep-sky imager. The planet or comet imager does have one major advantage over the long focal length deep-sky imager, their objects are very bright by comparison and the sub-exposure integration times are very short. This seriously reduces the accuracy constraints on the guiding for planetary and comet imaging. However, long focal lengths are also required for some of the tiny distant galaxies, and the smaller planetary nebulae, and for imaging these objects long sub-exposure integration times will be required. This becomes a good differentiator for your work as the accuracy in the guiding requirements really does become very difficult to achieve, once long integration time sub-exposures, at very long focal lengths are attempted.

Finally, rather than just creating new pretty images that nobody else has seen before, what about searching out new objects? How about trying to find a new asteroid, or a supernova/nova? Your imaging system should be capable of this work, and AstroArt as well as Maxim DL come along with comparator software so you can compare two frames of the same region taken at different times to see if something has moved, or if something new has appeared. You will find asteroids in some of your deep-sky shots simply by chance anyway. Go to an asteroid/near Earth object Internet site listed in Chapter 15 and see if your asteroid is a new one or not. I should probably recount to you the first asteroid a colleague discovered in one of my images as it may help you NOT to do what I did.

I had been imaging the Merope nebulosity in the Pleiades with the Hyperstar and had obtained a very deep shot – fairly long sub-exposure time, and lots of them. It was getting late in the evening, but I wanted to see what I had captured, so I started some image processing. Remember, it's getting very late, and I'm not in a very good mood, when I see this stupid annoying little rod of light – slap bang in the middle of the Merope nebulosity, see Figure 14.2. Now this really did annoy me, more work to be done in order to clone out that glitch. So I cloned out the light glitch and thought no more about it that evening. The next day I sent an image of the Merope nebulosity to Ron Arbour, a well-known U.K. supernova hunter, but I hadn't realised at the time that I'd sent an earlier version of the image without the light glitch cloned out. I think you can see it coming can't you? Ron e-mails me

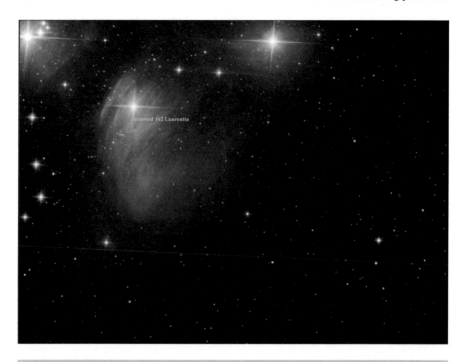

Figure 14.2 Asteroid 162 Laurentia on its way through the Merope nebulosity just as I was imaging this region for 4-frame (original) Hyperstar mosaic.

back almost immediately – "You realise you've caught an asteroid on here don't you?" he says. I'm a bit taken aback as I saw no asteroid on the image, and only realise after a while that Ron must be talking about the light glitch that I thought I'd cloned out. To cut a long story short we traced this one down to asteroid 162 Laurentia, unfortunately not a "new" asteroid, but certainly a new one for me. There is a sequel to this story. Fast forward to November 2006. I am imaging the Pleiades again, this time with the Sky 90 and the huge SXVF-M25C camera, so it's a nice big wide field image containing the whole of the Pleiades constellation. It's also a deep image, 10-minute sub-exposures and plenty of them. This time it is Noel Carboni, the guy who processed the image that gets back to me by e-mail. "You realise we caught two asteroids in that image don't you?" he said. Once again, no, I had no idea there were any moving objects in the image until Noel pointed out where they were. Using the Lowell asteroid site with a lot of trans-Atlantic e-mail chatter we soon found out these asteroids were 1193 (Africa) and 5063 (Monteverdi). Again, both asteroids were known, but a lot further down the food chain than the initial Laurentia find.

Having a closer look at the Lowell asteroid site I found that there were asteroids passing through the Pleiades region on a very regular basis, I had no idea that the Pleiades were the "Grand Central Station" for asteroids. Also note, the "mini-WASP" project I mentioned a little earlier would be a great asteroid-hunting imaging system with its very large field of view and reasonable resolution (image scale).

Finally we arrive at the specialist/obsessive sport of supernova hunting. Now this is something that doesn't actually ring my bell, but I know several people who have made this their life's work. Nowadays this is not a particularly good area to be in for differentiating your work, as there are professional institutes whose sole purpose is to use custom-built wide field imaging systems, under extremely good dark sky conditions, to go on "supernova patrols" every clear evening. As an amateur you are therefore up against some very heavy-duty competition, but despite this amateurs still manage to bag their fair share of supernovae each year.

I know very little about the art and science of supernova hunting, but what little I do know consists of the following. You don't look for supernovae in our own galaxy, as they would usually appear so bright that they would be immediately obvious; this of course also makes them very rare events. A good idea is to look for supernovae where there are lots of stars about. Now globular clusters have lots of stars, but as the majority of the bright globular clusters we know of are in our galaxy, this is actually once again not a good place to look. Other places that have high concentrations of stars are of course other galaxies, and it is in other galaxies that the supernova hunter generally looks for these highly elusive events.

So, supernova hunting differs from normal deep-sky imaging in several fundamentally important ways.

1) The supernova hunter is not after a pretty picture; lots of sub-exposures are not a requirement.
2) The supernova is likely to be a dim event if it is not to be readily picked up by one of the professional teams, and it is likely to be in a non-Messier non-Caldwell galaxy, apart from Caldwell 12 of which more a little later, if it is not to be discovered by hundreds of people at the same time! This means the supernova hunter takes one longish sub-exposure of a galaxy, with the biggest aperture scope he can afford, before moving quickly on to the next galaxy.
3) The imaging time is spent quickly taking sub-exposures of galaxies that are in the supernova hunter's list for that particular evening. The idea is to cover as many potentially interesting galaxies as possible in the imaging time available. Some galaxies are well-known supernova hunting grounds, Caldwell 12 being one of them, and these will be on the supernova hunter's search list. Some, very surprisingly have no supernova history at all, examples being M31 and M33 and these galaxies are unlikely to be searched by professionals.
4) After collecting the evening's data, the daylight hours are spent blink-comparing the evening's images against reference images taken at an earlier date and keeping an eye out for "new stars". Some advanced software with pattern recognition will take the legwork out of this stage for you as well.

As I mentioned above, this aspect of astronomical imaging does not interest me in the same way that taking pretty pictures does, but it might be an aspect of our imaging hobby that appeals to you greatly. If this is an area that does interest you, then firstly read up the enormous amount of information available on this subject before starting. Secondly, get yourself involved in a group who are already doing the same thing. In this way you can look at galaxies the rest of the group are not

already looking at and thus prevent not only duplicate imaging of the same galaxy, but also reduce the chance of multiple people discovering the same supernova at the same time.

Happy differentiating!

Asteroid 162 Laurentia

162 Laurentia is a large, dark, main-belt asteroid discovered by brothers Paul and Prosper Henry on April 21, 1876. The asteroid is named after A. Laurent, an amateur astronomer who discovered the asteroid 51 Nemausa.

Orbit	Main Belt
Semi-major axis	3.027 A.U.
Perihelion distance	2.503 A.U.
Aphelion distance	3.551 A.U.
Orbital period	5.27 years
Inclination	6.08 degrees
Eccentricity	0.173
Diameter	99.1 km
Rotational period	11.87 hours
Absolute magnitude	8.83
Albedo	0.053

Chapter 15

Your Largest Resource

It probably goes without saying, but the largest resource to support your new hobby is the Internet. Where do I begin to even start thinking about the possibilities? What resources are there for the amateur? It might be useful to start with a relatively short list of useful topic areas, and then delve a little deeper into some of them. We have, in no particular order:

- Up to date deep-sky images readily available from Hubble and large Earthbased telescopes.
- Photographic sky maps.
- Catalogues, including images, of the NGC, Messier, Caldwell, IC, Arps and just about any other deep-sky object you can think of.
- Free planetarium software.
- Free image processing software.
- Sites dedicated to Supernovae.
- Many amateur deep-sky, and planetary, imaging sites. Don't be put off by the word "amateur" here. Many of these skilled astrophotographers are able to create images that rival those coming from the World's largest telescopes!
- Sites dedicated to asteroids and near Earth objects.
- Sites listing the World's astrophotographers.
- Pay-for astronomical imaging software sites.
- Pay-for CCD download and control software sites.
- Sites for purchasing your astronomical telescope.
- Sites specialising in CCD cameras.

- Specialist forums dealing with specific telescope manufacturers, specific CCD manufacturers, specific telescope add-ons (e.g. Hyperstar), and specific image processing software, astronomical imaging in general, and in fact just about any topic you can imagine in astronomy.
- Sites where you can actually take your own images on a large observatory-based telescope!

And so it goes on, and on, and on.

This is your near infinite reference library, your market survey department, your purchasing department, your means of immediate communication with like-minded friends. This is a truly amazing resource; it is your Encyclopaedia Galactica.

So we return to the initial question again, where do I start? I will start with the sites I initially started with, and I'll progress in the way that I progressed. Before proceeding, I should say I have no affiliation, or personal interests (beyond learning) with regard to any of the sites I will mention.

I decided to buy the Celestron Nexstar 11 GPS scope for my main imaging instrument. As mentioned before, the reasons for this were several, but for me the main reason was the Hyperstar capability. So I needed to be in touch with other Nexstar users. What could be better than?

http://groups.yahoo.com/group/NexStarGPS/

A very active group that covers just about every question you will ever have regarding Nexstar GPS scopes. Michael Swanson is author of the NexStar User's Guide, and his site can be found here,

http://www.nexstarsite.com/

This is an extremely useful site for the NexStar owner, and Michael has personally helped me out of sticky problems on several occasions. Clearly, if you are a Meade, or Takahashi, or other brand-name owner, you will be able to Google all your own specific community links, be assured, they are out there in large numbers. As I also used a Hyperstar, and still use Starlight Xpress cameras, the Starlight Xpress Yahoo Group https://groups.yahoo.com/neo/groups/starlightxpress/info and the Fastar Group https://groups.yahoo.com/neo/groups/fastar/info are both also on my "Favourites" toolbar.

You will find Celestron at http://www.celestron.com/and the main U.K. distributor of Celestron products can be found at http://www.celestron.uk.com/.

My imaging CCD was a Starlight Xpress SXV-H9C because it was an almost perfect match to the Hyperstar lens, and is currently an SXVF-M25C. The Starlight Xpress range of CCD cameras can be drooled at http://www.sxccd.com/.

The Managing Director, Terry Platt, is an accomplished deep-sky imager in his own right, and has turned his hobby into a business. Terry is very responsive on both his site, and the Starlight Xpress Yahoo user's site. You will find many top class amateur imagers on this site who are always willing to help you improve your technique.

The first CCD download, autoguiding, and image processing package I bought was AstroArt3 (AA3) from http://www.msb-astroart.com/.

As mentioned in the image processing section, I found this software extremely useful and easy to use, and I really like the photometry package it offers. Also AA3 makes you work a little harder (than Maxim DL) in carrying out tasks such as mosaic formation. At first sight, this may appear to be of little use, but it allows you to understand more about what is "going on behind the scenes" of the software, so if and when you move to a more sophisticated package you will know the little tricks you need to carry out in order to bring the best out of the process. Within a couple of weeks of buying AA3, I downloaded the (one month free) software package Maxim DL. Being a lazy character, this was exactly what I was looking for, and when my free month was over I purchased the full image-processing package. Up until this point, I was still using AA3 for image acquisition, but having moved to Maxim for processing. I also bought the Maxim DL CCD control software that has been very easy to use with both the Starlight Xpress imaging camera, and the associated SXV autoguider camera. You can see what Diffraction Limited; Maxim DL's creators have to offer here, http://www.cyanogen.com/.

I also really liked being able to upgrade the software, at no extra charge, for one year after purchase. Not all image processing software costs you hard cash. There is a very powerful freeware package called Iris, that if you get proficient, will do everything you want http://www.astrosurf.com/buil/us/iris/iris.htm. This looks like very good software indeed (especially since it's free!). When I looked at it some time ago, the only problem I had was that the user interface was difficult for me, so I went for the commercial packages that spent a lot of resource getting the user interface just right. Don't be lazy like me, give Iris a try.

All the amateur imaging forums I have mentioned in the past have now gone and it looks like the job the forums did has now been taken over by Facebook. There are a number of astro-imaging sites on Facebook and also there are Facebook pages for the astro-imagers themselves. So my advice here is to simply join Facebook and hunt around for what you think are the best astro-imaging sites.

If you are processing your images using Photoshop, then you must have a set of Noel Carboni's actions available at http://www.prodigitalsoftware.com/. From this site, you can also purchase artificial star spike software (which I use extensively) and included in this software are actions that allow you to apply the Akira Fujii effect.

As I image in the U.K., it's a good idea to keep an eye on the weather. You can use http://meteoradar.co.uk/clouds-sun-UK-Ireland to see weather updates, but nothing beats looking out the window from time to time just to see what's really happening.

We now move on to resources/databanks for astrophotographers. Probably the resource I use the most is the superb complete listing (with images) of all the NGC objects, the NGC/IC project http://www.ngcicproject.org/. This definitive database and the accompanying images really help you out when you are hunting down a new object. The images also give you a very good idea if the object is worth pursuing both in terms of its size and brightness.

It seems whenever I image the Pleiades; an asteroid I have never seen before turns up in the image. This was most amazing to me at first, but I now realise on looking at the following sites, that asteroids are moving through M45 all the time.

If you discover a moving object on your images, check out the Asteroid Data Services by Lowell Observatory http://asteroid.lowell.edu/or the IAU Minor Planet Centre at http://www.minorplanetcenter.net/iau/mpc.html or the Near Earth Objects – Dynamic Site at http://newton.dm.unipi.it/neodys2/to see if your moving object really is a new one, or not.

What about the astrophotographer community itself? Key players can be found on a site maintained by Michael Stecker http://mstecker.com/pages/app.htm, you may even find something on the Author here. There are many, many, great astroimagers out there and it is difficult to provide a list of the "best" without omitting some truly great work. However, I was initially motivated by the work of Steve Cannistra http://www.starrywonders.com/and Rob Gendler http://www.robgendlerastropics.com/whose images, in my opinion, still rank amongst the best in the World. Perhaps not so well-known, but with an impressive portfolio of images is Wolfgang Promper http://www.astro-pics.com/. Why I like these images so much is that Wolfgang seems to have the same eye as me as to how these objects should be presented, especially with regards to color. Nick Risinger http://skysurvey.org/ carried out an insane astro-imaging project where he flew around the planet, imaging the night sky, in order to create a whole sky panorama. Now, that is a differentiator that is pretty hard to match let alone beat. The man who started and pioneered all this long before the CCD camera came along was of course David Malin with his state-of-the-art film work http://www.davidmalin.com/, pioneering, and highly inspirational, and remember this was using film.

What other titbits do I have on my "Favorites" bar? Well, there is some nice data on astronomy filters here http://www.iankingimaging.com/products.php, and you can read up on noise and sub-exposure calculations at http://www.hiddenloft.com/notes/noise_and_sub.htm

For more inspiring astronomical images, try looking at the "Sky Factory" here http://www.skyfactory.org/and of course at the Hubble images here http://hubblesite.org/gallery/.

Your Favorites toolbar will of course become populated by other addresses that you find useful or helpful.

These last few addresses are likely to be found on my toolbar only, but are included for you here out of interest. First, there is my New Forest Observatory site http://www.newforestobservatory.com/, then my Flickr images site https://www.flickr.com/photos/12801949@N02/.I have done work at the other end of the time spectrum here https://www.flickr.com/photos/12801949@N02/albums/72157621810713655 and you can read a bit more about me here http://www.newforestobservatory.com/bio/.

And finally, to bring you right up to date with what I have sitting on my quick access toolbar, we have of course the Astronomy Picture of the Day (APOD) site http://apod.nasa.gov/apod/astropix.html and the Earth Science Picture of the Day site http://epod.usra.edu/blog/. Here is a great site listing the best of the Sharpless catalogue with images http://www.sharplesscatalog.com/Sharpless.aspx?Sharp=204. If you want to see what the Sun is doing, then the Solar Dynamics Observatory site is the one for you http://sdo.gsfc.nasa.gov/data/. And if you want to know when to spot the Space Station orbiting over your location, then this is the place to go https://spotthestation.nasa.gov/.

15 Your Largest Resource

In the nine years since putting together the first edition of this book, content on the Internet has continued to grow at an exponential rate. You can find just about anything you want to know on the subject of astrophotography, and the only thing you need to take care with is choosing your site. Anybody can write up anything they want about any subject they want, there is no peer-review as there is with scientific papers. So make sure you take advice from people well known in the subject area, and be very careful in taking any advice from someone you've never heard of before.

Chapter 16

Book Recommendations

Although anyone starting in astrophotography today might be forgiven for thinking that "everything is on the WEB", books still have a very important role to play in our education.

My library consists of close to a thousand books, with maybe a hundred specialising in astronomy and astronomy-related subjects. I certainly do not rate all 100 books as indispensable, but there are a few that most certainly are.

1) This being a book recommendation section, I shall start off with something that is NOT a book! It is a star map. You will need a nice large star map in order to see where all those objects you will be imaging lie with respect to one another. There are a huge number of star maps on the market, but there's only one I personally like, it is the Hallwag International space map, "Die Sterne, Les Etoiles" by Hallwag, www.swisstravelcenter.com This is the nicest uncluttered star map I have come across that has all the major objects listed.
2) For star charts in a booklet form that you can carry out to your observing site, I have a single recommendation, and that is the superb "Sky Atlas 2000, 2nd edition" by Wil Tirion and Roger W. Sinnott. Very detailed and beautifully presented, this is a "must-have" publication, ISBN 0-933346-87-5.
3) It is probably a good idea to become accustomed to the well-known Messier and Caldwell objects before venturing off to find the less commonly known galaxies, nebulae and clusters. To this end, I use the two books by Stephen James O'Meara extensively. First, we have "Deep-Sky Companions: The Messier Objects", Cambridge University Press 1998, ISBN 0-521-55332-6. And second, there is "Deep-Sky Companions: The Caldwell Objects", Cambridge University Press 2002, ISBN 0-521-82796-5. Every object in both books is accompanied by a black and white image, and the descriptions to go

with each object are both descriptive, and in my opinion, beautifully written. I treasure these two books.

4) Stephen O'Meara is not unique, fortunately, in writing beautiful prose to go with deep-sky objects. Walter Scott Houston has also produced outstanding descriptions of these objects in his own book, edited by Stephen James O'Meara. The book is called "Deep-Sky Wonders", by Walter Scott Houston, edited by Stephen James O'Meara, Published by Sky & Telescope (Stargazing Series), 1999, ISBN 1-931559-23-6. This is truly a superb book, full of many black and white images, and plenty of objects that are not in the Caldwell or Messier lists – it's invaluable.

5) The next book I bought without knowing what I was going to get. I just saw the title on Amazon.co.uk and bought it. The book is "Observing Handbook and Catalogue of Deep-Sky Objects" by Christian B. Luginbuhl and Brian A. Skiff. Published by Cambridge University Press 1990, ISBN 0-521-62556-4. I'll be honest; when I first opened this book I was extremely disappointed. Very few pictures, many hand-drawn images, and at first sight not very interesting at all. This simply shows my early ignorance, I did not even realise at the time that this was one of the definitive works, often referred to on the NGC-IC Project Homepage http://www.ngcic.org/default.htm This book is a mine of data. Sectionalised by constellation, all the interesting objects associated with each constellation are discussed from an observer's point of view. Many faint objects that are not "popular" are described making this an excellent source of material if you want to go "off road" with your imaging and observing. I am embarrassed to say this book remained untouched on my shelves for something like 6 months before I realised what I had sitting there. Buy and browse through this book, you will learn to love it.

6) Already mentioned earlier in this book is the reference for constructing your own small astronomical observatory. Called "More Small Astronomical Observatories" this book also contains a CD with "Small Astronomical Observatories", the earlier publication. This book is one of Patrick Moore's Practical Astronomy Series, edited by Patrick Moore, published by Springer-Verlag London Limited 2002, ISBN 1-85233-572-6. As already mentioned, if you have thought about your own small observatory design, it's probably in this book.

7) Ultra wide angle full-page colour maps of the constellations are given in "The Photographic Atlas of the Stars". Published by IOP Publishing Ltd. 1999, HJP Arnold, Paul Doherty & Patrick Moore, ISBN 0-7503-0654-8. The huge, wide-field photographs in this book are an excellent reference for finding your way around the heavens and for locating the brighter deep-sky objects.

8) If you decide to go the Celestron Nexstar route like me, you will need THE reference book for your telescope. "The Nexstar User's Guide" by Michael Swanson is another in the Patrick Moore's Practical Astronomy Series. Published by Springer-Verlag London Ltd. 2004, ISBN 1-85233-714-1, this book contains everything you need to know about your Nexstar telescope.

9) A very large, encyclopaedic volume is "The Cambridge Atlas of Astronomy" Cambridge University Press and Newnes Books 1985, ISBN 0-521-26369-7. An immense work with each section written by a World expert in the field. Covers The Sun, the Solar System, The Stars and the Galaxy, The Extragalactic Domain and The Scientific Perspective. Another mine of information, full of beautifully drawn colour images, and colour photographs. A great book to sit down with on a rainy afternoon.

10) An astronomy data book, pure and simple is "The Data Book of Astronomy" by Patrick Moore. Published by the Institute of Physics Publishing 2000, ISBN 0-7503-0620-3. This data book will save you a great deal of legwork, or nowadays, I suppose, mousework. A newer edition of this superb publication is now available.

11) For an astronomy encyclopaedia, try the "Philip's Astronomy Encyclopaedia", edited by Patrick Moore, Philip's 2002, ISBN 0-540-07863-8. Very broad coverage of all things astronomical with excellent colour drawings and photographs.

12) This recommendation has a superb quotation on the back cover from James Michener's "Space": "This is one of the loveliest books in the world, the Professor had said, still clinging to the large flat volume. Norton's Star Atlas. Half the great astronomers living in the world today started with this as boys". I have "Norton's 2000 Star Atlas and Reference Handbook" edited by Ian Ridpath, Eighteenth Edition, Longman Group UK Limited 1989, ISBN 0-582-03163-X. I NEVER write in my books, yet I have pencilled in my own observations next to some of the star maps, this book invites you to personalise it in this way.

13) We mortals all aspire to take images like Robert Gendler, so why not buy his book and look at his images for inspiration? "A year in the life of the Universe" by Robert Gendler, with a Foreword by Timothy Ferris, published by Voyageur Press 2006 in association with Sky & Telescope, ISBN-13: 978-0-7603-2642-8. Beautifully produced, beautiful pictures, and very reasonably priced.

14) If you are interested in Cosmology and want an introduction into everything, then why not try "Bang! The complete history of the Universe" by Brian May (yes the Queen lead guitarist), Patrick Moore and Chris Lintott. Published by Carlton 2006, ISBN 1-84442-552-5. I am particularly fond of my copy, as Brian May has signed it for me himself. Thank you, Bri.

15) A massive, and utterly beautiful "pretty picture" book is Giles Sparrow's "Cosmos", Published by Quercus 2006, ISBN 1-905204-29-9. This really is a coffee-table book. Why? Because it is way too big to fit on any bookshelf.

16) There is no greater set of deep-sky object reference handbooks than the world famous set of three "Burnham's Celestial Handbook" by Robert Burnham Jr., published by Dover 1978 as a set of revised and enlarged editions.

17) I like stars, so I have many books on stars alone, and the three that I refer to the most are "Extreme Stars: At the Edge of Creation" by James Kaler, published by Cambridge University Press 2001, ISBN 0-521-40262-X.

18) "Stars and Their Spectra: An Introduction to the Spectral Sequence" second edition, by James Kaler, published by Cambridge University Press 2001. ISBN 978-0-521-89954-3.
19) "The Hundred Greatest Stars", yes you've guessed it, by James Kaler, published by Copernicus Books 2002. ISBN 0-387-95436-8.
20) In my review of this book, I said it is the most beautifully produced astronomy book I own, and I still feel that way. It is "The Arp Atlas of Peculiar Galaxies: A Chronicle and Observer's Guide" by Jeff Kanipe and Dennis Webb. Published by Willmann-Bell, Inc. 2006. ISBN 978-0-943396-76-7. I just love this book and the superb write-up on the great Halton Arp.
21) "Hidden Treasures" by Stephen James O'Meara is another collection of deep-sky objects worth of the imager's attention. Published by Cambridge University Press 2007. ISBN 978-0-521-83704-0
22) "Herschel 400 Observing Guide", your definitive guide to the Herschel objects, again by Steve O'Meara. Cambridge University Press 2007. ISBN 978-0-521-85893-9.
23) And finally, I include "Star Vistas" by Greg Parker & Noel Carboni, published by Springer 2009. ISBN 978-0-387-88435-6. This is a "pretty picture" book and contains many original Hyperstar images, as well as Sky 90/M25C images with the Sky 90 piggy-backed on the C11. Sadly "Star Vistas" pre-dates the Hyperstar III and the mini-WASP array, so there are many images in this Second Edition that you will not find in "Star Vistas". With Forewords by Sir Arthur C Clarke, Sir Patrick Moore and Dr. Brian May, "Star Vistas" is starting to become a bit of a collector's item.

The above list is anything but exhaustive, I have not included the interminable collection of "Hubble Space Photograph" books, for no other reason than I think you could choose any of these and be blown away by the images. No work, in my personal opinion, stands head and shoulders above the others. However, the books listed above are useful for both the beginner and the expert alike, so they should withstand the test of time in your ever-growing astronomical book collection.

Appendix 1

The Angular Size of Objects in the Sky

We measure the size of objects in the sky in terms of degrees. The angular diameter of the Sun or the Moon is close to half a degree. There are 60 minutes (of arc) to one degree (of arc), and 60 seconds (of arc) to one minute (of arc). Instead of including – of arc – we normally just use degrees, minutes and seconds.

1 degree = 60 minutes.
1 minute = 60 seconds.
1 degree = 3,600 seconds.

This tells us that the Rosette nebula, which measures 80 minutes by 60 minutes, is a big object, since the diameter of the full Moon is only 30 minutes (or half a degree).

It is clearly very useful to know, by looking it up beforehand, what the angular size of the objects you want to image are. If your field of view is too different from the object size, either much bigger, or much smaller, then the final image is not going to look very impressive. For example, if you are using a Sky 90 with SXVF-M25C camera with a 3.33 by 2.22 degree field of view, it would not be a good idea to expect impressive results if you image the Sombrero galaxy. The Sombrero galaxy measures 8.7 by 3.5 minutes and would appear as a bright, but very small patch of light in the centre of your frame. Similarly, if you were imaging at f#6.3 with the Nexstar 11 GPS scope and the SXVF-H9C colour camera, your field of view would be around 17.3 by 13 minutes, NGC7000 would not be the best target. In this case you would likely see just a general red glow of this massive H2 region over the whole frame, with very little structure apparent. It is for these reasons why it is a good idea to get a "feel" for the relative size of objects compared to your field of view.

It is also a good idea to get a feel of the size of your night sky, and how big or small objects will appear in your whole hemisphere of night sky. For example, let's say you have a telescope imaging system with a relatively large field of view of 1 degree by 1 degree and you point your telescope randomly in the sky. What is the chance that you will land on a chosen object? In other words how many square degrees of sky are there in a hemisphere?

I need to use radians measure to easily make the link to square degrees and compare with a hemisphere. So for an ordinary planar angle (not a solid angle) we find that Pi radians are equivalent to 180 degrees. In terms of solid angle (square degrees, or Steradians), 4Pi Steradians are the solid angle subtended by a whole sphere, and so a hemisphere subtends 2Pi Steradians.

Let's go through the maths:

1) 4π Steradians = Whole sphere.
2) $180/\pi$ = degrees per radian.
3) $(180/\pi)^2$ = square degrees per Steradian.
4) $2\pi \times (180/\pi)^2$ = square degrees for a hemisphere = 20,626 square degrees.

So the whole hemisphere of the night sky covers 20,626 square degrees, and our large field of view covers only 1 square degree, so randomly pointing our telescope at the sky with the hope of finding an object gives us a one in 20,626 chance of stumbling upon it. The night sky is a BIG place to hunt for small dim objects.

Appendix 2

The Designation of Deep-Sky Objects

I have no hesitation in letting you all know that I am totally and utterly confused by the designations used to name deep-sky objects.

This was clearly brought to my attention literally only a few days ago (in 2007) when I had just imaged the Christmas tree and Cone nebula area NGC2264 with the wide field setup. In the lower centre part of the image there is a very nice golden coloured open cluster – what is the name of this cluster? I looked everywhere and finally came upon it on Davide de Martin's absolutely superb "SkyFactory" site http://www.skyfactory.org/. Davide listed this open cluster as OCL494, and that didn't help too much as I had never heard of OCL either. What on Earth does OCL stand for?? Well I guess I was a bit slow there since OCL stands for "Open Cluster" which I suppose makes sense. Still, I had never heard of this designation before, so it still wasn't very enlightening.

I put the same question out on the Forums and got two further replies back. One said it was Cr 105, and another said it was Tr 5 or Trumpler 5. Now I thought at first that the guy who had answered Cr 105 had got it completely wrong since if you "Google" Cr 105 you get back something that is the 3rd furthest object from the Sun. But then if you persevere and delve a little deeper you find out that Cr also stands for "Collinder" and Collinder 105 is indeed the name for this nice little open cluster in NGC2264. Mind you, so is Trumpler 5 or Tr 5, so OCL494, Cr 105 and Tr 5 are all the same thing, the pretty little golden coloured open cluster in the Christmas tree region of Monoceros. I find this all unbelievably confusing, so in order to help myself as much as you, I have put together the very brief list below which includes some of the designations you will have seen associated with my deep-sky images in Chapter 13. This list is nowhere near comprehensive, it prob-

ably doesn't cover a 5th of the catalogues out there, but it may give you an idea where some of these obtuse names have come from. I have put the designations together in object list form.

General Deep-Sky Objects

There are only four designations that we come across on a regular basis for this category.

1) **M:** The well-known Messier catalogue named after Charles Messier who didn't want us confusing these vermin of the skies for precious comets. The total number of objects is either 109 or 110 (depending on what book you look at). For an example M45 is the designation for the Pleiades open cluster in Taurus.
2) **Caldwell:** The Caldwell catalogue is named after Patrick Alfred Caldwell-Moore. Patrick came up with his own list of interesting objects not included in Messier's catalogue, and unlike the M objects, the Caldwell objects cover both celestial hemispheres. Patrick did not use his "Moore" surname as there would have been confusion with the Messier (M) objects. There are 109 Caldwell objects for you to discover. Caldwell 1 (the most northerly Caldwell object) is NGC 188 an open cluster in Cepheus.
3) **IC:** The "Index Catalogue". Most of the objects in this catalogue had been discovered *photographically*, and Dreyer created this list from two indexes between 1884-1894 and 1895-1907. IC1318 is the huge Gamma Cygni nebulosity in central Cygnus.
4) **NGC:** The well-known "New General Catalog". Again a Dreyer masterpiece, with most of the objects having been discovered *visually*. Go to this fantastic resource http://www.ngcic.org/default.htm to find every NGC object listed with an accompanying black and white photo and data. NGC7000 is the huge North America nebula in Cygnus.

Diffuse Nebula

Again there are four designations that I have come across with the diffuse nebulae, but many more exist.

1) **Ced:** "Cederblad" from S. Cederblad "Catalog of Bright Diffuse Galactic Nebulae" 1946. Ced 214 is a nice emission nebula in Cepheus.
2) **Gum:** From C.S. Gum, "A survey of Southern HII regions". The Gum nebula (Gum 56) is a huge supernova remnant in the constellations Puppis and Vela. This huge region is something like 40 degrees across, and extremely faint.
3) **Sh2:** The "Sharpless" catalogue from S.Sharpless "A Catalogue of HII regions" 1959. Sharpless 2-155 is the Cave Nebula (also Caldwell 9). I have included a link to the best Sharpless objects (which includes images) in Chapter 15.
4) **vdB:** From "van den Burgh" 1966 "A study of reflection nebulae". The Elephant's Trunk Nebula is vdB142 in the massive HII region IC1396 in Cepheus.

Dark Nebulae

There's one very-well known catalogue here due to Barnard.

1) **B:** "Barnard". From "Catalogue of 349 Dark Objects in the Sky", 1927. The most famous member of this listing is of course B33, the Horsehead Nebula in Orion.

Open Clusters

This is the category that caused me all that confusion with the open cluster in NGC2264.

1) **OCL:** Now this actually took a lot of tracking down. It is apparently from "The Catalogue of Star Clusters and Associations". OCL494 is that nice open cluster in NGC2264 in Monoceros.
2) **Tr:** From Trümpler "Preliminary results on the distances, dimensions and space distribution of open star clusters" 1930. Trumpler 14 has one of the highest concentrations of massive, luminous stars in the Galaxy. Situated towards the edge of a large molecular cloud Trumpler 14 is part of the Eta Carina complex, which contains eight star clusters.
3) **Cr:** "Collinder" From P.Collinder "On structured properties of open galactic clusters and their spatial distribution" 1931. A catalogue of 471 open clusters. Collinder 470 is the cluster associated with the Cocoon nebula [IC5146, Caldwell 19].
4) **Mel:** P.J. Melotte, "A catalogue of star clusters shown on the Franklin-Adams chart plates" 1915. Mel 111 is the Coma Berenices star cluster.

Galaxies

1) **Arp:** Halton Arp, "Atlas of Peculiar Galaxies", 1966. My favourite Arp galaxy is NGC2276 (Arp 25) in Cepheus.
2) **Holm:** "Holmberg". There are 9 Holmberg galaxies, 1,2,3 & 9 are in the M81 region and 4&5 are in the M101 region. You can just about make out Holmberg IX in the image of M81 in Chapter 11, it lies very close to M81 itself.
3) **Mrk:** "Markarian". A catalogue of 1515 galaxies by B.E.Markarian et al. Markarian 421 is an active galaxy (blazar) in Ursa Major.

Galaxy Clusters

1) **Abell:** G.O. Abell, "The distribution of rich clusters of galaxies" 1958. Abell 2065 is a group of galaxies in Corona Borealis lying at a distance of 1.5 billion light years.

As I mentioned in the Introduction, this is a far from complete listing, and much more information can be found at http://www.sctscopes.net/Glossaries/DSO_Database_Notations.html

Greg Parker

B.Sc. (1st Class Hons), Ph.D.

Greg Parker was Professor of Photonics, and Head of the Nanoscale Systems Integration Group at the University of Southampton, Hampshire, U.K. until he retired in September 2010.

He was born in Barking, Essex (U.K.) in 1954. His first life-changing experience was moving to New Zealand with his parents for a couple of years at age 12. This has led to a lifelong love of sandy beaches and surfing.

On leaving school, he joined the Harwell and Culham laboratories and started a life in scientific research. He attended the University of Sussex and received his first degree in Physics, Mathematics, and Astronomy in 1978 with 1st Class Honours. He then joined the Philips Research Laboratories at Redhill, Surrey, U.K. where he did research on new Silicon-based electronic devices. At the same time, he earned a Ph.D. at the University of Surrey for his work at Philips. He was awarded the Ph.D. in December 1982 and spent the next five years in different semiconductor-based industries until he joined the University of Southampton in April 1987.

His University research was primarily in nanoscale optical devices and circuits, called Photonic Crystals, and in December 2000 he was made Professor of Photonics having begun his Academic career in 1987 as a Junior Lecturer. In July 2001, he span out the photonics company Mesophotonics Ltd. based on his Photonic Crystal research. He has also created three other successful companies. Information on his Consultancy business Parker Technology can be found at www.concept2innovation.com.

He has published over 120-refereed scientific papers, an undergraduate textbook on the physics of semiconductor devices and a "pretty picture" deep-sky images book titled Star Vistas, which is published by Springer. He also has 14 filed Patents.

Parker's interest in Astronomy goes back to his early childhood, but took a major boost when he lived within the Dartmoor National Park and had many nights with crystal clear skies and virtually no light pollution. He will never forget the awesome sight of a completely light pollution free sky as he looked out of his tent flap somewhere in the middle of Dartmoor on a warm Summer's evening in 1970. Today, he is a CCD imager [http://mstecker.com/pages/appparker.htm], taking images of deep-sky objects with technology he never dreamed would exist in his lifetime. As Arthur C. Clarke said, "Any sufficiently advanced technology is indistinguishable from magic." Greg's observatory can be seen at https://www.flickr.com/photos/12801949@N02/albums/72157625324238668 and his CCD imaging page can be found here https://www.flickr.com/photos/12801949@N02/albums/72157622020758946

Parker lives in the New Forest, Hampshire, U.K. with his wife, son, cat, dog, Celestron Nexstar 11 GPS reflecting telescope, Sky 90 refractor, and mini-WASP array. He is a fully certified nerd, Star Trek fan (original series), and very proud of it.

University Website Biography

Light has always been a defining factor in the life of Greg Parker, Professor of Photonics at the University of Southampton's School of Electronics and Computer Science.

It began with a young boy's love of the stars in the night sky and his fascination with his father's photographic collection, taken whilst he served in the First World War in Afghanistan & Egypt - he was actually in Luxor at the time Howard Carter discovered Tutankhamen's tomb. This followed through to Greg's internationally acclaimed career in photonics and his own passion for capturing images of deep-sky objects. "These things go into your subconscious mind and make a really big impact although you don't realise it at the time. Then, years later, they resurface".

He vividly remembers the year the Daily Express featured the world's first ruby laser on its front cover. "It was around 1963–1964, three or four years after the laser was invented by Maiman in America," he recalls. This groundbreaking invention featured a ruby rod in the middle of a spiral Xenon flash tube and resulted in the 10-year-old disembowelling old watches to retrieve the rubies from their mechanisms.

"I dug the rubies out and got a magnifying glass to shine the Sun on them, hoping to make a laser. Of course I never did but I must have spent a year trying to do this and it was a big letdown", he says. The disappointment, however, didn't put him off: "That was when laser and light and flashtubes all started for me," he adds.

His early career was spent studying and working in industry. On leaving school he joined the Harwell & Culham laboratories, also taking an HNC in applied physics at Oxford Polytechnic. Having gained a taste for study, he went to Sussex University to read maths, physics and astronomy, graduating with first class honours in 1978. He then joined the Philips Research Laboratories in Redhill and enrolled for a PhD at the University of Surrey.

Greg joined Southampton's Department of Electronics, as it was then, in 1987. The move was partly prompted by the onset of change in the big research labs. "The grass was beginning to look a lot greener on the other side," he says. "Over the last 20 years a lot of those places have gone. You just can't play anymore and they've become very commercial. It's difficult to be inventive and innovative in industry, it doesn't accommodate free thinkers very well whereas a university will".

He steadily climbed the ranks at Southampton, specialising in novel growth systems for Silicon compatible materials and Silicon-based optoelectronics, and was appointed Chair of Photonics in 2000. During his time, Greg has designed, built and developed four LPCVD systems for the Microelectronics Group, published over 120-refereed papers, created three successful companies and is now group leader for the Nanoscale Systems Integration Group.

Around 1994, Greg had a Eureka moment with the creation of the world's first photonic crystal to work at optical wavelengths. The cry, however, didn't come until many months after their unintentional fabrication. "I had an EPSRC grant to make very thin, tall wires of single crystal Silicon," he says. "One of the early steps

in the process is a sheet of Silicon with very deep holes going down into it. This was just a precursor to the process and didn't mean anything to me at the time."

The project was successfully completed and the samples were stored on the shelf. Six months later he was reading an article on photonic crystals - something he'd never heard of before but he now suspected the precursors could be linked to them. At a colleague's suggestion he took some careful measurements and realised he had created the world's first photonic crystal to work in the infrared region.

Greg convinced BTG plc to invest in the new photonic crystal technology and they invested £2.8 million in the spin out company Mesophotonics Limited in 2001. The technology allows light to be bent, routed and processed at a sub-millimetre scale resulting in a low cost, high volume production of integrated optical devices. "They are no more than an array of holes in an optical wave guide but by placing the holes in a certain manner you can create lots of different functionality," says Greg. A second round investment of £5.5 million was attracted in late 2003.

Another dimension to Greg's career in light is his interest in photography, first sparked by his father. "Dad was born in 1900 in the squalor of the East End and to get away from a pretty grim existence he joined up very early in World War I," he says, "for some reason he decided he was going to do photography out in Afghanistan." As a result the Parker boys grew up in a house surrounded by boxes of old photographs. "It obviously had a big impact on me and my older brother. He was a forensic photographer in Scotland Yard for 33 years," he adds.

In 1985 Greg created the first portable high-power, high-speed flash unit with a 1/40,000 second duration for his older brother Alan. A design that, 20 years after development, remains virtually unchanged and is still in use by award-winning nature photographer Andy Harmer.

Greg's own photography necessitates a slightly longer exposure time; he needs two to three hours for his deep-sky imaging work. In July 2006 he will stage his first exhibition of astrophotography at the University of Southampton library. The work will be entirely his own from beginning to end; all images on display will have been photographed, printed, mounted and framed by Parker himself.

He readily admits it can be an addictive obsession but one he is keen to share, and use to inspire others. He says, "I want other people to come in and see what a guy off the street did within a year with something you can buy commercially that someone with an ordinary job can afford. I wouldn't have believed it!"

Although Greg has been stargazing for over 40 years and has his own mini dome observatory in his New Forest garden, he only started imaging the skies in November 2004.

"CCD cameras with long exposure times have only been around for about ten years and it's only in the last five or six years you could get them at a reasonable price to do the job," he says. "I started imaging literally one year ago but the technology allows you to do it as long as you're au fait with computers".

The camera downloads the data which Greg then processes digitally using Adobe Photoshop. This enables him to manipulate the picture and bring out the faint detail. The result is a galaxy of prints that bring the splendours of the cosmos to life.

"That's why it's a great one for me," he says, "it brings together optics, the stars, photography and the computational processing. It's got the lot in the one hobby." And helps provides light relief to an academic career immersed in luminescence.

Physics World Article

The article that appeared in the September 2002 issue of Physics World was fairly heavily edited, to the extent that some of the meaning was lost entirely. Below you will find something a little closer to the original manuscript.

The Most Amazing $2^1/_2$ Hours of my Life – So Far!

If you have been fortunate in your choice of day job, there comes a time around middle-age, when if you're very lucky you can afford to buy the toys you wished you'd had as a child. Some people at this crisis point in their lives opt for sports cars, or even powerful motorbikes – I on the other hand decided to buy a lovely 6-inch refracting telescope. This Helios branded telescope was incredibly powerful and gave me great views of the Planets, as well as nice views of the Orion nebula and the Andromeda galaxy. This was not a "goto" telescope, although it did come with a motor-controlled German Equatorial mount. The lack of computer-controlled "goto" was a firm decision on my part. I didn't want a computer finding all these wonderful deep-sky objects, I wanted to do that all by myself and have the "fun" of being able to hop from object to object without any computer-aided help. I have to admit I didn't have much fun! I was too inexperienced to find my way around the Heavens, and all those Messier and Caldwell objects still remained quite elusive. So after a couple of months I admitted defeat and bought a Celestron Nexstar 11 GPS telescope, computer-controlled and an on-board GPS system for accurate position location and for setting up the local time. This advanced telescope also tells you which stars you should align against to set it up for an evening's observing.

When the telescope finally arrived I could not wait to start observing. As with all new astronomical gear it was the proverbial "cloud-magnet" so it was a week or so before I could take it outside for its initial trial run. On the first clear evening I took it outside and followed the instructions (to the best of my ability at the time) and was quite disappointed with the instrument. The telescope couldn't even locate Jupiter even though it was blazing away up there for all with a pair of eyes to see. I later realised that this was due to me wrongly calibrating the telescope by mistaking Capella for Procyon and therefore invalidating the two-star align (I cannot remember what the second alignment star was, or how I could have possibly got "align success" with one guide star being completely wrong, but that's what happened).

After a few more days of overcast weather the evening of Thursday 2nd May 2002 finally fell clear. Out came the telescope, which I managed to set up properly this time by using the correct alignment stars. By 9.30 p.m. I had observed Jupiter and its moons for half an hour and it was now time to try the handset again to see if I could find those elusive Messiers and other deep-sky objects.

Not knowing what would be visible that night I simply typed in "M3" and off the telescope went. The motors whirred for maybe a minute, the last little whir being used to take up the gears' backlash. Expecting to see nothing through the eyepiece I was totally amazed to see a fuzzy ball of light glowing right in the middle of the eyepiece. Never having seen this object before [M3 is in fact a very

nice example of a globular cluster], or anything like it, I thought this must have been a fluke and just a lucky "hit".

Pushing my luck I typed in another number: M88. Off went the telescope again and this time there was a galaxy right in the middle of the eyepiece! Now although several decades of scientific training should have told me that I couldn't have been so lucky twice in a row, I was not entirely convinced that this still wasn't just chance. However, I was very excited by all this and got my wife to take a look through the eyepiece. She was not too impressed – and I guess that for £3,000 you might expect to see at least the Starship Enterprise come into view.

I was not daunted. I went indoors and brought out my Norton's 2000.0 star atlas – I knew its day would come, and today was the day! It was about 10.00 p.m. when I opened the page on "Interesting Objects Maps 9 and 10, clusters, nebulae and galaxies". I typed in the name of the first object on the page – NGC 3132 – and set the telescope running. As in the early classic computer game – nothing happened! The handset indicated that the object was below the horizon and so it would not slew the telescope. I then went to the second object on the list – NGC 3242 – a planetary nebula in Hydra called the "ghost of Jupiter" – I'd never even heard of this one before. This time the motors whirred into life and the stars flew across the field of view. The motors wound down and I looked through the eyepiece just as the gear backlash was being taken up. An amazing glowing object quickly locked itself into the centre of the eyepiece. It was indeed the ghost of Jupiter, and a marvellous sight in the eyepiece!

Like a kid in a sweetshop, I now had this whole mass of clusters, nebulae and galaxies all ready to be viewed. All I had to do was type in the Messier or NGC number. This was so good it seemed unreal. During the next hour I worked my way down the list in Norton's and logged 27 out of the 34 objects on that page. It was an incredible experience. Getting greedy I turned to a different page in Norton's and started on another list of objects. If you have not seen M13 – the great globular cluster in Hercules – through a reasonably sized telescope, you must, it is simply breathtaking.

Just after midnight the sky clouded over and I had to stop. It was just as well really as I may have perished outside from the cold if I had not been forced to give up the evening's viewing. With regards to new discoveries [for me at least], it was, at the time, the most amazing two and a half hours of my life.

So how can I possibly summarise an experience like that? It is very difficult of course, but I can offer a comparison. A few years ago I bought a sub-notebook computer (a Libretto) that was a little larger than a videocassette and weighed just one kilogram. I fitted a 40Gb hard drive to this machine, which meant that I could carry in one hand – and have access to – not just the whole Encyclopaedia Britannica, but actually something like twenty times the data content of the whole of the Encyclopaedia Britannica. Even Star Trek (First Generation) was not that bold.

Now I have a computer-controlled telescope that can take me accurately to any object in the night sky just by typing the coordinates into a handset. This is a totally amazing piece of technology, and it is available to the general public at effectively very low cost, thanks to mass-production techniques. We may live in "interesting" times, but as Physicists we also live in truly amazing times.

Greg Parker is professor of photonics at the University of Southampton. He lives in the New Forest with his Wife, Son and Nexstar 11 GPS telescope.

Postscript to the Second Edition

One of the major changes in this edition from the First Edition is the removal of the sub-title "Astrophotography with Affordable Equipment and Software". The mini-WASP array and other development in technology and equipment have created many new and affordable ways to make high-quality deep-sky images.

The new Hyperstar III has also opened up Hyperstar imaging to the amateur astrophotographer, and it really is the easiest and quickest way to get into taking great pictures of nebulae, especially faint nebulae.

I hope the information on how to process Professional observatory data doesn't discourage you from trying to take some deep-sky images of your own, but if it does, maybe I've saved you a lot of money and heartbreak.

If you are still interested in taking your own deep-sky images after reading this book, then I wish you clear, dark skies, and many, many hours of happy deep-sky imaging.

All the best,
Greg Parker
Brockenhurst, UK
2016

Index

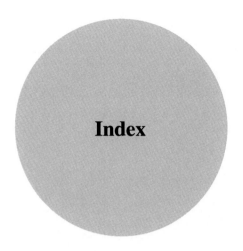

A
Abell, G.O., 154, 175
Africa (1193), 158
Akira Fujii, 89, 116, 119, 127, 129, 163
Al Sufi's cluster, 112
Albireo, 58
Aldebaran, 58, 127
Aldebaran and the Hyades, 127
Alnitak, 56, 57
Alpha Virginis, 119
Altair, 58
Altair, Tarazed, Alshain, and Barnard's "E", 111
Alt-Az (imaging), 5
Aluminium pier, 5, 47
Aperture, 5, 10, 21, 25–27, 31, 35, 44, 45, 47, 65, 70, 71, 77, 81, 153, 157, 159
APM08279+5255, 154, 155
Apochromatic, 19, 21, 25, 37
Arbour, R., 157
Arc minutes, 30, 31, 123
Arc seconds, 30, 32
Arcseconds per pixel, 30, 31
Arp, 154, 161, 170, 175
Array, vii, xi, 30, 43–44, 48, 66, 76, 77, 79–82, 90, 92, 107, 109, 114–116, 119, 122, 126, 129, 131, 132, 136, 141, 144, 146, 156, 157, 170
Asteroid(s), xii, 43, 157, 158, 160, 161, 163
AstroArt, 4, 39, 42, 157, 162
Astronomy Now, 51
Astrophotographer(s), vii, 155, 161, 163, 181
Auriga, 118
Auriga Imaging, 92, 103
Autoguider/Autoguiding, 21, 25, 26, 29, 39, 42, 47, 60, 61, 64–66, 68, 71, 72, 77, 80, 156, 162, 163
Auto-sequencer, 60, 61
Azimuth motor, 9

B
B33, 56, 175
Bandwidth, 20, 155
Bang!, 169
Barnard, B., 175
Barnard's Loop, 130
Beehive cluster, 129
Belkin, 11, 40
Bias frames, 86
Binoculars, 15, 16
Bloated stars, 19, 25
Blue halos, 19
Bob's Knobs, 24, 29
Broadband filters, 156
Brocchi's cluster, 112
Bubble nebula, 51, 55, 61, 96, 103, 105

C

Caldwell, 1, 143, 154, 156, 161, 167, 168, 174, 179
Caldwell (1), 156
Caldwell (12), 159
Caldwell (31), 118
Caldwell (4), 51, 120
California nebula, 85, 90, 92, 115
The Cambridge Atlas of Astronomy, 169
Camelopardalis, 92, 131
Cannistra, S., 26, 62, 64, 164
Canon 200 mm prime lens, 43, 77, 125, 127
Canon 400 mm, 79
Canon 5D MkII DSLR, 80, 111, 125, 127
Canon EOS lens, 81
Canon Remote, 80
Capella, 179
Caph, 136
Carbon star, 108, 116, 129, 131, 154
Carboni, N., vii, 9, 20, 42, 72, 82, 88, 96, 99, 102, 158, 163, 170
Cassiopeia, 55, 132, 136, 141
Castor and Pollux, 109
CCD, xi, 2, 4, 5, 7, 9, 16, 20, 21, 23, 24, 26, 29–33, 35, 37, 38, 40–43, 60–62, 67, 69–71, 73, 75, 78, 79, 81–83, 86, 150, 153, 156, 161, 162, 164
CCD artefacts, 61
CCD calculator, 29
CCD imaging, 2, 3, 16, 23, 32, 36, 157
CCD Inspector, 71
CD, 46, 168
Ced, 174
Celestron, 2, 3, 5, 7, 9, 10, 12, 22, 23, 25, 26, 30, 40, 63
Celestron bino-viewers, 2
Celestron f#6.3 reducer/corrector, 2, 3, 10, 26, 27, 30, 31, 35
Celestron heavy-duty wedge, 5
Celestron 80 mm wide field scope, 7
Celestron Nexstar 11 GPS, xi, 1, 30–31, 155, 162, 179
Celestron Power Tank, 13
Cepheus, 20, 54, 96, 105, 120, 139, 174, 175
Christmas tree, 113, 173
Chromatic aberration, 19, 22, 26, 37, 63
Clusters, 28, 33, 34, 38, 52–57, 61, 72, 112, 114, 117, 128, 132, 136, 145, 147, 148, 159, 167, 173, 175, 180
Coathanger cluster, 112
Cocoon nebula, 54, 175
Collimate/collimation, xi, 6–8, 21, 24, 26, 28–29, 62, 67, 69, 72, 73, 76, 83

Collinder (105), 173
Colour, 2–4, 10, 16, 19, 29, 30, 36, 38, 39, 60, 80, 91, 96, 99, 123, 155, 168, 171
Colour balance, 36, 99–100
Coma, 3, 5, 31, 36, 53, 82, 151, 175
Combine, 3, 21, 26, 62, 86, 92, 96
Comets, 31, 41, 43, 72, 157, 174
Computer, xi, 1, 9, 10, 12, 22, 39–44, 48, 65, 71, 78, 96, 98, 104, 154, 179, 180
Condensation, 9, 39, 46
Cone nebula region, 173
Corrector lens, 10, 23, 30
Counterweight, 64
Crop, 87
CRT monitor, 9, 40
Culham, 176, 177
Curve(s), 86, 87, 89, 91, 123
Cygnus, 54, 58, 87, 104, 122, 140, 143, 148, 174

D

Dartmoor National Park, 176
The Data Book of Astronomy, 169
de-Bayer, 86
DEC, 28, 63, 64, 96, 154, 156
de Martin, D., 173
Deep (image), vii, 1, 2, 15, 17, 27, 38, 57, 80, 95, 113, 121, 130, 138, 147, 158, 159, 161, 176, 178, 181
Deep-Sky Survey (DSS), 95, 96
Deep-Sky Wonders, 168
Degree, 3, 4, 21, 25, 30, 37, 52, 53, 55, 62, 70, 75, 79, 80, 132, 136, 145, 154, 160, 171, 172, 174, 176
Dehumidifier, 9, 13, 40, 46
Delphinus, 90, 125
Depth of focus, 3
Differentiate (work), 38, 153, 155
Diffraction spikes, 7, 71, 81, 88, 127
Digital Development Filter, 87, 90
Dither, 61, 68, 80, 86
Dome aperture, 44, 47, 48, 78
Dome rotation, 44, 48, 78
Double Cluster, 16, 55, 56, 117
Dragonfly Telephoto Array, 79
Drift method, 28, 47
DSS2 data, 93, 95, 96, 99, 102
Dumbbell nebula, 123
Dust doughnuts, 65
DVD, 41

E

Emission line, 37, 38, 156
Equatorial imaging, 5, 13, 21
Equatorial mount, 13, 22, 24, 25, 156, 179
Exo-planet, 76

F

f#, 6, 23, 25, 31, 35, 60, 61
Fastar, 6, 162
FeatherTouch focuser, 3, 42, 69, 76
Fibreglass dome, 2, 10, 12, 46
Field of view (FOV), 1, 3, 6, 21, 23, 25, 28, 29, 31, 36, 47, 52, 54, 56, 59, 62, 64–66, 68, 72, 75, 76, 79, 80, 82, 85, 86, 116, 124, 131, 143, 149, 158, 171, 180
Field rotation, 4, 23–25, 28
FITS format, 68, 96
Flaming Star nebula, 118
Flatness (chip), 62, 67, 72
Flats, 23, 62, 63, 67, 70, 82, 86, 87, 157, 169
Focal plane diameter, 3, 36, 75, 80
FocusMax, 42, 66, 81
Fog, 15, 52
Forums, 13, 32, 153, 162, 163, 173
Fringe killers, 19, 20
FWHM, 59, 66

G

Galaxies, 1, 10, 16, 27, 31, 34, 52–55, 57, 63, 65, 70, 79, 121, 124, 133, 151, 154–156, 159, 167, 169–171, 175, 178, 180
Galaxy season, 52, 121
Gamepad controller, 10
Gamma Cassiopeiae, 132
Gamma Cygni nebula, 55
Garnet star, 139
Gemini, 57, 135
Gendler, R., 32, 62, 154, 169
Geoptik, 81
Ghost of Jupiter, 2, 180
Gradient, 33, 60
Gradient Xterminator, 87, 90, 91
Gravitational lensing, 155
Great Andromeda galaxy, 55, 154
Great Globular Cluster, 2, 16, 138, 180
Great nebula in Orion, 16, 52, 56, 147, 149
Greg's "3" asterism, 137
Guide scope, 7, 9, 21, 25, 26, 42, 75, 77, 79, 156
Guide star, 21, 22, 59, 66, 68, 79, 179
Gum, 174

H

Hallwag International Space map, 167
Halogen lights, 16
H-alpha, 20, 26, 37, 38, 58, 99, 110, 134, 135, 139, 140, 142, 146, 149
H-alpha filters, 20, 22, 77
Harmer, A., 178
Harwell, 176, 177
Hasta la Vista Green, 91, 92
Health warning, 16
Helios refractor, 1
Hercules, 2, 16, 54, 138, 180
High resolution, 27, 29, 65, 70, 154
High-speed flash, 178
HII, 37, 88
Histogram, 87, 98, 99
Holm (Holmberg), 175
Horsehead nebula, 20, 56, 110, 142, 175
Hot pixels, 65, 68, 86
Houston, W.S., 168
How, T., 40, 43, 44, 78, 81, 82
HSIII, 70–72
Hubble data, 95
Hubble images, 38, 164
Hubble palette, 38
Hubble space telescope, 35
Hutech, 9, 36, 37, 80, 82
Hydrogen beta (H-beta), 38, 110
Hyperstar, vii, 2, 3, 5, 8, 13, 23, 25, 26, 29–33, 35, 36, 46, 52, 54, 56, 60, 63, 64, 67, 69–71, 73, 76, 78, 82, 93, 94, 118, 123, 130, 133, 134, 145–147, 149, 153, 155–158, 162, 170, 181
Hyperstar III, vii, 26, 31, 34, 42, 62, 65, 66, 70–72, 74, 76–78, 80, 93, 112, 113, 115, 120, 133, 138, 143, 147, 153, 156, 170, 181

I

IC, 161, 163, 168, 174
IC405, 118
IC1318, 54, 148, 174
IC1396, 55, 139, 174
IC2118, 51
IC5070, 54, 143
IDAS light pollution filter, 9, 36
Image processing, vii, 5, 20, 40, 42–44, 57, 61, 68, 76, 85, 86, 89, 91, 92, 94, 102, 157, 161, 162
Integrated Flux nebulae (IFN), 144, 154, 156
Integration times, 22, 26, 60, 66, 107, 110, 113, 120, 126, 131, 139–141, 143, 157
Iris nebula, 20, 51, 61, 74, 120

J
Jellyfish nebula, 61, 135
Jupiter, 2, 179, 180

K
Kemble's Cascade, 92, 131

L
La Superba, 116
Laptop, 3, 39
Latitude, 24, 47, 53, 108
Laurentia (162), xii, 158, 160
LCD monitor, 40, 41
Legault, T., 28
Leo, 121, 137
Leo Trio, 53, 121
Levels, 98, 99
Light pollution, xi, 8, 15, 16, 20, 36–38, 51, 77, 87, 176
Live View, 80, 81
Lowell, 158
Lowell observatory, 164
Luginbuhl, C.B., 168
Lynx, 154, 155

M
M3, 53, 179
M5, 53
M13, 2, 16, 54, 138, 180
M15, 55
M27, 54
M31, 10, 16, 55, 124, 154, 159
M33, 16, 55, 133, 159
M35, 57
M42, 3, 16, 52, 56, 57, 149
M44, 129
M45, 38, 56, 57, 128, 163, 174
M46, 57
M51, 52
M63, 53
M64, 53
M65/66, 53, 121
M74, 55
M78, 130
M81/82, 57, 175
M88, 180
M92, 54
M97, 51
M100, 53
M101, 53
M104, 53
M106, 53
M25C CCD, 69
M26C CCD, 79
Malin, D., 164
Markarian's Chain, 53
Maxim DL, 4, 7, 8, 10, 39, 42, 43, 59, 62, 66, 68, 86, 87, 90, 92, 156, 157, 163
May, B., 169
Meade, 22, 26, 30, 162
Meade f#3.3 focal reducer, 31
Mel, 175
Mercury, 36
Merope, 157
Mesophotonics Ltd., 176, 178
Messier, 1, 20, 82, 96, 121, 130, 154, 161, 167, 174, 179
Micron, 3, 20, 30, 71, 72
Mini-ATX computer, 3
Mini-WASP array, xi, xii, 43–44, 48, 66, 75–77, 79–83, 90, 92, 116, 129, 131, 132, 136, 141, 144, 146, 170, 176, 181
Minute, 9, 21, 24, 28, 33, 35, 45, 53, 55–57, 60, 61, 72, 74, 80–82, 86, 108–113, 115–117, 119, 120, 122–133, 135, 136, 138, 139, 141, 143, 144, 146–148, 154, 156, 158, 171, 179
Minuteminute, 34
200 mm lens, 44, 78, 80–82, 91, 109, 111, 129, 136, 150, 151
35 mm sensor, 80, 82
Monkey head nebula, 37, 134
Monoceros, 56, 113, 145, 146, 173, 175
Monochrome, 3, 20, 37
Monteverdi (5063), 158
Moon, 3, 15, 20, 34, 38, 51, 56, 58, 60, 87, 145, 171, 179
Moore, P., 46, 168–170, 174
More Small Astronomical Observatories, 46, 168
Mosaic, xii, 32, 42, 53–56, 82, 92–93, 96, 103, 109, 113, 117, 121, 131, 139, 140, 143, 151, 154, 158, 163
Mrk, 175

N
Narrowband filter, 22, 26, 36–38
Nebulae, 1, 20, 23, 34, 35, 37, 57, 63, 70, 74, 76, 80, 96, 147, 154, 156, 157, 167, 174, 180, 181
New Forest, vii, 9, 10, 43, 46, 176, 178, 180

New Forest Observatory, vii, 73, 75–77, 164
Newtonian, 22, 36
New Zealand, 176
Nexremote, 10, 40
Nexstar 11 GPS, 2, 7, 8, 10, 12, 25, 28, 31, 32,
 52, 63, 134, 171, 180
The Nexstar User's Guide, 162, 168
NGC, 96, 147, 154, 156, 161, 163, 168,
 174, 180
NGC188, 156
NGC869/884, 55
NGC891, 55
NGC1333, 41, 93, 94
NGC2024, 57
NGC2158, 57
NGC2174, 134
NGC2244, 56, 145
NGC2264, 173, 175
NGC2438, 57
NGC3242, 2, 180
NGC3628, 53, 121
NGC6914, 54
NGC6946, 54
NGC6960/6992/6995, 54
NGC7000, 54, 61, 73, 143, 171, 174
NGC7023, 120
NGC7331, 55
NGC7635, 51, 55
NGC/IC project, 163, 168
Nitrogen-II, 38
Noel Carboni's PhotoShop actions, 9
Noel's Actions, 91, 98–100
North America nebula, 34, 35, 52, 54, 61, 73,
 74, 143, 174
Norton's 2000, 169, 180

O

O'Meara, S.J., 167
Observatory, vii, 2, 3, 9–11, 25, 39–43, 45–47,
 49, 54, 61, 69, 77, 78, 154, 162, 168,
 178, 181
Observing Handbook, 168
OCL, 173, 175
OCL494, 173, 175
Off-axis guider, 21, 26
OIII, 77, 140, 146
One-shot colour, 4, 30, 36, 37, 60, 86
Optimum (sub-exposure time), 32, 33
Orion, 16, 20, 37, 52, 56, 57, 59, 61, 110, 130,
 134, 142, 147, 149, 175, 179
Orion's belt and Horsehead nebula, 110
OTA, 28

Oxford Polytechnic, 177
Oxygen-III, 38

P

Paint Shop Pro, 102
Palette, 38
Parallel imaging, vii, 75, 76, 78–81, 83,
 132, 156
Paramount ME, 44, 60, 66, 78
Parker, G., 170, 176–178, 180
Parker Technology, 176
Pazmino's cluster, 114
Pelican nebula, 54, 143, 154
Peltier cooler(s), 79
Periodic error, 25
Permanent set-up, 46, 47, 49
Philip's Astronomy Encyclopaedia, 169
Philips Research Labs., 176, 177
Philips screws, 24
The Photographic Atlas of the
 Stars, 168
Photometry, 39, 163
Photonic Crystals, 176, 177
Photoshop, 9, 20, 42, 80, 87, 88, 90, 92, 96,
 98, 102, 103, 163, 178
Photoshop actions, 9, 100
Physics World, 2, 179, 180
Piggyback, 10, 11, 25, 27, 63
Pillars of Creation, 38
Pinwheel galaxy, 53
Pixels, 3, 7, 29–32, 36, 52, 59, 63, 65–67, 72,
 73, 75, 80, 86, 87, 96, 104, 156
Planet, 1, 35, 45, 64, 70, 153, 157, 164, 179
Planetarium software, 161
Planetary nebula, 2, 35, 38, 54, 57, 123, 135,
 157, 180
Platt, T., 3, 10, 26, 162
Pleiades, 20, 38, 56, 57, 61, 128, 157, 158,
 163, 174
Polar alignment, xi, 28, 33, 45, 47, 59,
 65, 156
Polaris, 23, 34, 47, 58, 144, 156
Polarissima Borealis, 156
Pole, 23, 156
Poor star shapes, 3, 56
Power outage, 10
Primary mirror, 21, 24, 69, 70
Prism, 19, 21
Procyon, 179
Promper, W., 164
Pulsar dome, 78
Pulsar Optical, 12, 46, 47

Q
Quasar, 154, 155
Quasi-stellar object, 154

R
R.A., 25, 28, 47, 63, 96, 154
Radiospares, 81
Red light, 15
Reducer/correctors, 26, 30, 31, 35, 36, 43, 63, 64
Reflecting telescopes, xi, 21–25, 155, 176
Reflector, vii, xi, 1–3, 7, 10, 19–22, 24–27, 30, 36, 47, 63–65
Refractor, vii, xi, 1, 9, 11, 19–22, 24–27, 30–32, 34–37, 43, 47, 60, 62–66, 68, 74–79, 81, 149, 176
Registar, 85, 92, 93, 103
Reticule eyepiece, 28
Ritchey-Chrétien (R.C.), 22, 156
Roll-off roof, 46, 61
Rosette nebula, 37, 56, 57, 107, 145, 146, 171
Rotating camera, 13
Round stars, 6, 13, 24
Ruchbah, 132
Running Man nebula, 147
Russ Croman's Gradient Xterminator, 87

S
Sadr, 54, 148
Sampling, 3, 29, 31, 32, 80
SBIG 11000, 156
SBIG 8300 CCD, 79
Schmidt camera, 23, 36, 70
Schmidt-Cassegrain (S.C.), 1, 22, 26, 28, 30, 60, 62, 63, 69
SD mask, 62, 68, 86, 91
Seconds, 4, 8, 12, 23, 33, 53, 60, 61, 66, 98, 118, 121, 130, 134, 145, 154, 155, 171
Semiconductor physics, 176
Sequence, 15, 60, 61, 85, 170
Sh2, 174
Sharpless, 154, 164, 174
Signal to noise ratio, 32–34
SII, 77
Silica-gel, 46
Sirius, 81, 126
Skiff, B.A., 168
Sky & Telescope, 51, 168, 169
Sky 90, xii, 9, 11, 30, 34, 35, 43, 44, 52–54, 60, 62, 64–67, 69, 74–82, 85, 88, 90, 92, 107, 108, 110, 112, 114, 115, 117, 119, 122, 124, 126, 128, 130, 131, 133, 135, 139–142, 144, 146, 148, 149, 158, 170, 171, 176
Sky at Night, 51
Sky Atlas 2000, 167
Sky background noise, 32
Sky Factory, 164
Sky glow, 8, 32, 36
SkyView, 95, 99
Smooth (image), 32
Southampton, 177
Speed (optical), 33, 35
Spica, 119
Spring, xii, 52–53
Square degrees, 172
Stack and rotate, 4
Star bloating, 19
Star fields, xii, 33, 34, 57, 72, 74, 76, 81, 85–92
Starizona, 2, 3, 26, 28, 42, 65, 69, 70, 76
Starlight Xpress, 2, 4, 7, 10, 26, 30, 44, 70, 71, 75, 77, 78, 81, 162, 163
Star map/atlas, 15
Star Trek, 176, 180
Stecker, M., 164
Steradian, 172
Stitching, 32, 103
Stock 2 and Double Cluster, 117
Subaru, 20, 57
Sub-exposures, xi, 3, 7, 9, 25, 28, 32–36, 38, 39, 56, 57, 60, 61, 65, 66, 68, 70, 74, 80, 86, 87, 90, 108, 113, 117, 119, 124, 131, 138, 141–144, 155–157, 159, 164
Sulphur-II, 38
Summer, xi, 53–55, 176
Supernova, 33, 54, 65, 157, 159, 174
SuperWASP, 76, 79
Swanson, M., 9, 162, 168
SXV-H9C, 31, 32, 56, 134, 146, 162
SXV-M25C, 3, 30, 31, 156, 171
SXVF-M25C, 9, 10, 52–56, 62, 158, 162
Synthetic green channel, 100

T
Takahashi, 31, 63, 64, 162
Takahashi f#4.5 reducer, 9, 43, 75
Takahashi Sky 90, xi, 9, 31–32, 63, 81
Tarazed and Barnard's "E", 82, 108, 150
Tr, 173, 175
Tracking, 25, 60, 61, 175
Transits, 68

Index

Trapezium, 61
Triangulum, 16, 55, 133
Trius M26C CCD, 43
Trumpler 5, 113, 173

U
Uninterruptible power supply (UPS), 12, 40, 43, 44
University of Sussex, 176
University of Toronto, 79
Ursa Minor, 34
USB 2.0, 39
UV/IR cut filter, 37, 82

V
V1331, 85–87, 122
VAIO laptop, 3
V-curve, 81
vdB, 55, 174
Veil nebula, 54, 140
Venetian blind effect, 61
Vibration, 24, 47

Vignetting, 3, 31
Virgo Cluster, 53
Virgo/Coma galaxy cluster, 82, 151
Visibility, 15, 20

W
WASP, xi, xii, 43–44, 48, 66, 75, 76, 78–82, 90, 92, 116, 129, 131, 132, 136, 141, 144, 156, 158, 170, 176, 181
Water snakes, 46
Wedge modification, 5
Wide field refractor, 9, 62, 64, 149
Witch head nebula, 51
Wooden decking, 12, 47

Y
Yale University, 79

Z
Zenith, 16, 51

Made in the USA
Middletown, DE
23 February 2018